2499

GV
951
.W537

Winningham
Rites of fall

DATE DUE

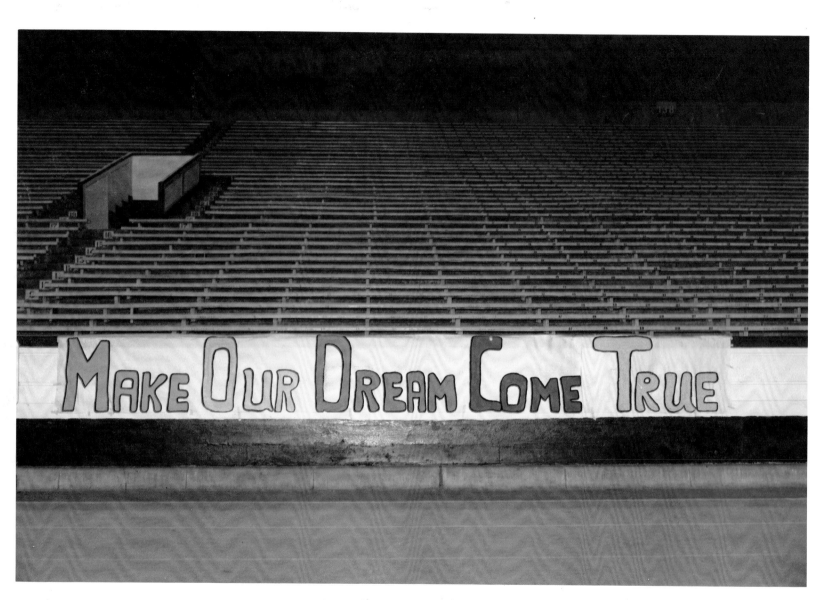

Rites of Fall HIGH SCHOOL FOOTBALL IN TEXAS

Photographs by Geoff Winningham

Text by Al Reinert

Commentary by Don Meredith

University of Texas Press, Austin and London

Deepest appreciation and gratitude to
the John Simon Guggenheim Foundation,
whose support made possible the completion
of the photography for this book.

The photographs in this book were taken
during the years 1972 to 1978, in the state of
Texas. For those readers who are interested in
the specific time and place of individual pictures,
an index is provided near the end of the book.

Library of Congress Cataloging in Publication Data
Winningham, Geoff.
 Rites of fall.
 Includes index.
 1. Football—Texas. 2. School sports—
Texas. I. Reinert, Al. II. Title.
GV951.W537 796.33'262'09764 79-18745
ISBN 0-292-77020-0
ISBN 0-292-77021-9 pbk.

Requests for permission to reproduce
material from this work should be sent to
Permissions, University of Texas Press,
Box 7819, Austin, Texas 78712.

"The dogmas of the civil religion should be simple, few in number, precisely formulated, without interpretation or commentary. . . . These would not be, strictly speaking, dogmas of a religious character, but rather sentiments of sociability without which no man can be either a good citizen or a loyal subject."
—Rousseau, *The Social Contract*

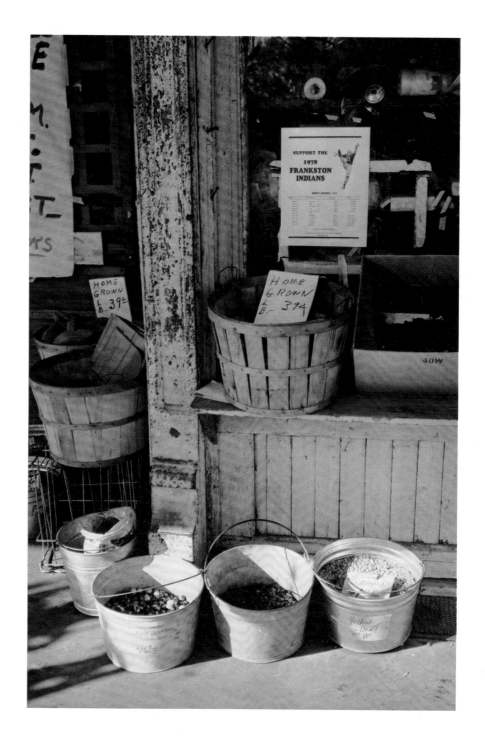

**PNG fans spend 3-day vigil
for those few remaining tickets**

Port Neches–Groves football fans lined up late last week for the few remaining tickets to the Indians' football games. Only 22 of the scarce ducats remained and there to get first shot at them was Al Herrera, who recently moved into the district. Al, his wife Gail, Jack and Sandra Mertens and Jerry and Monroe Pratt took turns holding their first place position and will each get one of the six tickets available to each person in the line.

Second in the line was Elizabeth Culver, who was sharing the long wait with Margie Gutierrez, whose son, Joe, is a member of the Indian varsity.

E. W. Sweeney, the third person in line, wasn't waiting to buy tickets. He already has two, but waited to get better seats for the 1978 season.

Mr. and Mrs. Robert Droddy were the fourth and final members of the line. When they got their tickets the sparse supply was exhausted. Youngsters Rob and Emily Droddy were on hand to help their parents with their vigil.

—*Midcounty Chronicle*, August 30, 1978

Each week in the fall, sometime along about Monday or Tuesday afternoon—when the Friday-night football passions are at their lowest ebb in the town at large—certain earnest and farsighted men from a Texas community gather in the rear of a town square coffeeshop or a barbecue parlor, maybe in the VFW hall or the bank boardroom. If the local high school is especially rural and small, or its football team is undistinguished, they will likely meet unobtrusively, in the coach's office perhaps, and talk over old times and declining prospects. However, if the school is large or suburban, or if a promising season is underway, they might well take over the Regency Room at the Holiday Inn and have themselves a regular luncheon, watch game films, and listen to lectures by assistant coaches. The scope of the gatherings varies across the state, in keeping with local tradition and the team's current fortunes, but by suppertime on Tuesday about a thousand such meetings will have been held in the towns and neighborhoods of Texas, among men concerned with the worth of those places.

In their other roles, they might be deacons and county grand jurors, precinct judges, trustees of the soil conservation board and 4-H Club sponsors, men with responsible habits and a broad sense of citizenship. They are by their very nature civic boosters, and like all boosters everywhere they are sure of their purpose because it seems to them so

essential and so obvious for the good of the community, so personally selfless. Generous with their time and money and fervid as a result, they devote themselves six months a year to advancing the interests of the local high school football team. Calling themselves the Bobcat Boosters or the Bay City Quarterback Club, they organize caravans to out-of-town games, welcoming committees for home games, team banquets with guest speakers; they pay for tutors or surgeons for dull or injured players, for various kinds of fancy equipment—prostyle Riddell helmets, say, or sideline headphones for the coaching staff—things the local school board can't find any way to finance or justify.

Somehow, towns that don't need streetlamps have fifty thousand watts of cadmium SuperTroopers to light their high school field a dozen times a year, while schools that can't afford microscopes have carpeted training rooms with exercise machines and, probably, a whirlpool bath, all of it paid for by boosters club subscriptions. The boosters mount campaigns to search for a new head coach if they think it's time, to lobby when needed with the school board or league officials, to sell season tickets or ads in the game program. In the old days they also used to help with the covert recruitment of exceptional thirteen-year-olds, but this got so out of hand after Texans got rich—the classic story is the oil company that was purchased so Sammy Baugh's daddy could be transferred to Sweetwater—that the state interscholastic league finally cracked down in the late fifties. Nowadays the boosters clubs are all chartered and regulated, required to have bylaws and certain officers, and sanctions are occasionally imposed in a manner that league officials consider to have ended the more outrageous cases of boosters club zeal.

The league's authority is tenuous in any case, though, since most of the boosters have no real connection with the local high school itself, or any particular interest in it apart from its football team. A few might be fathers or uncles or older brothers of current players, their enthusiasm warmed by blood pride, but these are exceptions, temporary boosters. And no doubt most of them played on the team in their own schoolboy days and continue to cling to the experience for the bold definition it briefly gave their lives, but their steady dedication is too sincere and expensive to be merely nostalgia. These are not simply football fans, after all, but community leaders, men who regard the support of high school football as a civic obligation, one more immediate than charity and more profound than voting, something on the order of civil defense.

On the outskirts of dozens of nondescript Texas towns, the resident boosters have erected billboards, usually artless but large, proudly announcing "The Home of the Hutto Hippos" or "Entering Panther Country." Whenever possible these include a list of historical successes—"Class 2A Bidistrict Champions 1964, State Semifinals 1965"—painted in over the years like entries in an almanac, vintage seasons in the town's career. Positioned strategically in the last open curve of a farm-to-market road, these handmade brags are as often as not the sole claim or welcome encountered on the threshold of a Texas town. Even approaching Gonzales, where the first battle of the Texas Revolution took place, the only notice posted anywhere by the townsfolk reads: "This is Apache Territory, District Champions 1958." It is a truer measure of their values than art or war or politics: the way they choose to declare themselves.

In most small Texas towns there are few enough ways to excite one's passion or ambition, to assert oneself. Life is bounded and determined by the land and the weather and the distant impositions of the government and God—both about equally predictable and final—which means life is physical and seasonal, elemental, stoical. It is commonplace by definition—or as common, that is, as life in a place such as Texas can be. Full of their own rich yearnings, Texans have always seemed to struggle hardest against ordinariness, and for more than half a century now the basic stage and focus for that struggle has been on high school football fields.

High school football is the one thing that can both unify a Texas town and set it apart from the hundreds of other similarly rural and unremarkable Texas towns. Places like Nederland, Junction, or Hull-Daisetta can easily escape the notice of Rand McNally, for instance, but in Texas they are powers to be reckoned with a thousand miles away, denounced by far-flung boosters and politicians, spied on and worried about. Their success at high school football is their one claim to recognition by the larger world, and thus it provides the clearest reflection of their own sense of worth. It is for many Texans the best indication of a town's vitality and pride, its sense of identity, and no one is more conscious of this than the men most concerned with the life of the town.

By Wednesday morning all the boosters have signs up in front of their homes, cardboard cheers and admonitions on the upcoming game—"Lasso the Mustangs"—handlettered in the school colors. Retail merchants put out placards and allow their windows to be luridly painted, businessmen pointedly display their boosters club sponsor certificates, team rosters are taped up in restaurants, bars, and other meeting places, like the names of favorite sons. By late afternoon football slogans show up on local motel marquees and Dairy Queen signs, on the message boards outside all the churches, and a few special banners, handpainted on old sheets, are hung in the customary places. Reminders appear everywhere, on passing cars, water towers, buttons worn by twelve-year-olds.

Male conversations begin drifting from more normal and prosaic lines—usually weather in the country and money in the city—toward the questions of Friday's game: the probable status of an injured lineman, the reputation of a foreign tailback, the records of the coaches and their teams' resolve. The approaching cares of Friday grow large in many female minds as well, from budding majorettes to mothers and wives, bringing the same sense of purpose and urgency into their lives. Banded together as the Boosters' Helpers or the Bobcat Moms, or in more effete parts as the Junior League, the community's women support its sons with as much assurance as its men encourage them. They hold bake sales to buy team blazers or send the band on trips, they dote on the new coach's wife to make her feel at home, they see that the PTA doesn't interfere too drastically with school athletic policy. These women, however, are much more alert to the ramifications of the game itself —to the social gravity of Friday night—and so as it nears they direct their attention to closer, more personal and practical concerns, such as how they will get to the game, with whom and where they will sit, how to keep warm and dry. As a result there will come a time when the women are running things.

By Thursday afternoon nearly everyone has something to practice or plan for, at the very least to mull over. The local high school's entire line of extracurricular pursuits—the marching band, the student government, the drill team, pep squad, honor guard, baton twirlers, mascot handlers, cheerleaders—all are rehearsing their parts, substantial or not, in the elaborate ceremony that the game inspires. Talk among fans grows more single-minded by the hour, generally louder, telephones are kept busy. If the game is to be played out of town, someone reliable is dispatched to paint all the railroad trestles between home and the rival town, and caravans are organized; cars are cleaned up and decorated, dresses are examined, chrysanthemums refrigerated.

If the game is considered important, a public pep rally is held—on the square in rural towns, at a neighborhood park in urban areas—either Thursday night or Friday afternoon, possibly both, depending on whether the game is at home or away. The school band plays and the cheerleaders lead cheers; various local politicians, along with the head of the boosters club, the school principal, and a minister or two, make speeches; then the team is introduced and the coach says a few tongue-tied, embarrassed words. Everyone joins in singing the

school fight song. The crowd cheers at every cue and every opportunity, expressing their support by the fact of their appearance, rewarded by their sense of belonging. At no other point in the year, in most small towns, will as many people gather as appear for a high school football rally.

In the visiting team's hometown, a kind of mobilization occurs. For a crucial game, the boosters club may coerce the city council and the chamber of commerce into calling half-day holidays, and stores and offices will close by noon to let everyone get ready. Schools may let out early so the various supporting casts can go home to get uniformed, find their instruments and pom-poms, and return in time to board the buses. Cars and pickups run around on last-minute errands, collecting dates and families, gassing up, heading eventually toward the town square, where one of the boosters is keeping a list of vehicles and passengers to insure that everyone arrives together and safely.

Squad cars arrive to lead the procession—local policemen or sheriffs, highway patrolmen if county lines must be crossed, or, most prestigiously, a Texas Ranger if an off-duty volunteer can be rounded up. On an autumn Friday evening some three hundred Texas communities will migrate in this way; on stretches of the High Plains they might travel two hundred miles or more, and towns reaching the state finals will go twice that far for play-off games. Convoys of thirty or forty beribboned cars and pickups are common, often several following at intervals, honking and whooping, waving crazily at bystanders, shouting out the names of their town and team.

In the vanguard of this rowdy entourage, in a regulation schoolbus wrapped with banners and trailing streamers, ride the young Football Heroes on whom all are depending. Notwithstanding a few brief outbursts of nervous bravado, it is a very quiet and somber bus. The prospective heroes are mostly fifteen and sixteen years old, unused to being depended upon for anything at all, justifiably haunted by the fear that they're really still just children.

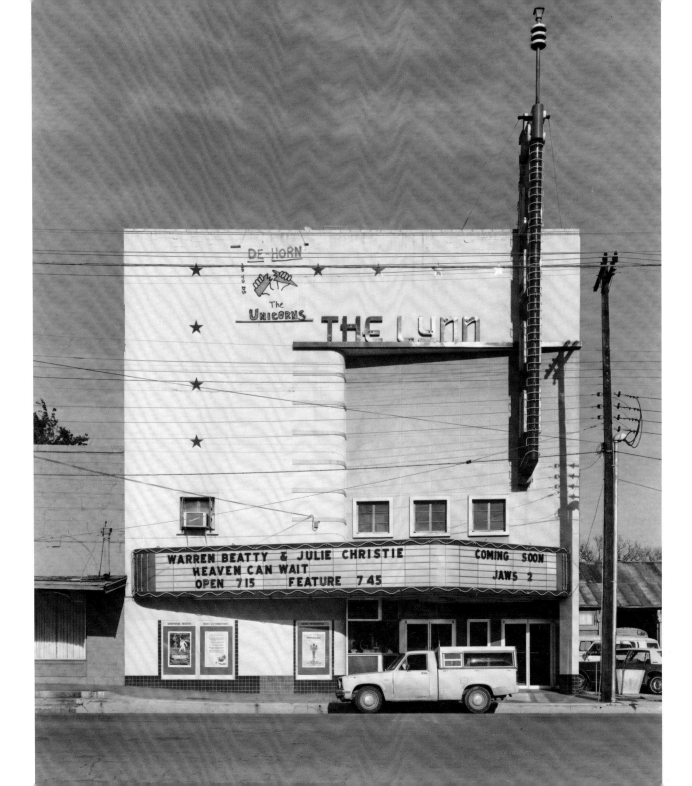

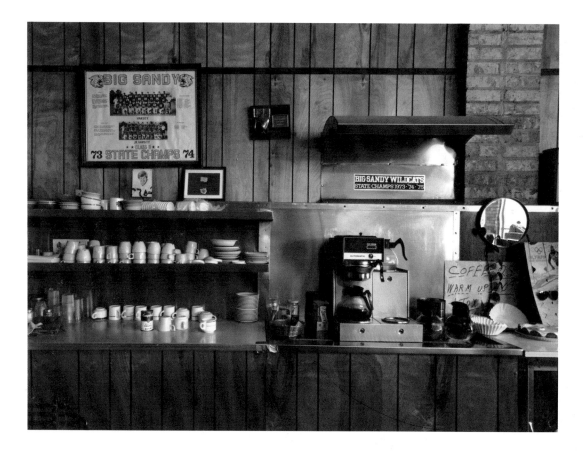

"You'll get forty or fifty folks for a Monday-night boosters club meeting even in a blizzard or a blinding rain. In fact, when they have a revival around here, they avoid Monday nights because they can't compete. People are just gonna go to the boosters club meeting no matter what. The story is that Rob Rutherford, one of our biggest fans, had bought a new mule last fall. Well, the mule got out on Monday night and Rob had to chase him down, making him late for the meeting. First thing Tuesday Rob sold the mule. He said *nothing*, not even a good mule, could interfere with his boosters club meetings."
— Odis Hammock, principal, Big Sandy School

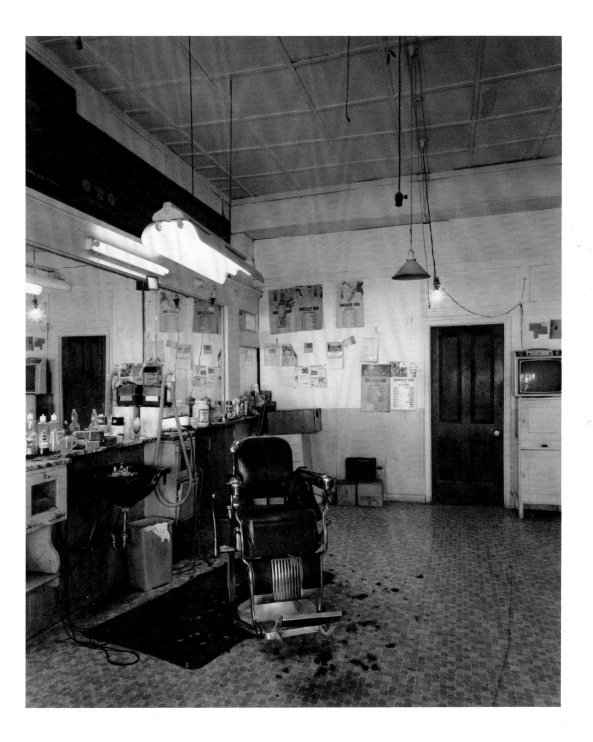

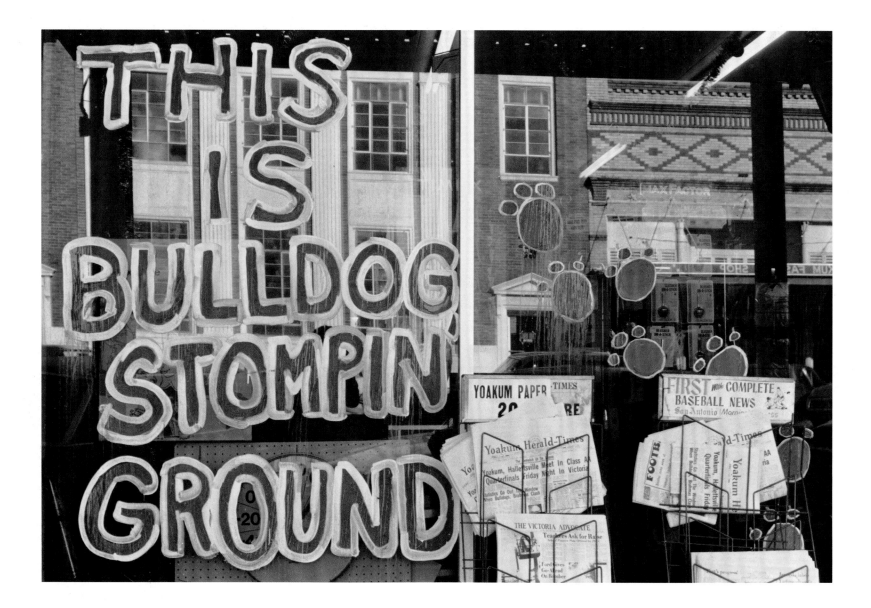

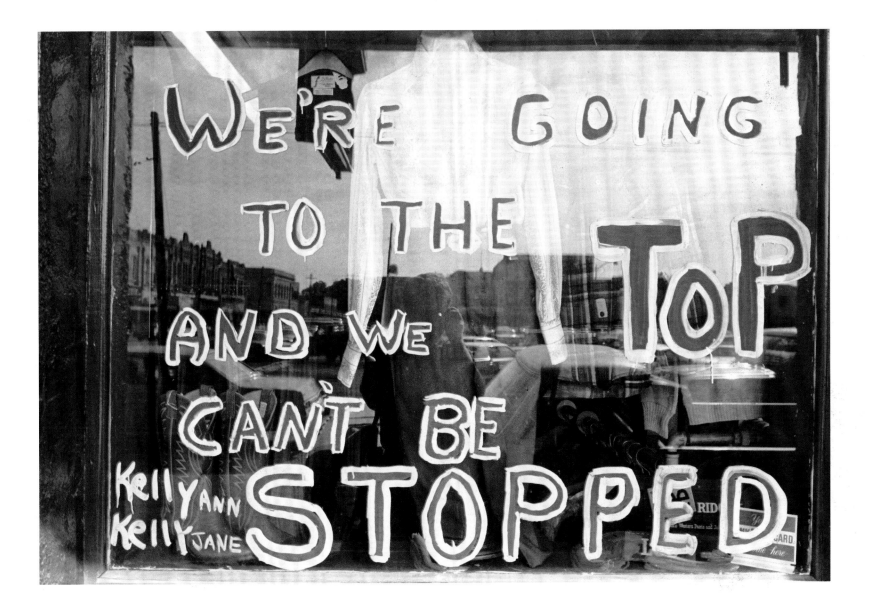

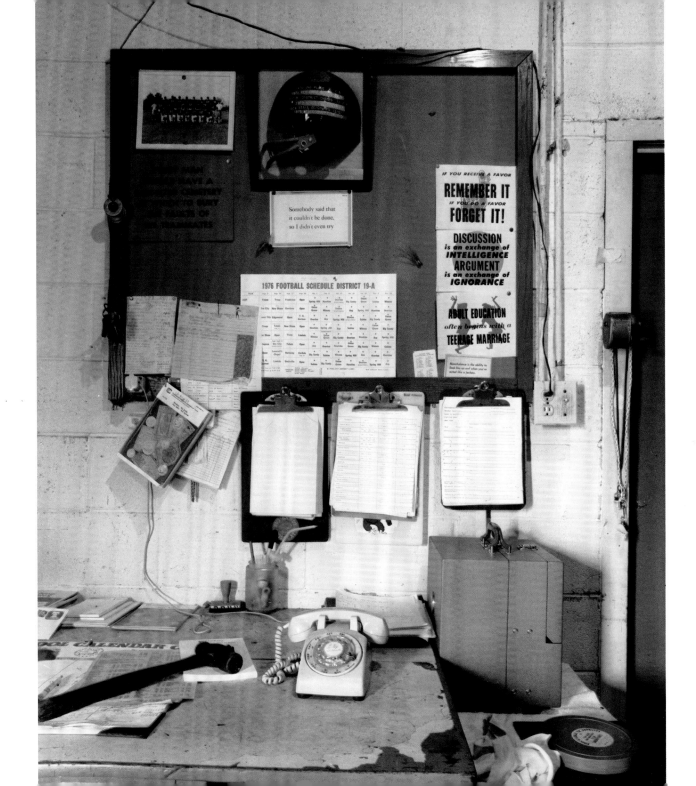

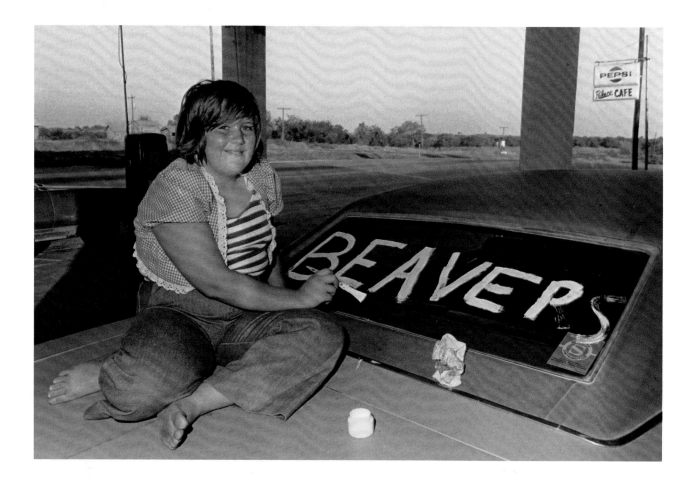

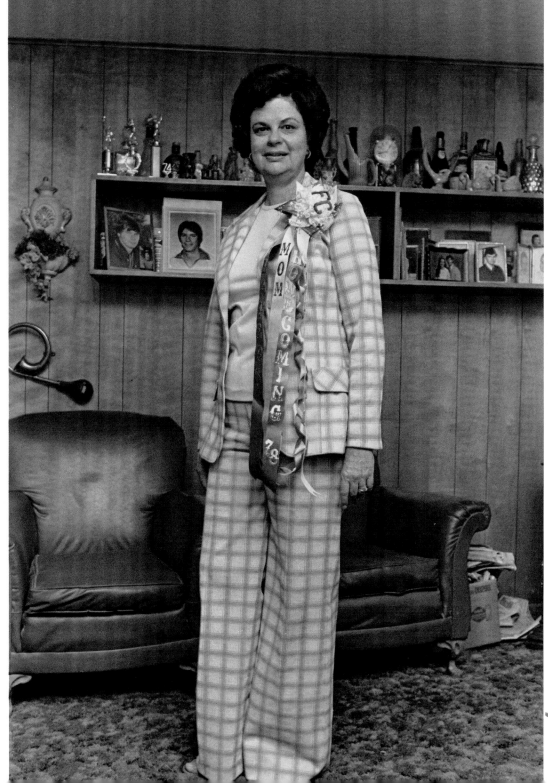

19

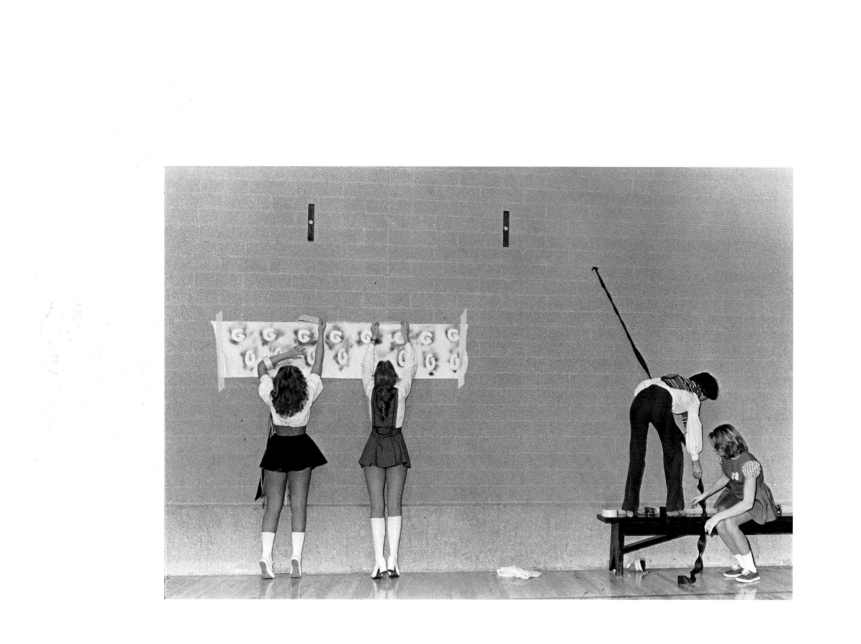

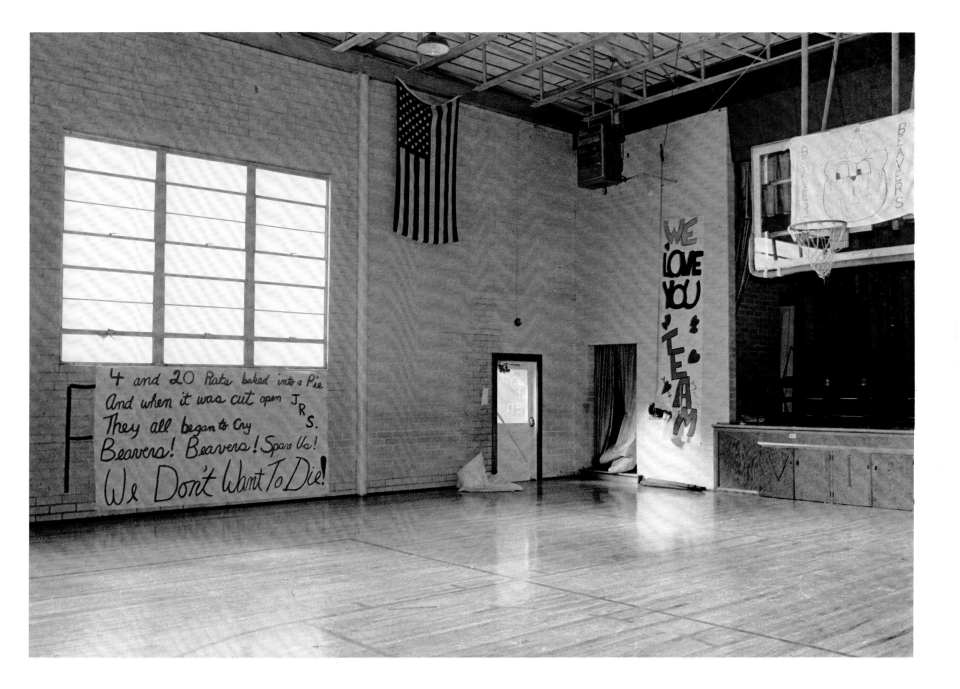

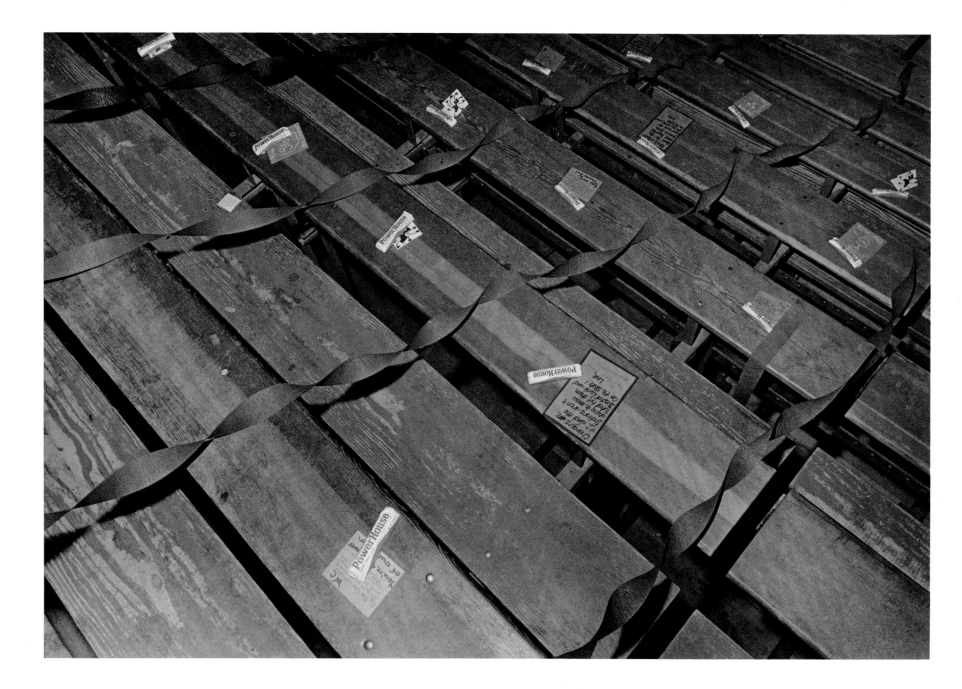

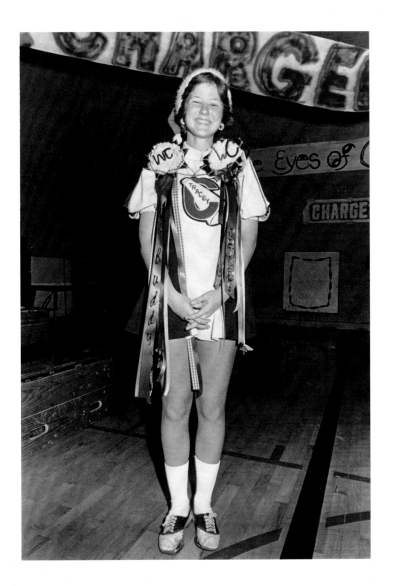

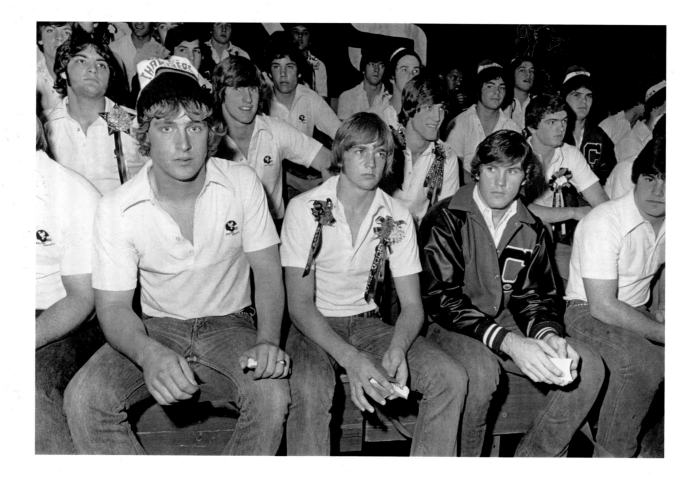

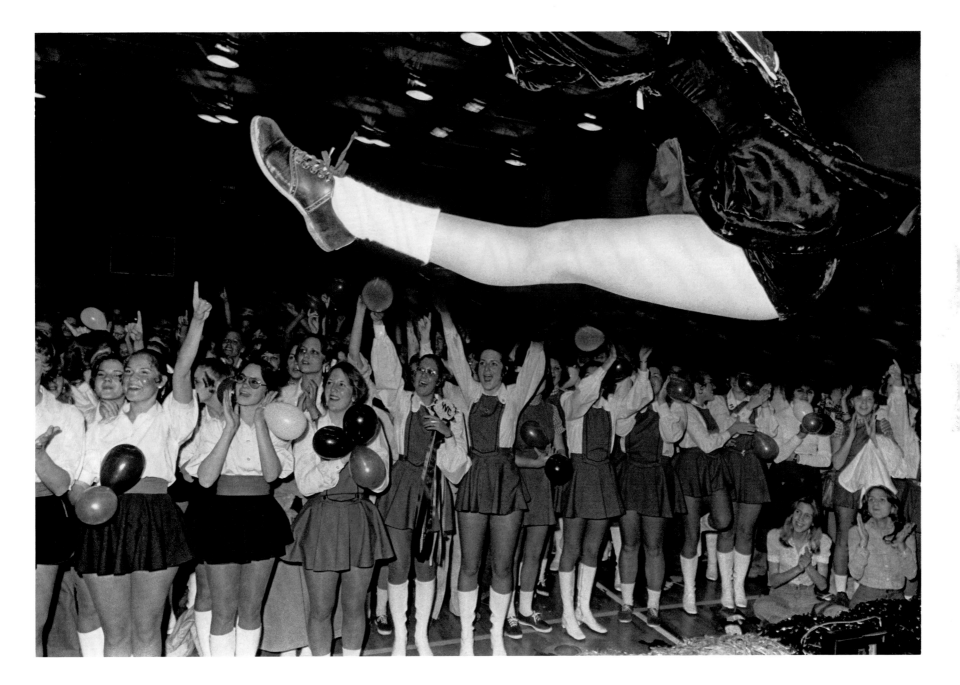

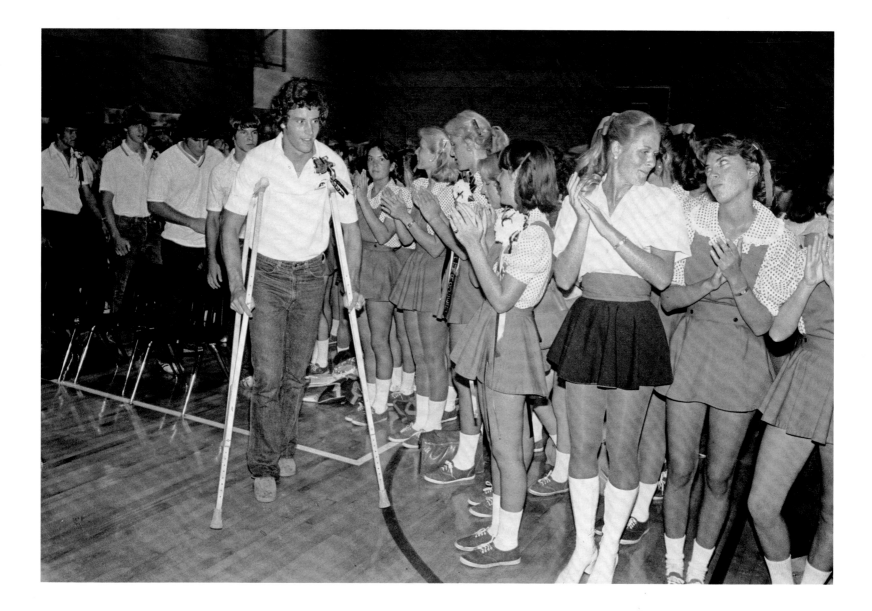

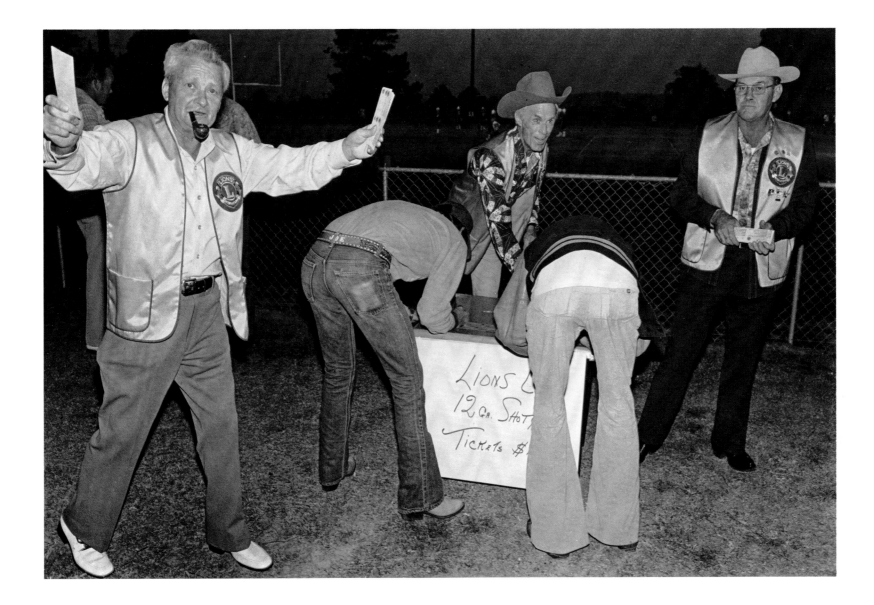

"Heavenly Father,

"Bless this land: make us a land of peace, tranquility, and benevolence toward our fellow man; and

"Bless these athletes: let them show the fullness of strength which thou has given them; and

"Bless these coaches: make them strong and understanding teachers; and

"Bless these officials: make them sharp of eye and wise of judgment; and

"Bless each of us as fans: teach us to want the Kingdom of Heaven with all the fullness of spirit with which we want a touchdown for our team on this glorious evening.

"In Jesus' name we pray. Amen."

—The Invocation,
Plano vs. Odessa Permian, 1978

In Baytown, on the Texas coast, they have torchlight parades before big games, snake-dancing down Main Street like carnivalgoers in Rio, at once affirming and celebrating their faith in the Sterling High School Rangers, four times district champions. In the more sedate but equally dedicated Highland Park district of Dallas they hold candle-lit vigils and have pregame suppers in parish halls, while out in Brownwood they have special livestock auctions to benefit the team. In Houston's Spring Branch suburb the students stencil bearclaws all over shopping center parking lots to remind the faithful that The Bears are coming, and on San Antonio's west side there are neighborhood fiestas with football-shaped piñatas and fireworks. There is all the loud talk and frantic behavior that precede any important test of faith.

The hour of truth comes on Friday night and is rarely subtle or ambiguous. The ritual of football is simple and direct and yields plain judgments, the kind most Texans seem to prefer. It is a game every bit as forthright, as physical, and as territorial as they are, a kind of symbolic range war for a still very land-conscious people. Football in Texas is a blend of culture and pastime as natural and congenial as hockey in Minnesota or fishing in Florida, as Colorado skiing or ghetto boxing.

The devotion to football is a social sentiment shared all over Texas, in each of its ethnic and geographic enclaves, across all of its classes. The two most elite public high schools in the state—Highland Park in Dallas and Lamar in Houston—have been on-and-off football powers throughout their histories, fielding teams made up largely of oilmen's sons, lavishly boosted and cheered in style, just as excited as anyone else. For years these two teams would meet in the state eliminations with teams from the oil boomtowns—places like Abilene, Stamford, and Wichita Falls—teams composed of roughnecks' sons and, often as not, of roughnecks themselves. The oil-belt towns were notorious for their twenty-year-old seniors and their eligibility hassles, for their giant linemen, windswept fields, for beating up unpopular referees who weren't quick to leave. They dominated Texas schoolboy football during the forties and fifties, the years between the discovery of oil and the integration of the schools.

Texas blacks had always competed in a league formed among their own schools, separate and unequal in every measurable way, short on uniforms and travel budgets but equally devoted to the native passion. In the sixties, Beaumont's Soul Bowl could prompt a week of riotous amenities and

draw twenty thousand people to a borrowed college stadium for the crosstown meeting of the Charlton-Pollard Cougars and the Hebert Panthers, both teams which had sent numerous alumni to the pros—Bubba Smith's daddy was the Cougars' coach—both with statewide followings. Scouts from a hundred Yankee colleges would come in for the game. Those were the days when foreign conferences like the Big Ten built national football reputations by recruiting southern blacks, especially Texans. Most collegiate teams in Texas weren't very noticeably integrated until the early seventies, nearly a decade after the high schools had managed it.

The success of Texas school integration was guaranteed on the Friday evening in 1962 when San Antonio's Brackenridge Eagles took the state class 4A championship—the highest classification—with a side-arm-throwing Chicano quarterback and a soon-to-be-famous black running back named Warren McVea. Within five years the balance of prowess had shifted from the oil-belt towns to East Texas, where there were blacks enough to make integration meaningful, difficult, and potentially divisive. As many Texans saw it, football was the only thing that made it seem worthwhile.

The boosters clubs were generally where it started: meetings between black and white counterparts, trading hopes and scouting reports, telling the old stories to receptive new ears, sharing their passion. Most of the better restaurants and Holiday Inns of East Texas were first integrated by the local high school football boosters club. The rest was inevitable: Texas high school football was a stronger cultural force than segregation, broader in spirit and more fun to watch, too innocent for prejudice.

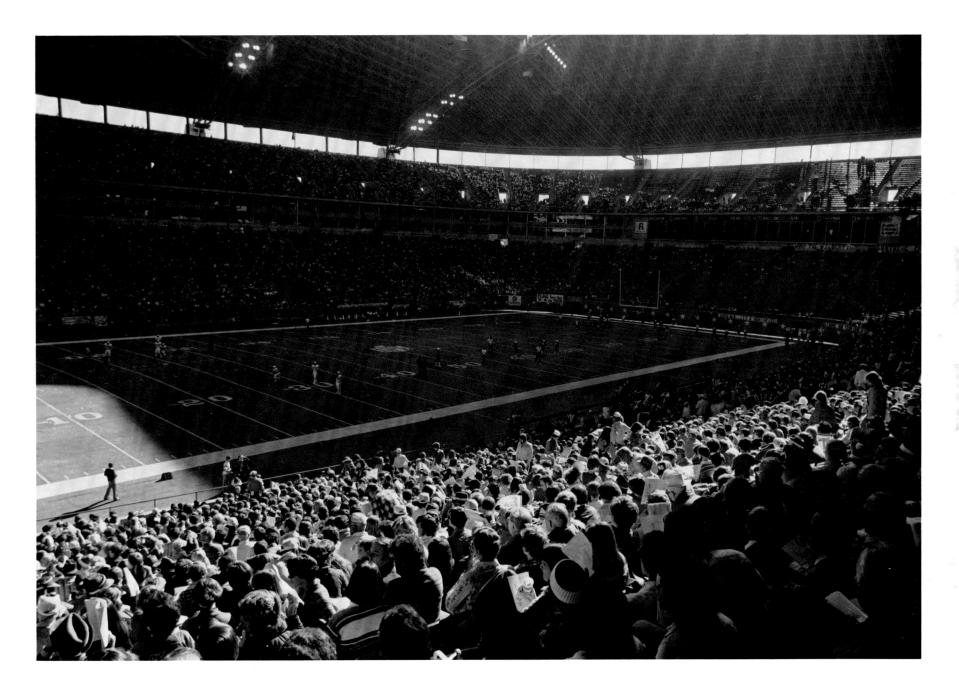

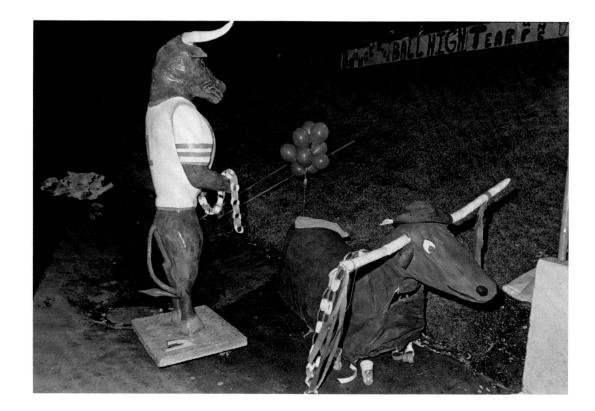

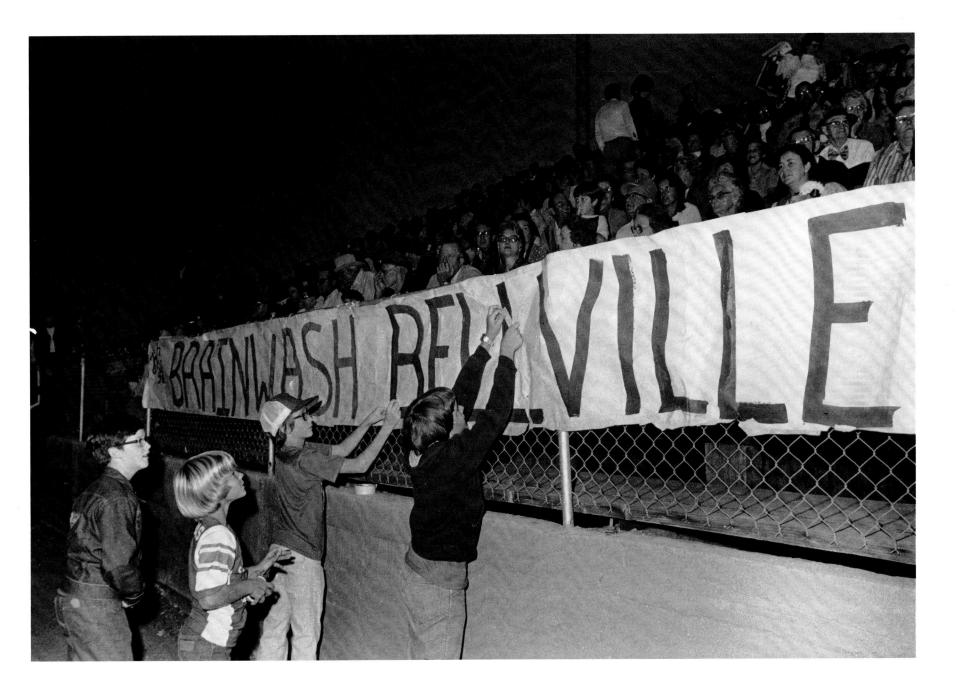

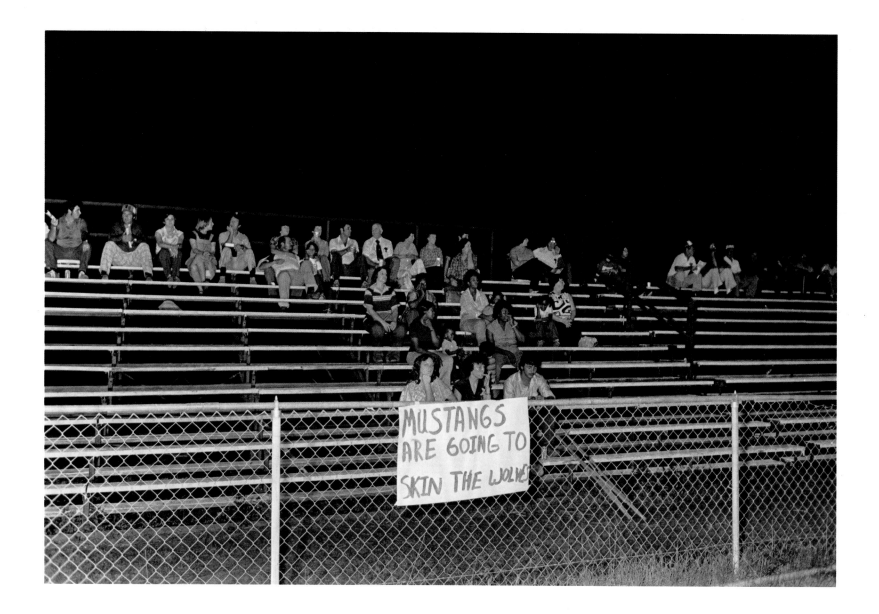

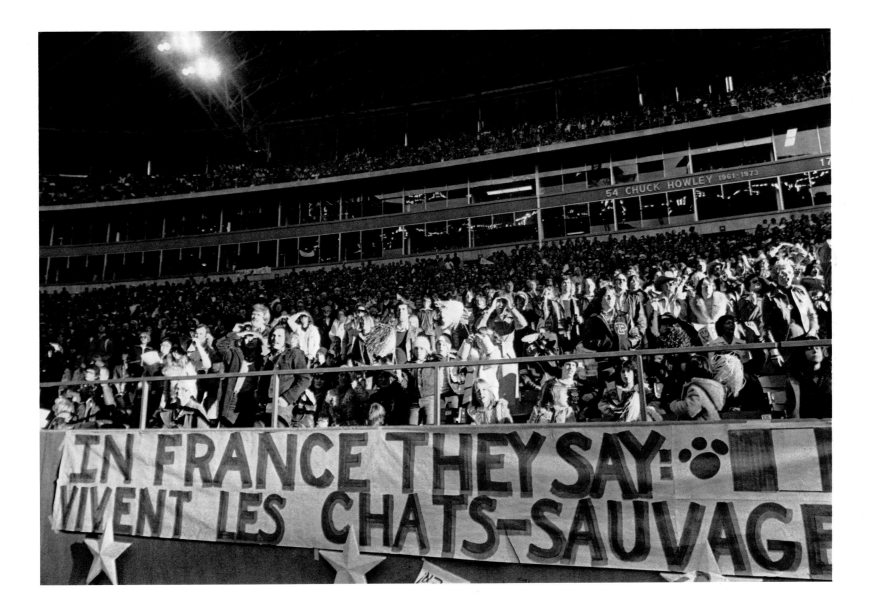

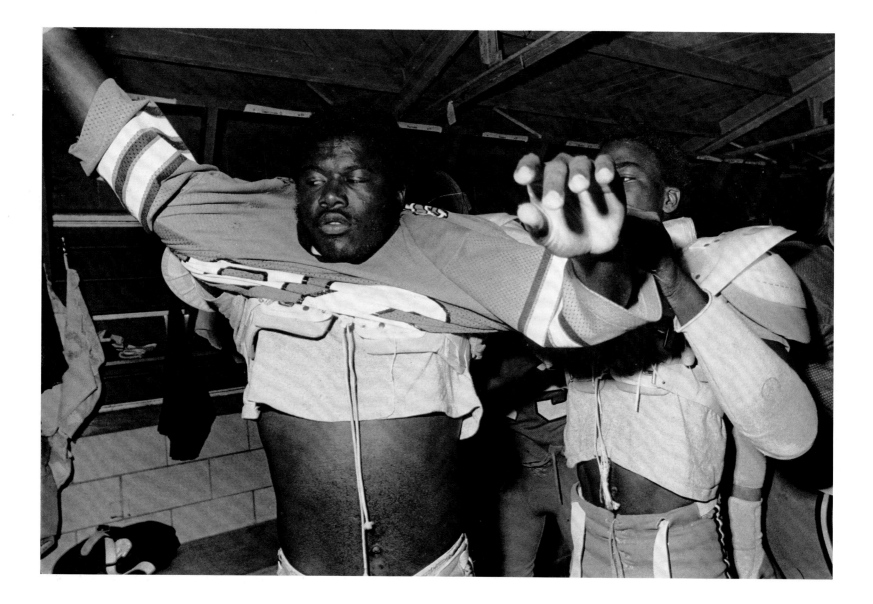

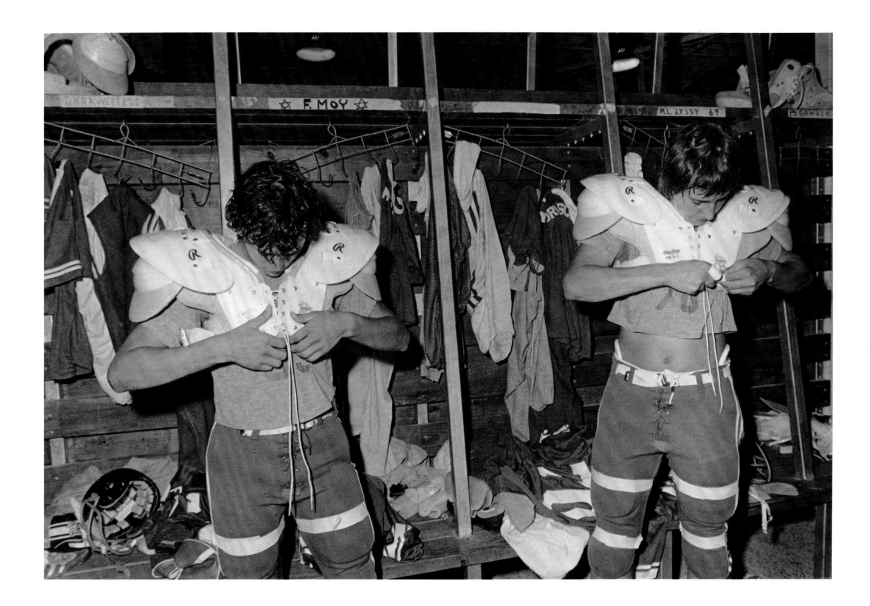

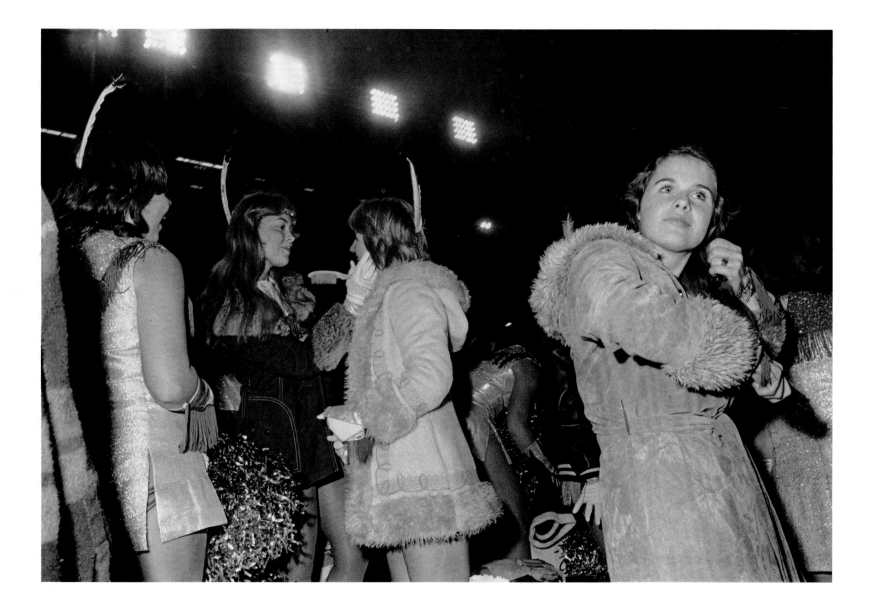

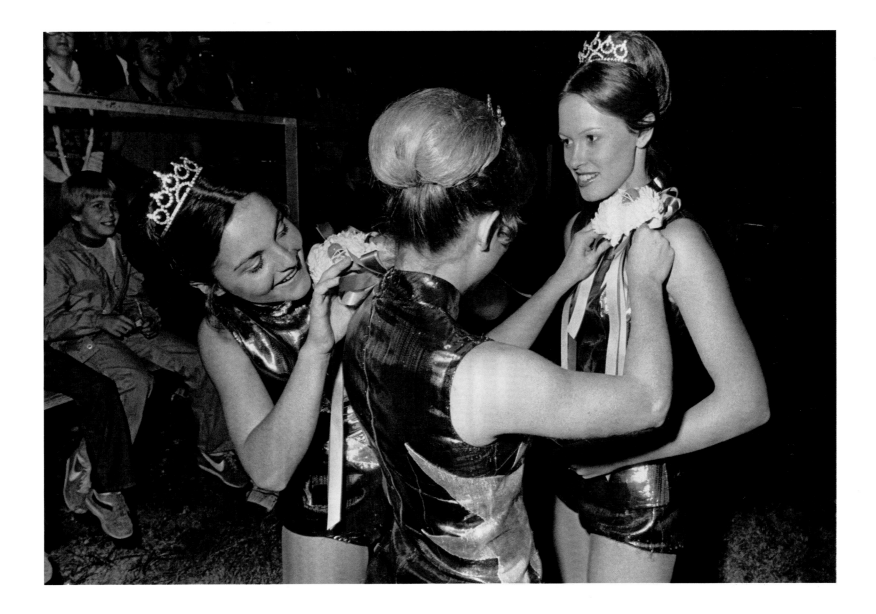

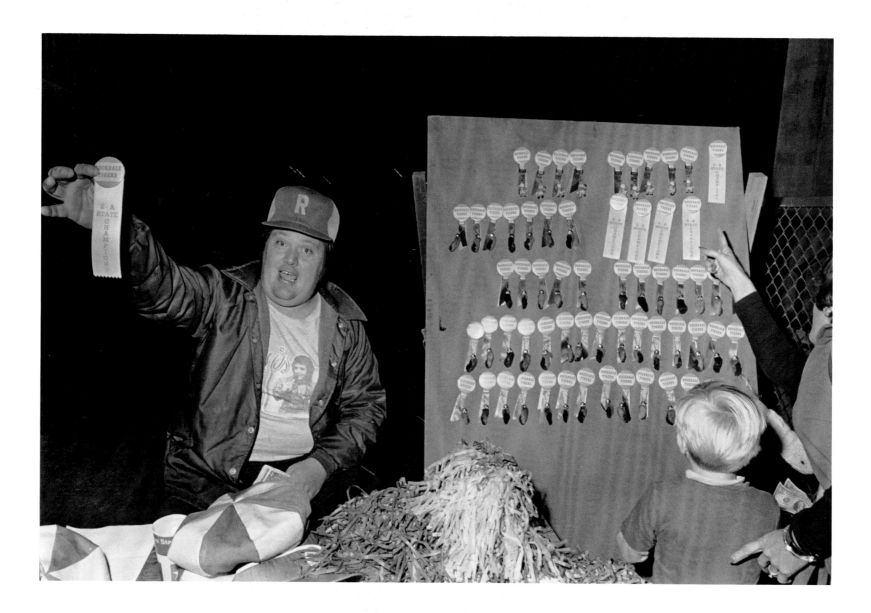

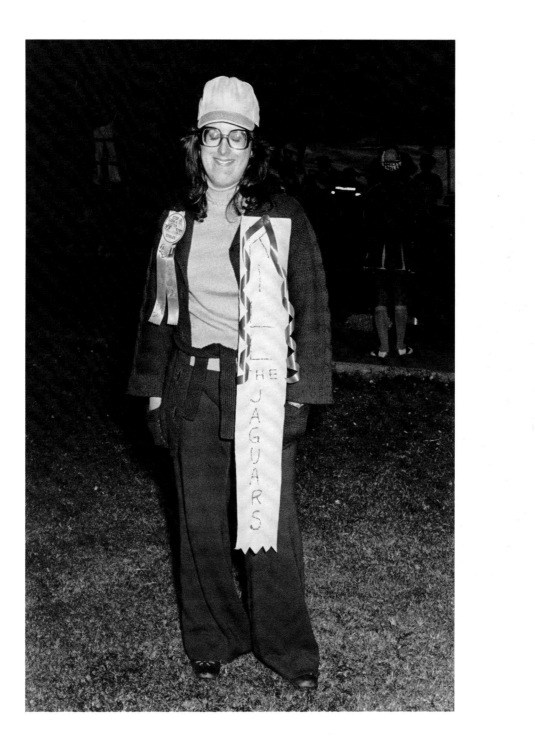

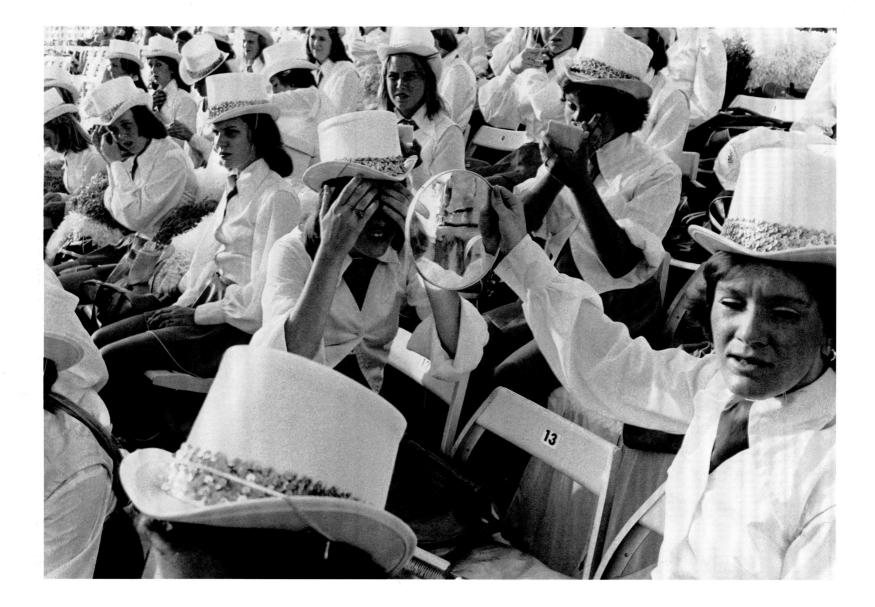

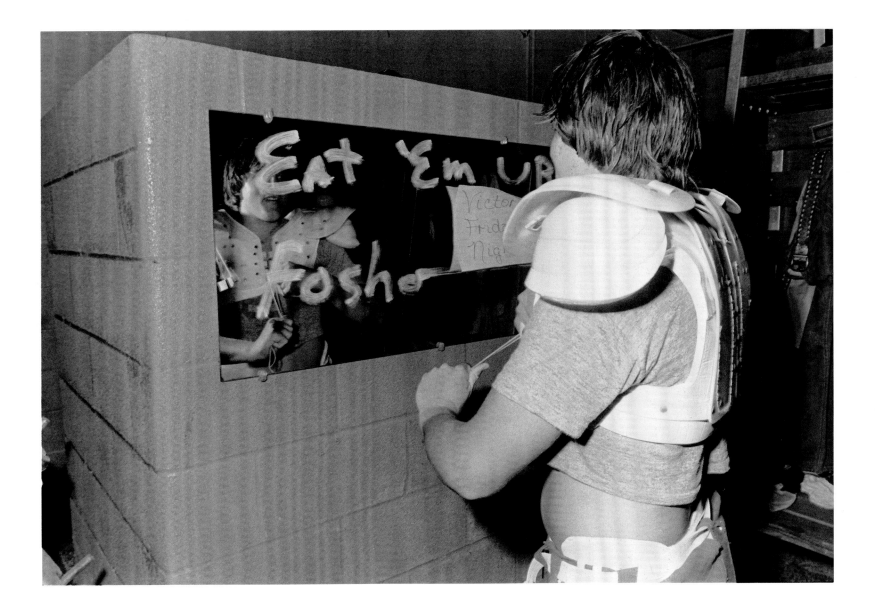

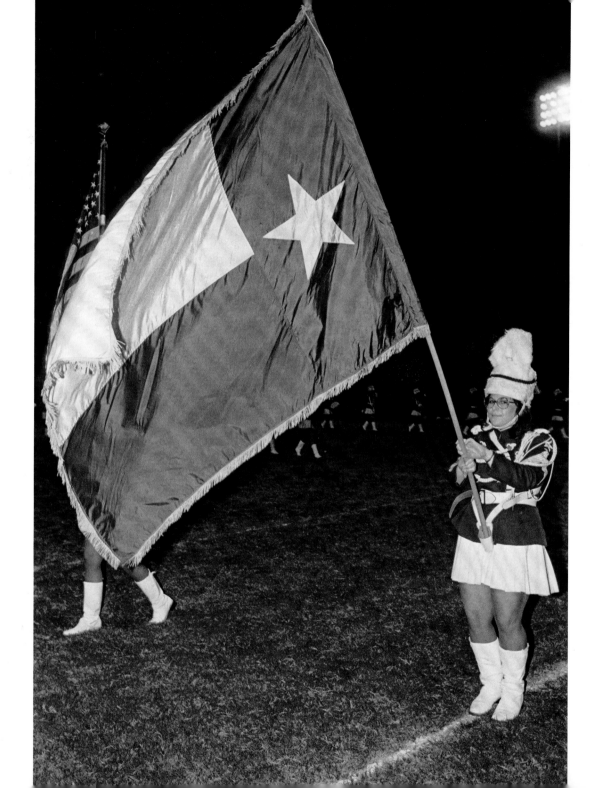

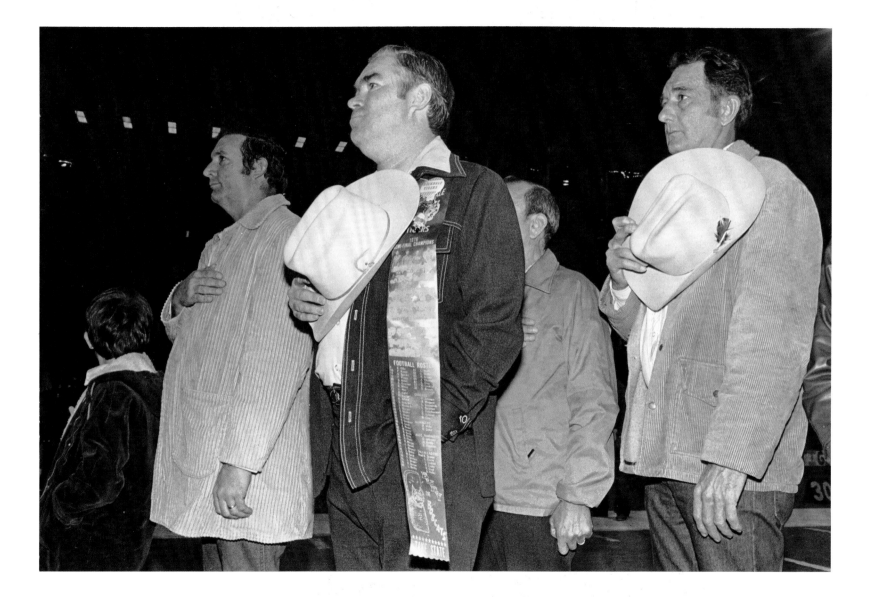

"Before we go out there and play, I want you to know how I feel. I am proud of you. Deep inside I'm proud because you have shown what young men can do when they set their minds to it. You are the pride of our school and our community because you have sacrificed pleasure for discipline and you have given up selfish goals for togetherness. That has made you a great team and has brought you here tonight.

"Now let me tell you this and you remember it from the kickoff to the final second. This is YOUR time. I mean it. You hear me now. This is YOUR minute and YOUR hour. And it has arrived for thirty-five thousand people to see. That field and those people are waiting for YOU. In the future, years from now, when you remember this night and this game, it will be in a memory clear as crystal, as close as yesterday. You will remember, even in your old age, every move and every step of this important game, and I want you to remember it with pride and satisfaction.

"You might say that we have been climbing a mountain this year. And with every step the air is getting thinner, cleaner, and purer. Air that only champions can breathe. I know you understand what I mean. As we get higher we feel the power and the glory of this mountain. But we must not look back to see how far we have come. We must look ahead, one step at a time. And we must climb together, mindful of each other, so that if one man slips, another will hold. Yes. That is the secret, as I've told you many times. Climbing together as one, as brothers in our goal.

"And if you reach the top of this mountain, you will breathe the cleanest, finest air of all. They say that life is never the same for a man who has stood at the very top of a great mountain.

"But this is not something you do just for yourself. You know that. But remember those people who love you, who raised you and are here to see you do what you were born to do. They LOVE you, boys. Oh God, you can HEAR it in their VOICES when they cheer for you. Win or lose, they love you. But whatever happens here tonight, let them see you at your BEST. And let us be TOGETHER out there tonight. This is YOUR time. This is YOUR minute and YOUR hour. You OWN this time, boys. Now let's go out there and take what's ours."

—Pregame talk to the team by Johnnie B. Felder, head coach, Kashmere High School, Houston

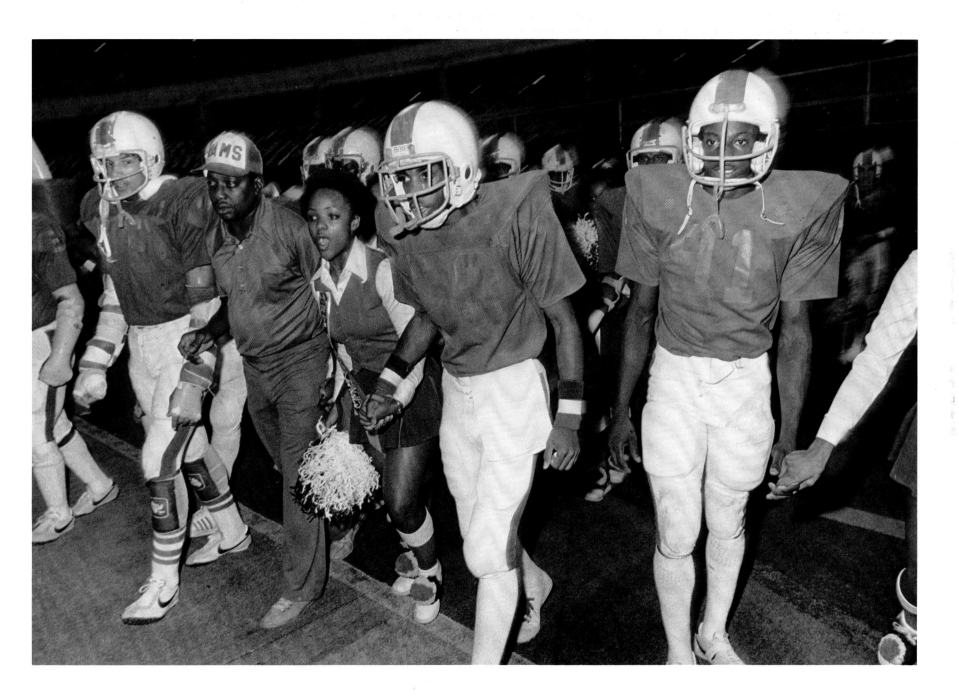

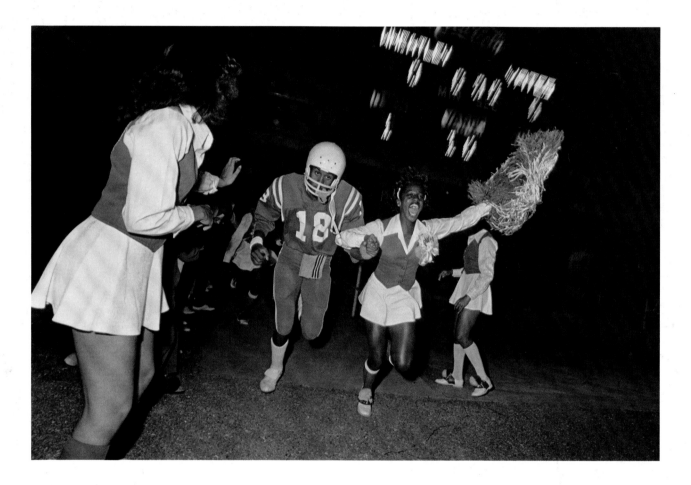

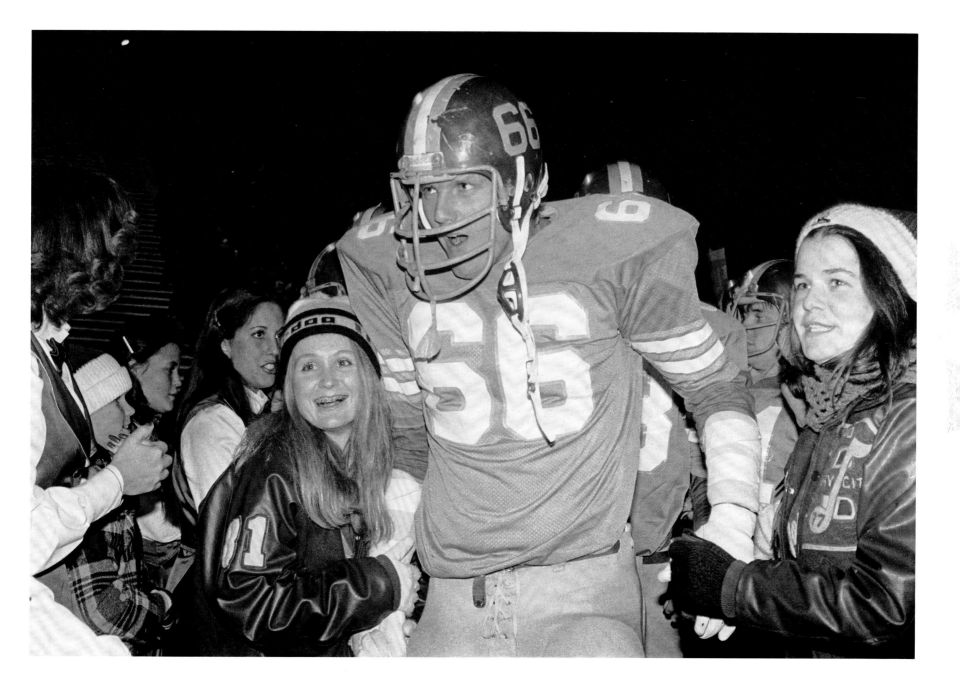

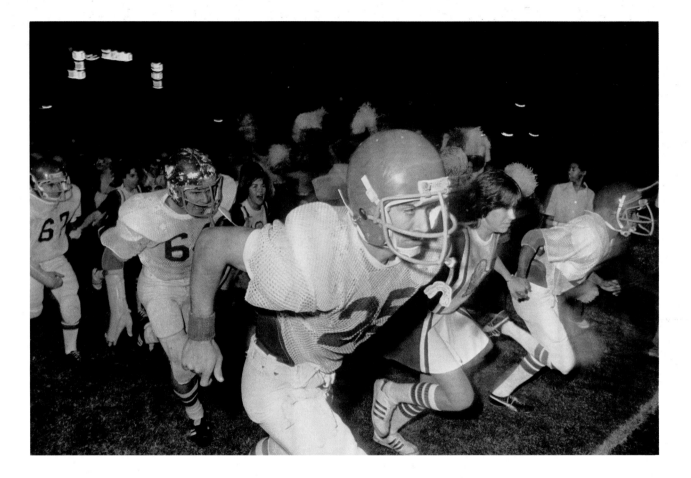

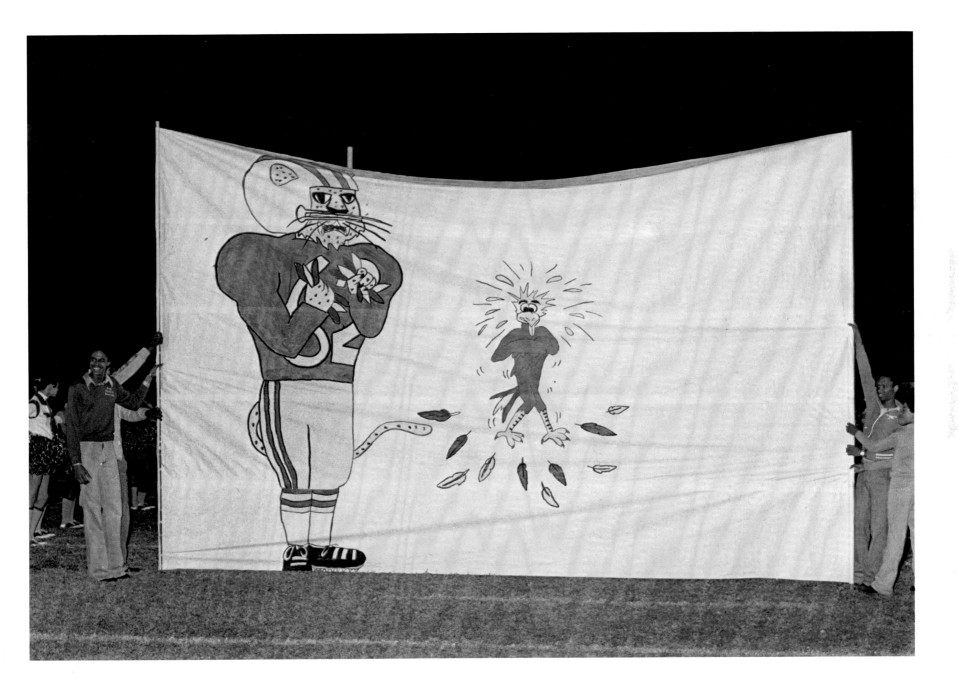

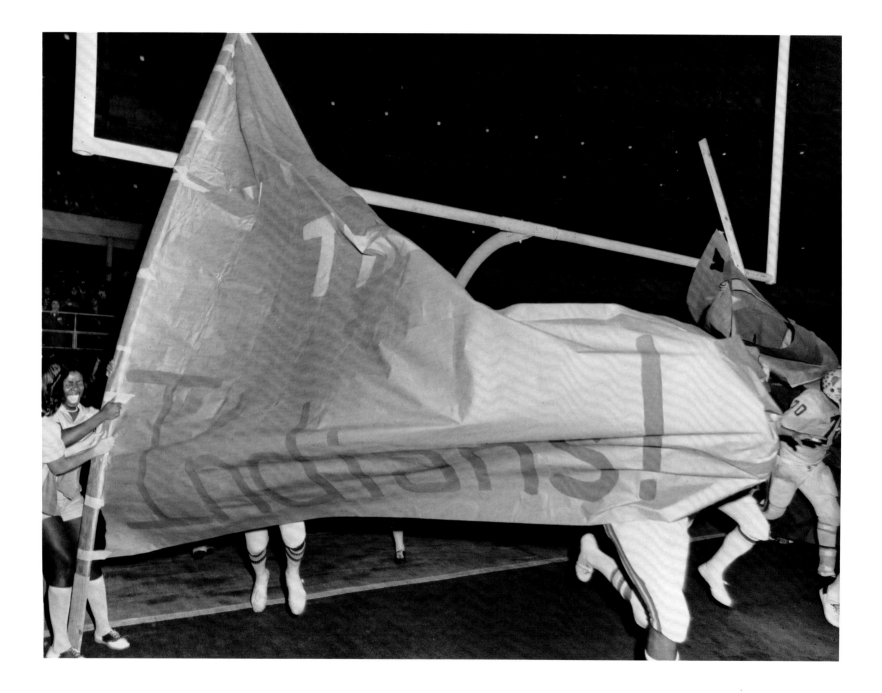

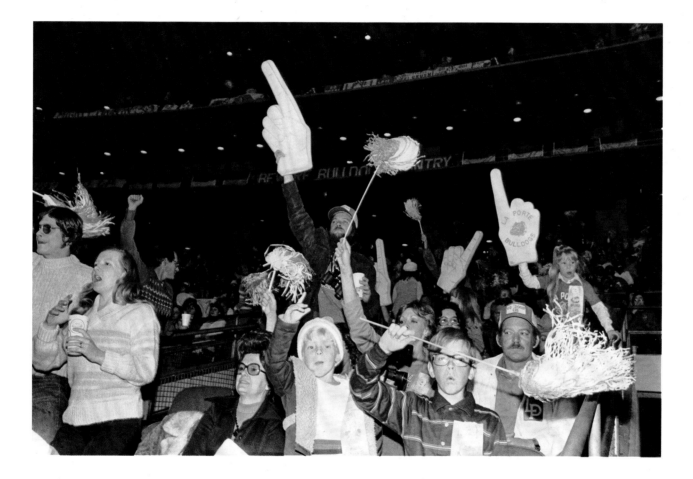

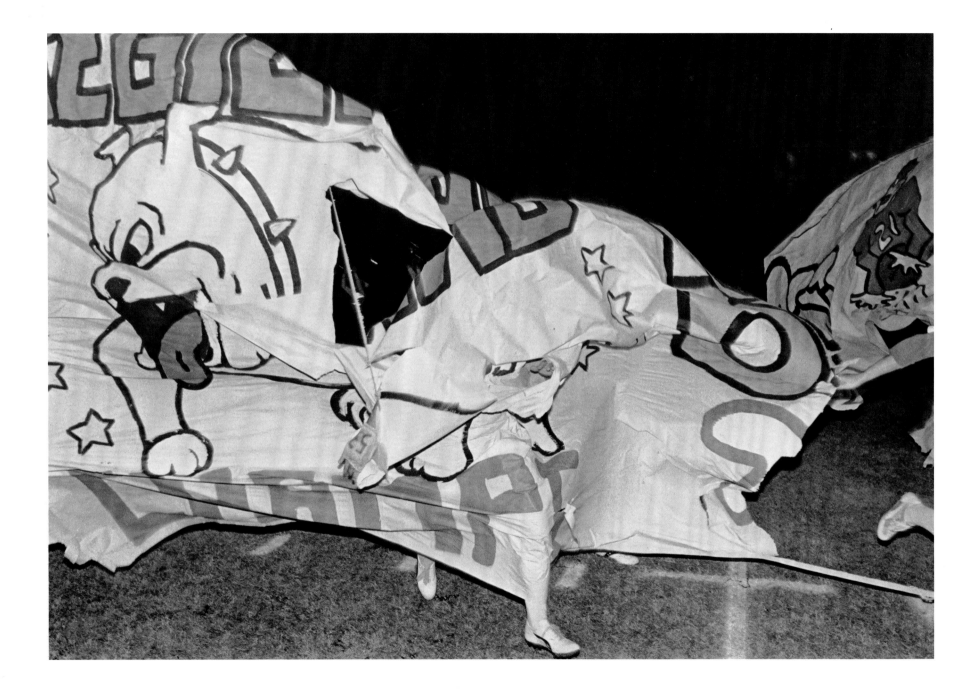

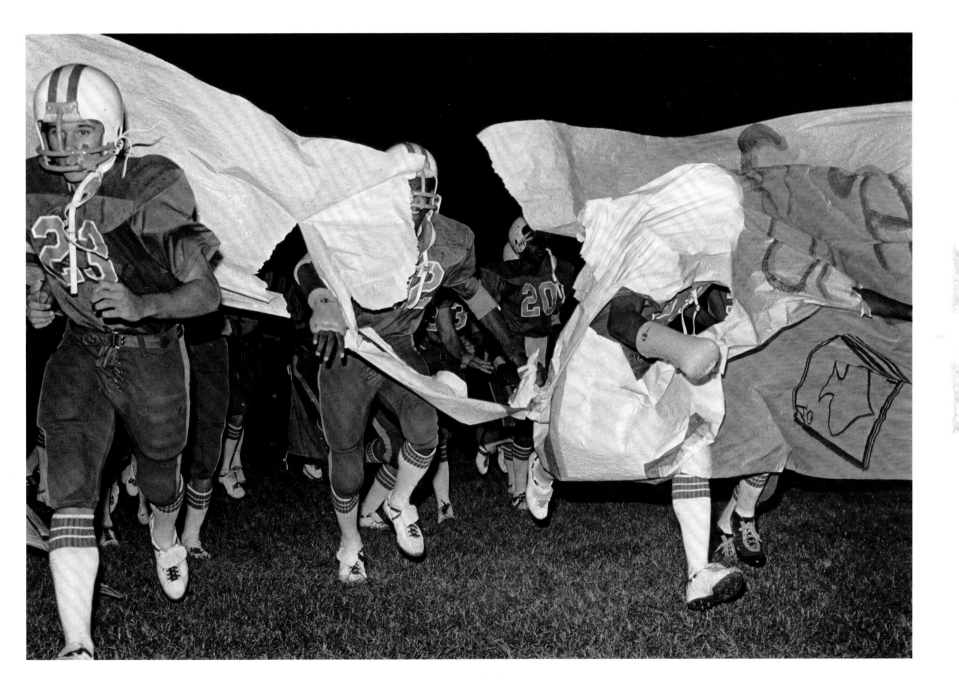

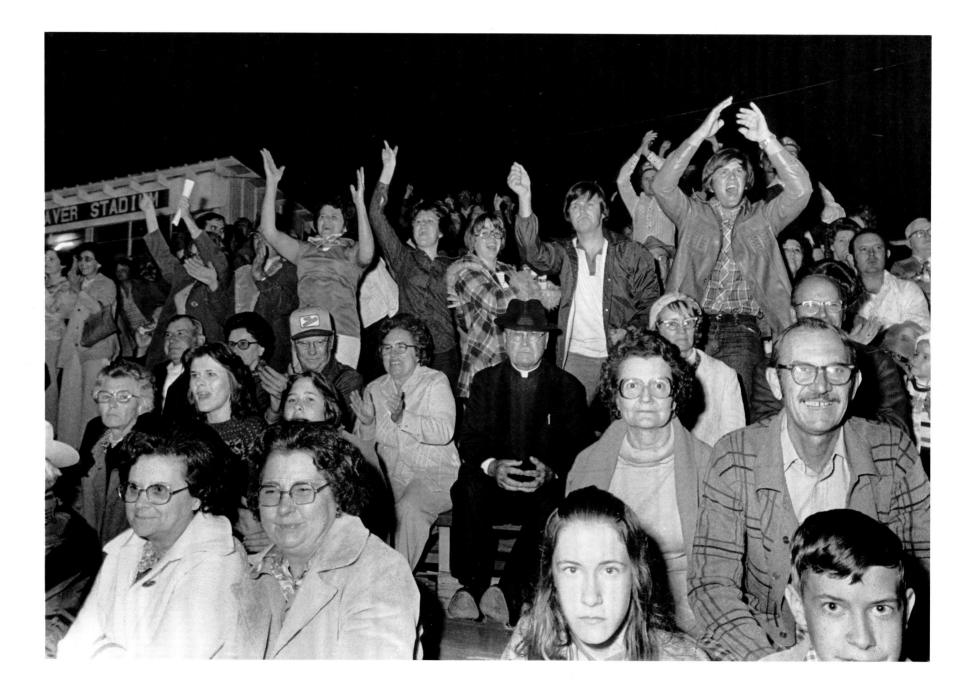

54

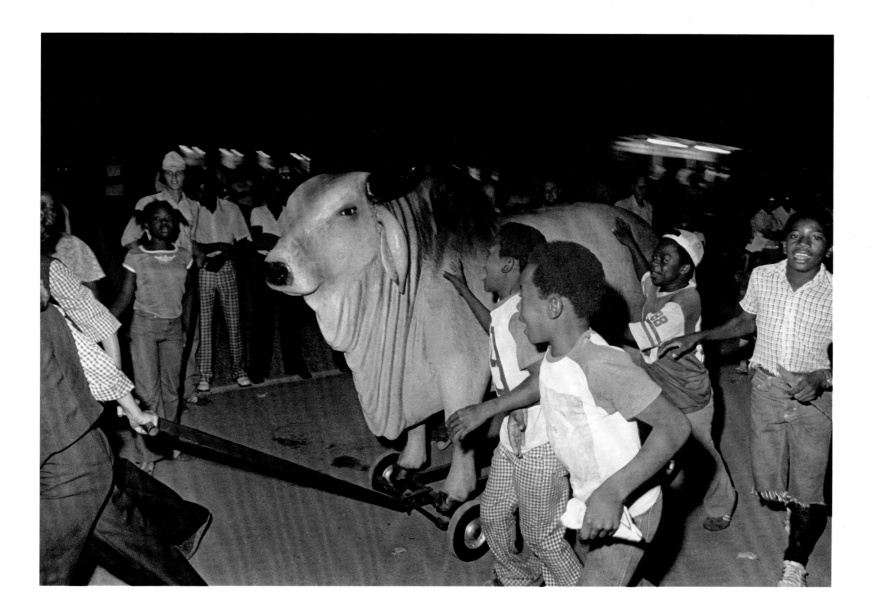

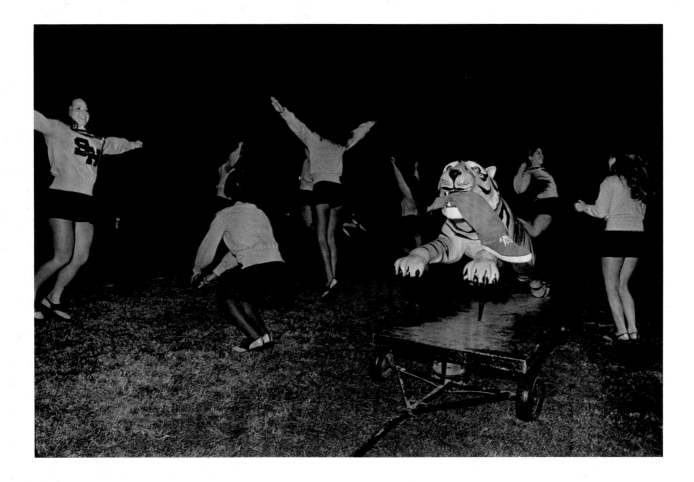

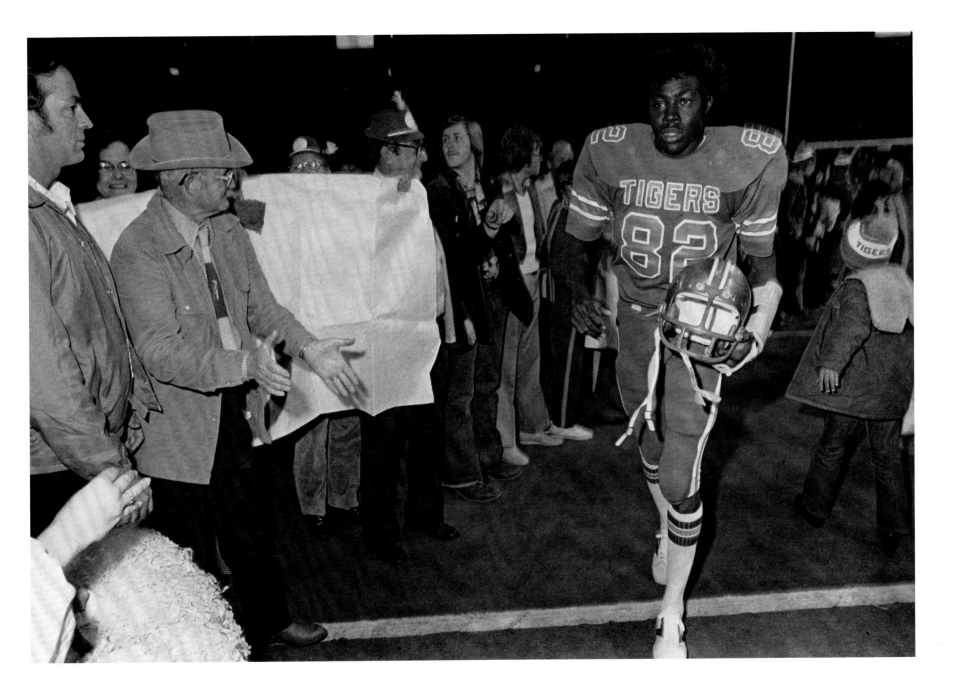

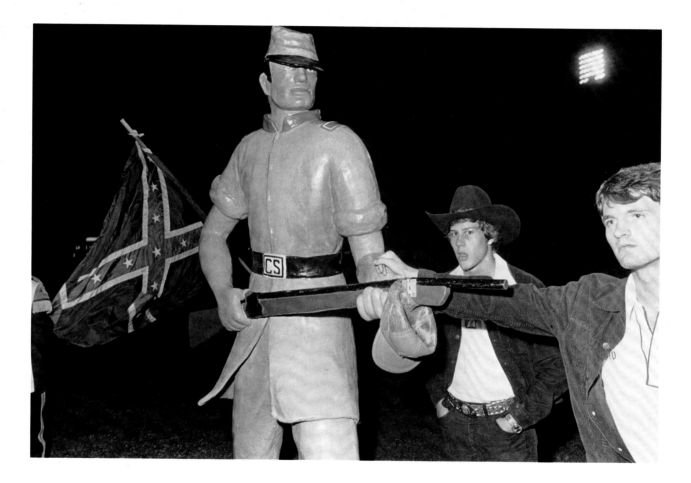

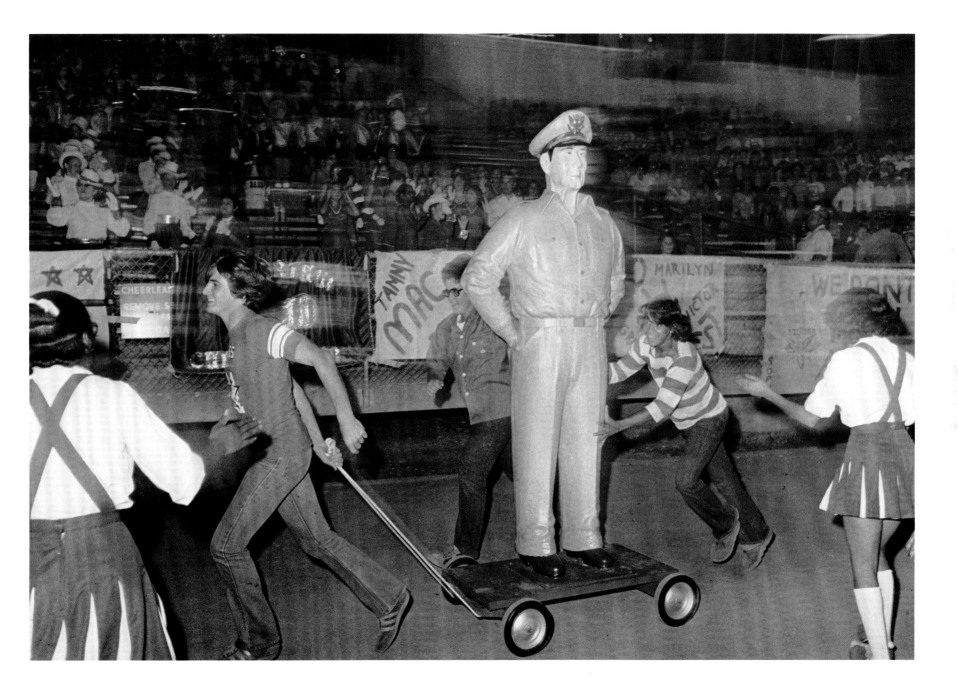

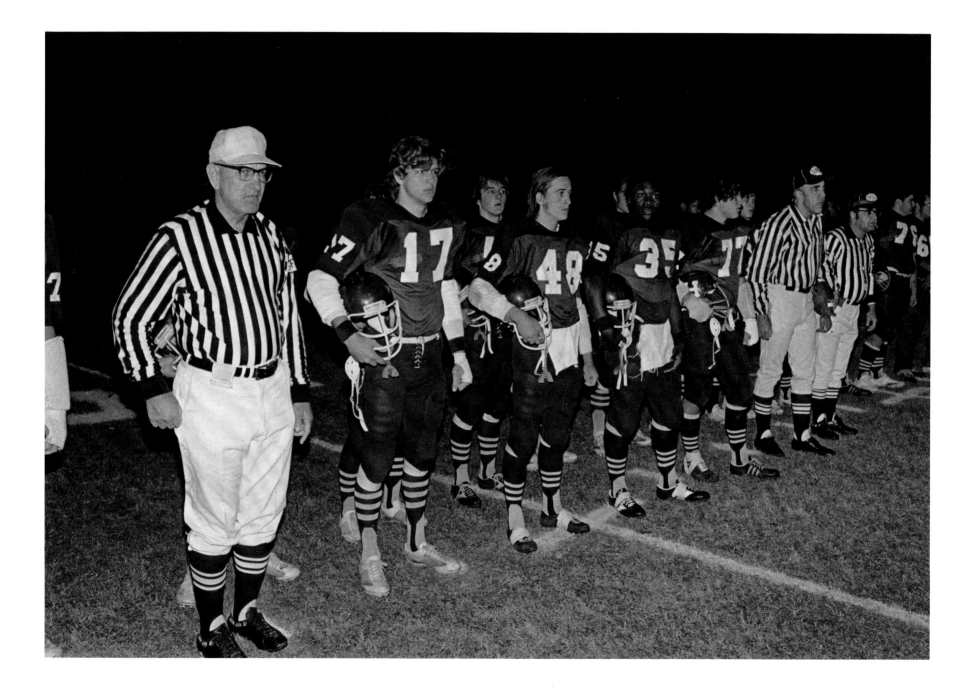

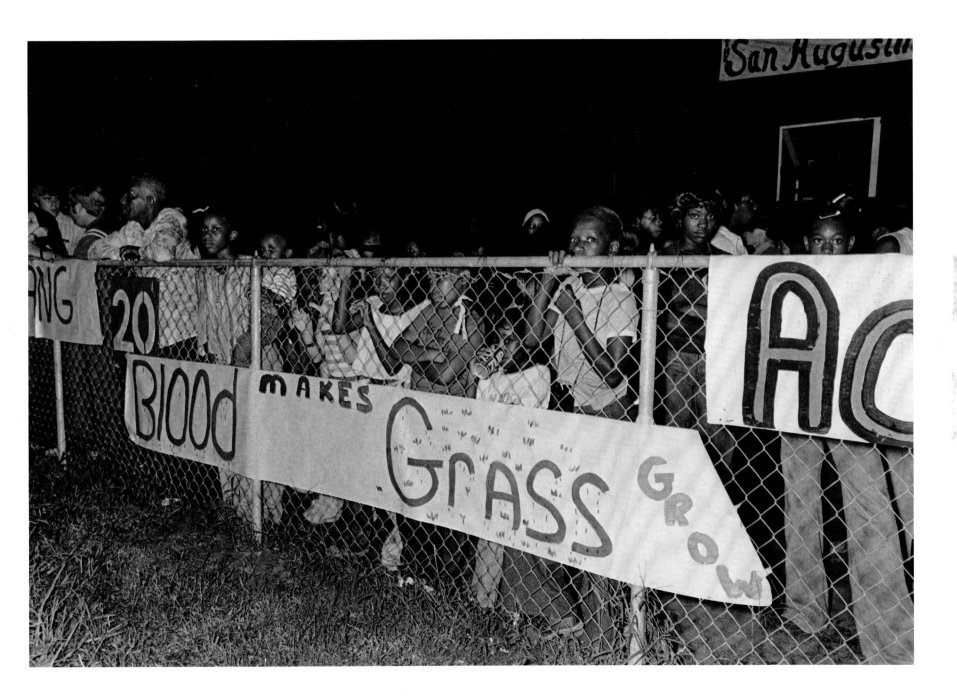

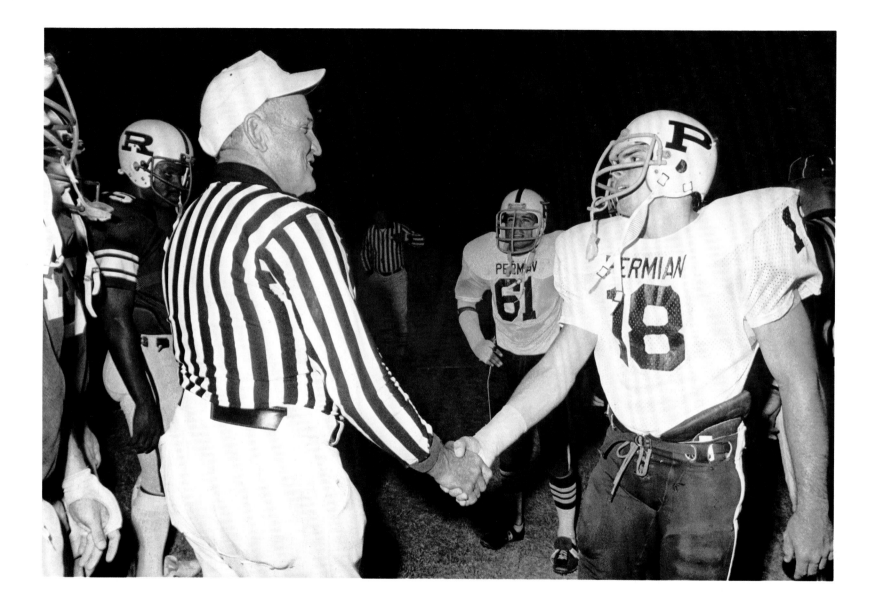

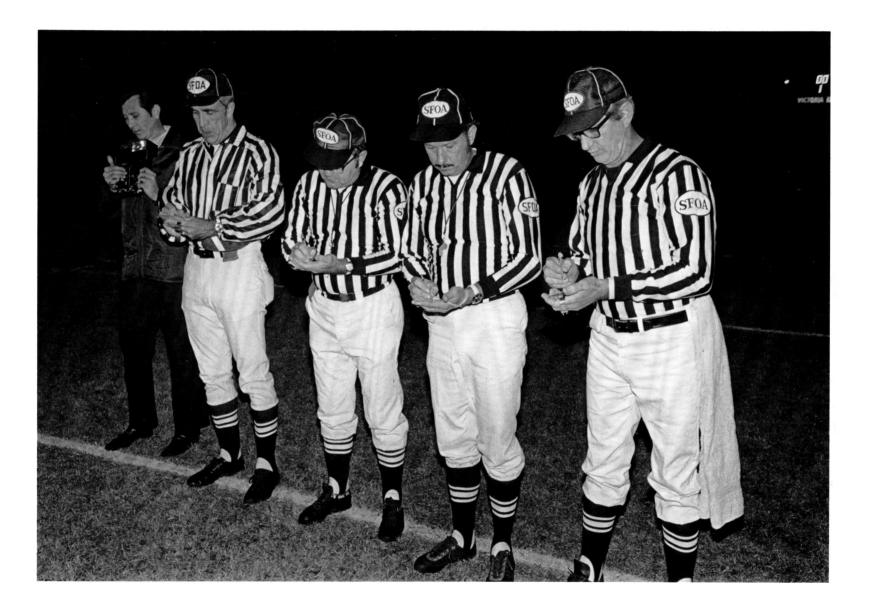

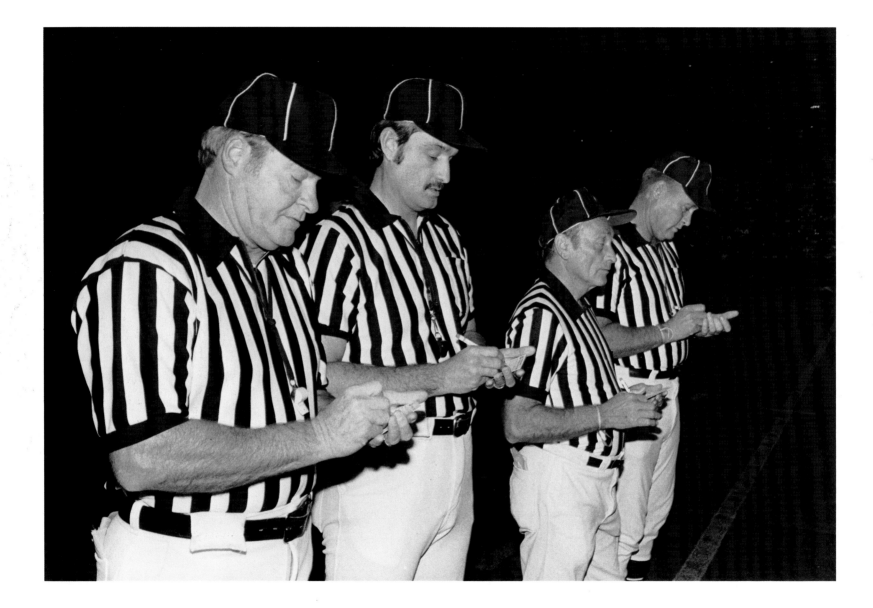

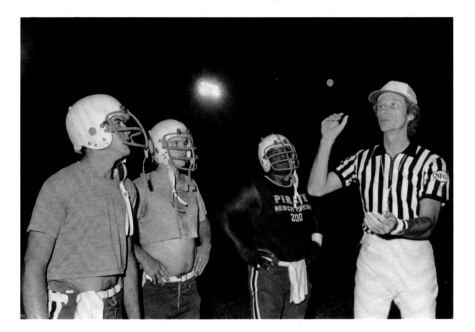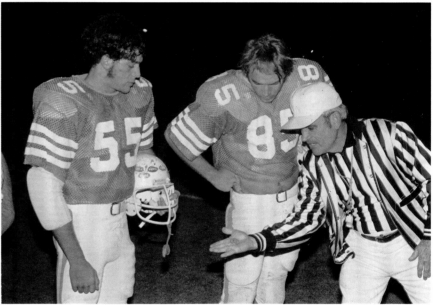

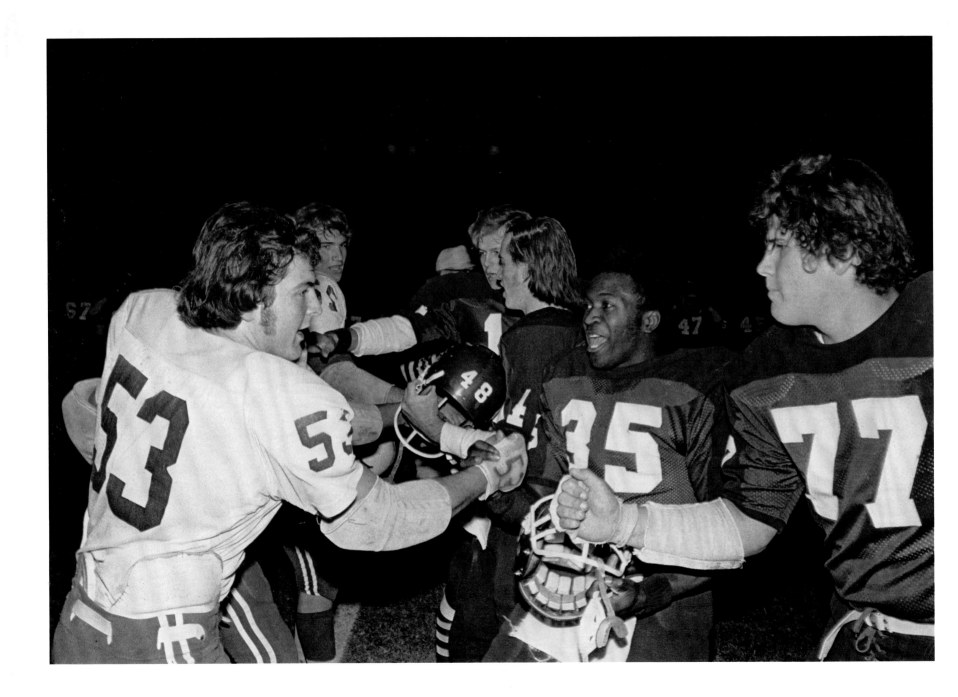

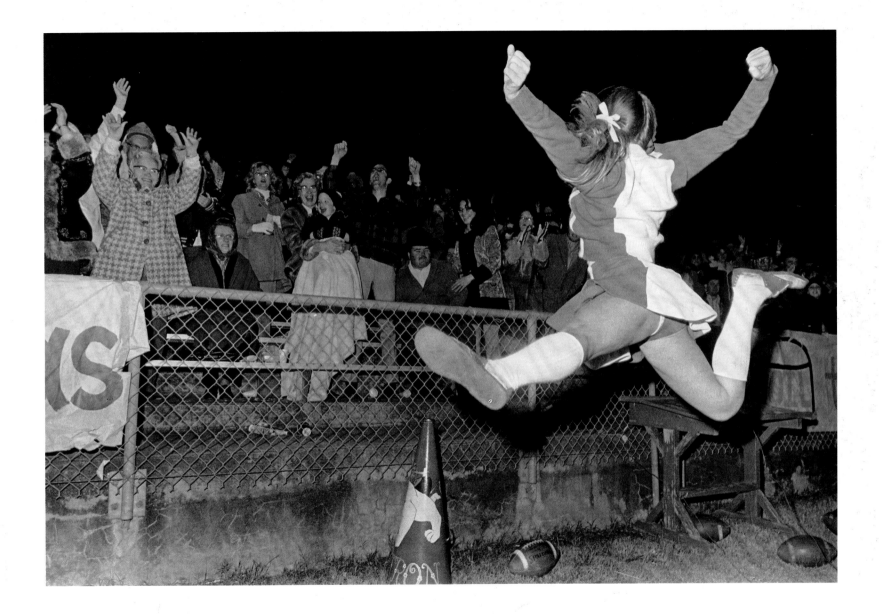

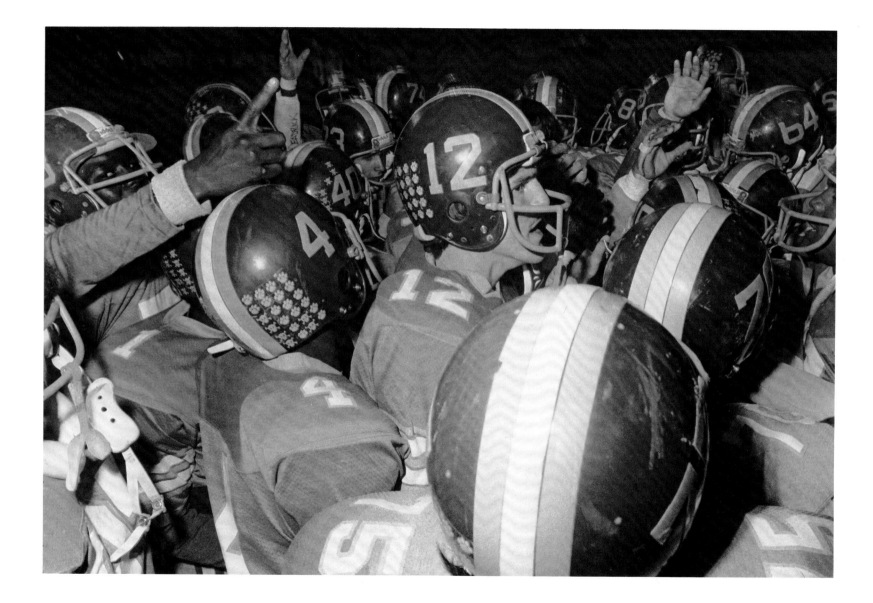

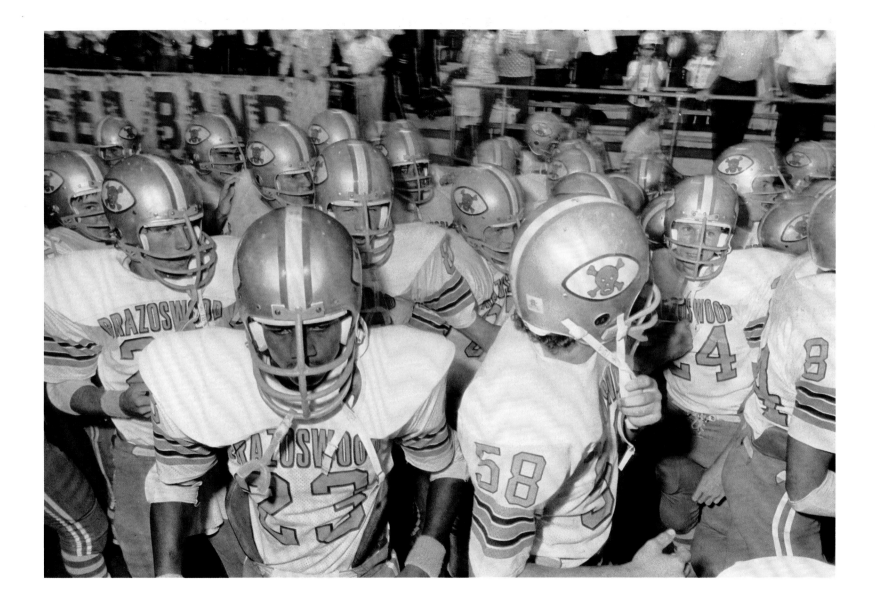

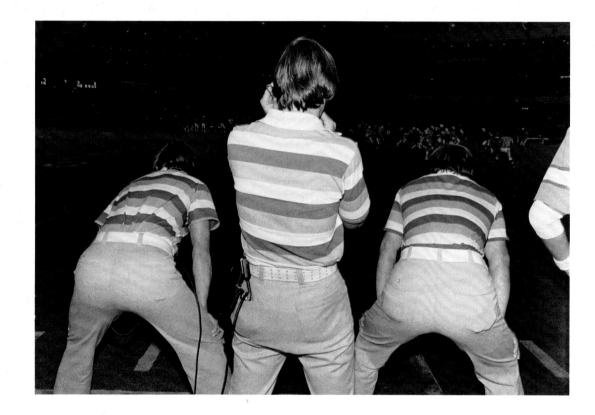

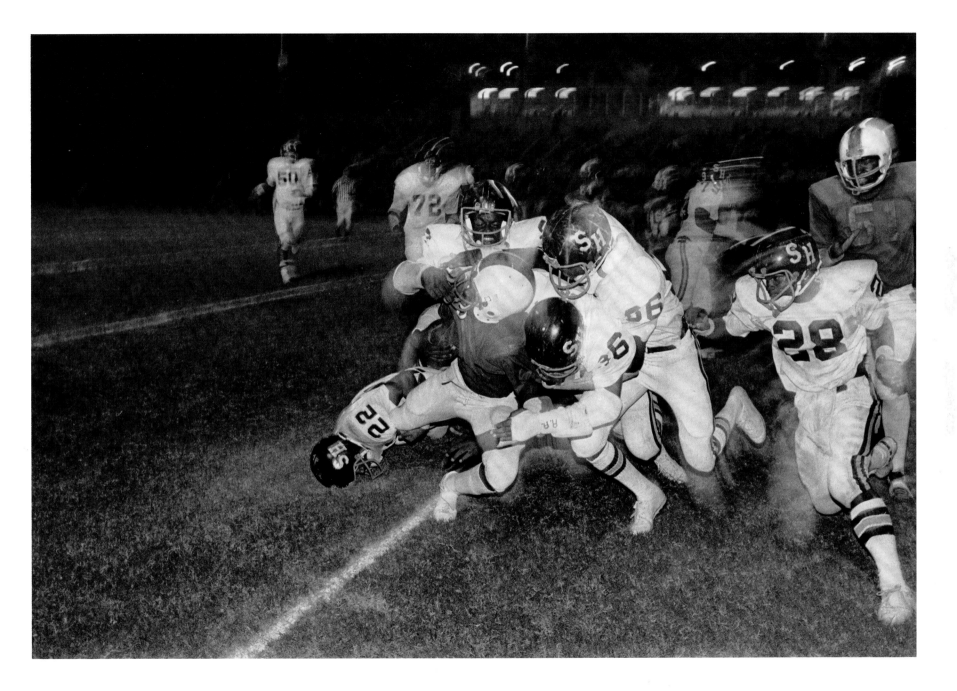

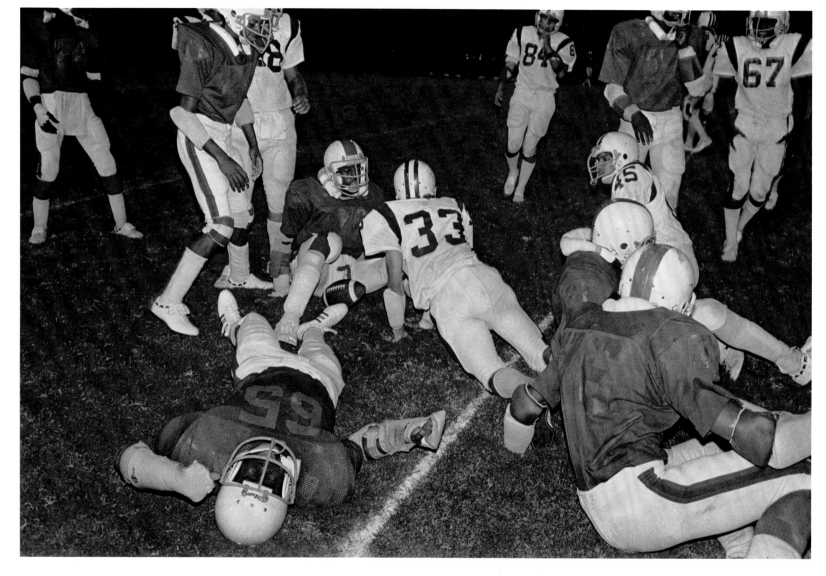

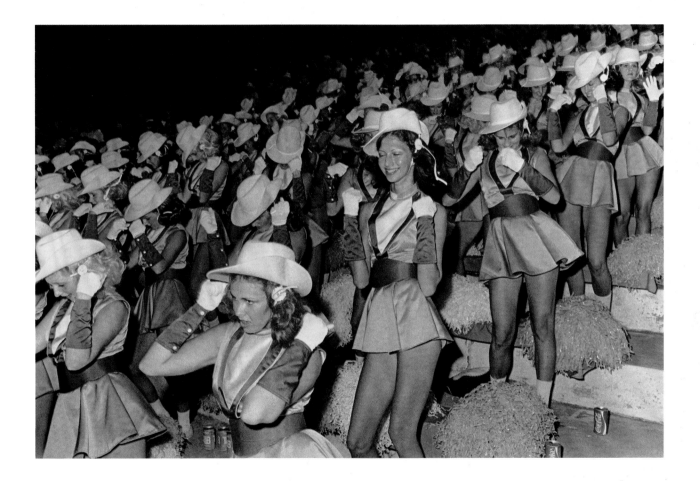

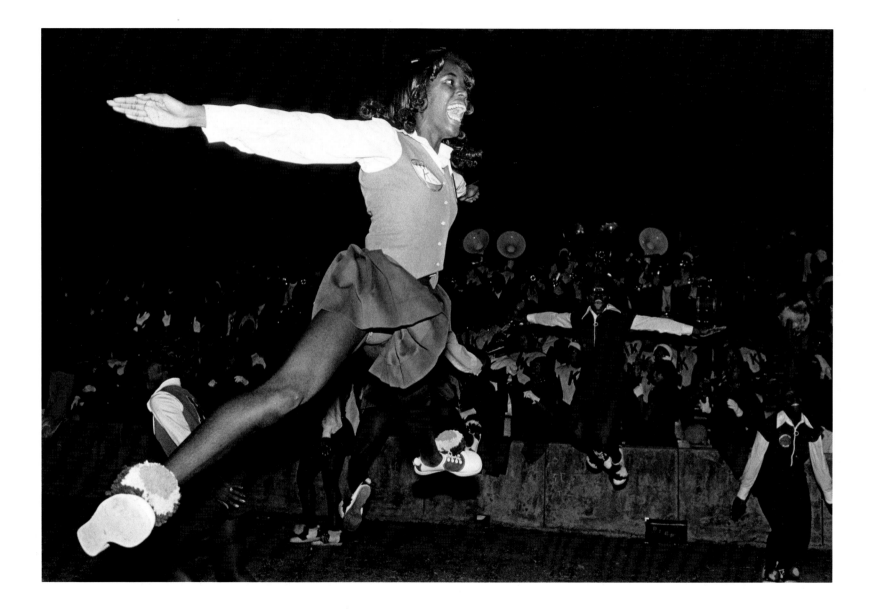

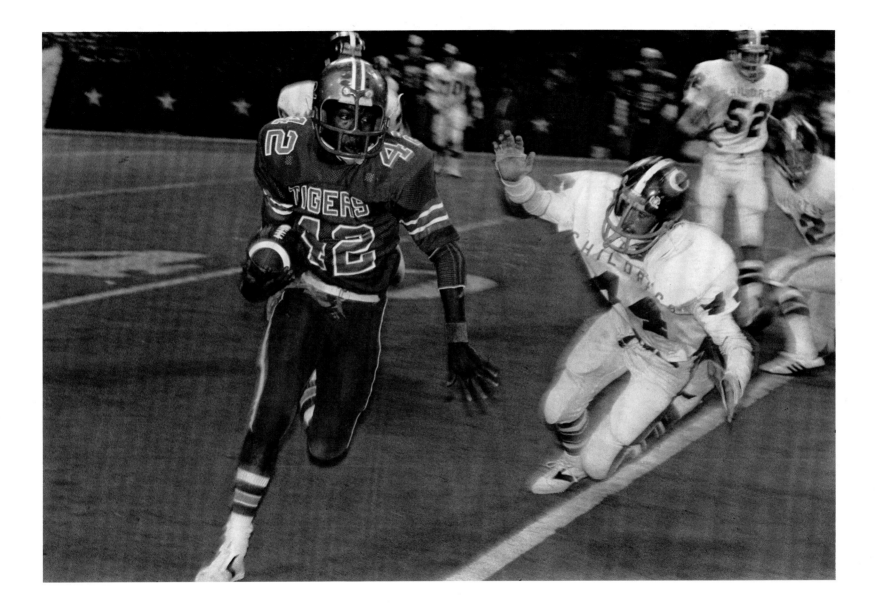

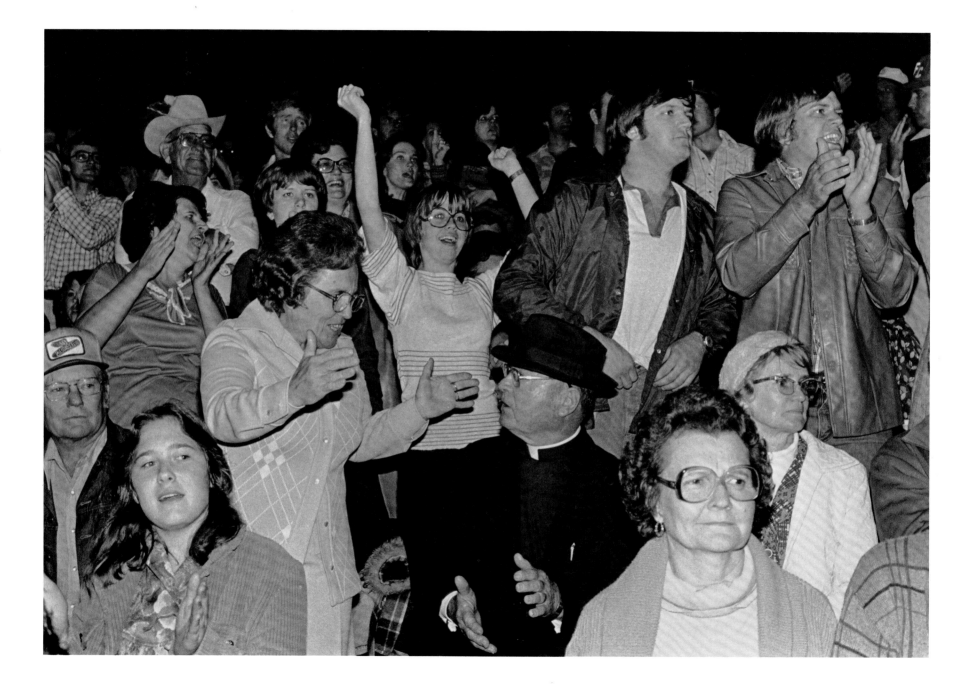

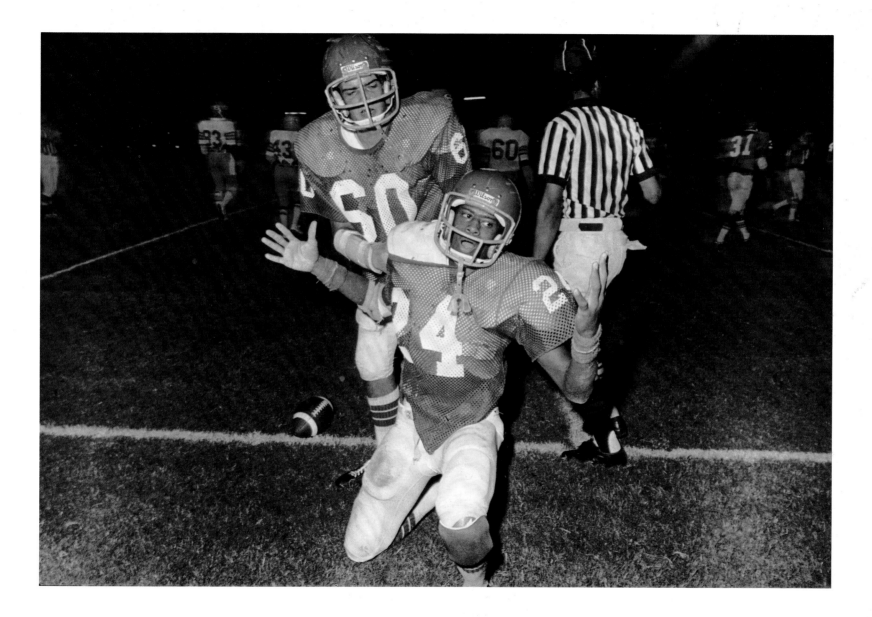

"Those Groom boys were really going to show me. I was hit, slammed, punched, and even double-teamed. But they weren't so tough. Heck, I didn't even get my lipstick smeared."
—Frankie Groves,
right tackle for the 1948 Stinnett Rattlers

Not until Frankie Groves did a girl play Texas high school football. The remote northern Panhandle farmtown of Stinnett, where she lived, had a population of just nine hundred in the postwar forties, so Coach Truman Johnson—like any good football coach—was always on the lookout for promising recruits. He spotted Frankie at a school picnic: she was sixteen years old, 105 pounds, and a ruthless tackler. "I was a rough kid," she recalls. Johnson added her to the roster in time for the 1948 homecoming game against archrival Groom. Frankie suited up at home, like the rest of her teammates, since the Stinnett field had no locker room. "She was just sensational," said her coach, but the Groom team, no doubt bestirred by the boyish nightmare of losing to a girl, played their best game of the season to win by a touchdown. "They tried pretty hard to run over me, but they never made it," says Frankie good-naturedly, even proudly, sounding like any old veteran recalling a tough one. Immediately after the game the state interscholastic league ruled that girls were henceforth ineligible, ipso facto, for football. Coach Johnson was summarily fired by an indignant school board.

Thus was Texas high school football made officially pure and simple: a man's game, reserved for boys. Any feminine involvement would be strictly supportive, in accordance with Texas tradition. It was a decision made, of course, by Texas men.

Texas girls wishing to participate have their work cut out for them. They are expected to lead cheers and twirl batons, to make music, to provide entertainment and coy motivation, to stand by their boys in their hour of need, uncritically, enthusiastically. It is a role straight out of masculine fantasy—like the role of Football Hero—and many Texas girls take to it with the same naïve eagerness as the boys do theirs. Beginning in the sixth or seventh grade, even earlier in some cases, they start painting banners with the junior pep squad, practicing baton or learning jumps, commencing a diligent apprenticeship that may carry them, four or five years later, to a kind of self-fulfillment.

The role gives shape and direction to their pliant teenage lives, a first sense of their own distinction. It has relatively little to do with the actual game, really, more to do with boys. High school romance is all roles and melodrama anyway, and football is merely the setting that defines the roles. Many a first date is to a Friday-night football game. Boys get the car for the first time and girls receive their first corsages, huge gaudy mums with foot-long ribbons, their date's name spelled out in glitter, heavy enough to stoop their shoulders. It is the girls, too, who wear the letter jackets most proudly and conspicuously, indoors, all day, everywhere; most boys don't wear them much until after graduation, when they're trying to recapture that sharp sense of adolescent glory or laugh about it. But by then it's an empty symbol and the girls are unimpressed.

Even after they grow up, though, there is still some girlish part of many Texas women that responds to the would-be heroes of schoolboy football. The crowds at Texas high school games invariably include as many women as men—hardly the case at college or professional games—and the women are always the most uncritical, the most enthusiastic. The men, spoiled by Monday Night Football and instant replays, often find the Friday-night version clumsy and slow; they may grumble and pout, harass the coach and the referees, sometimes yelling epithets at their own team, their own boys. Only the women are completely loyal and supportive, as if they, too, were trying to recapture some old and fondly remembered self, when they still had men they could really believe in.

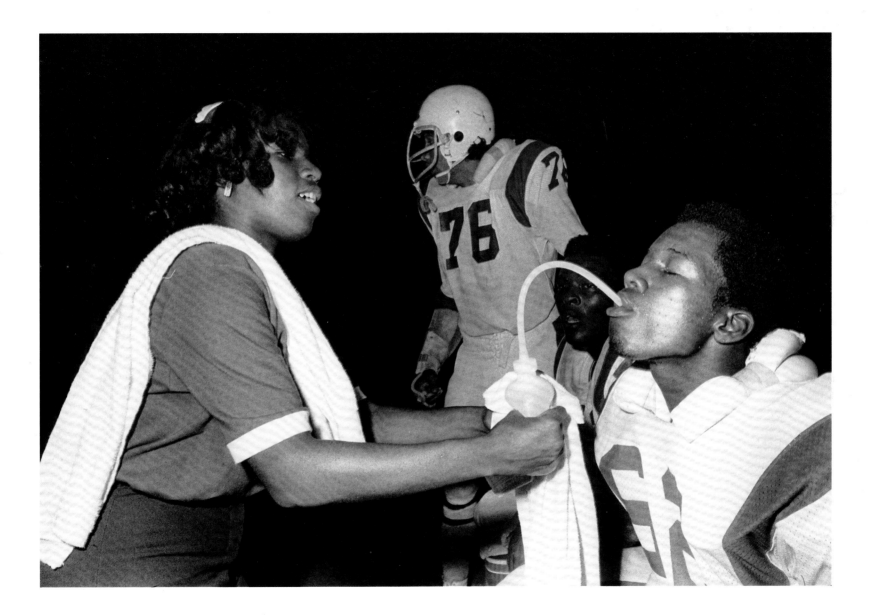

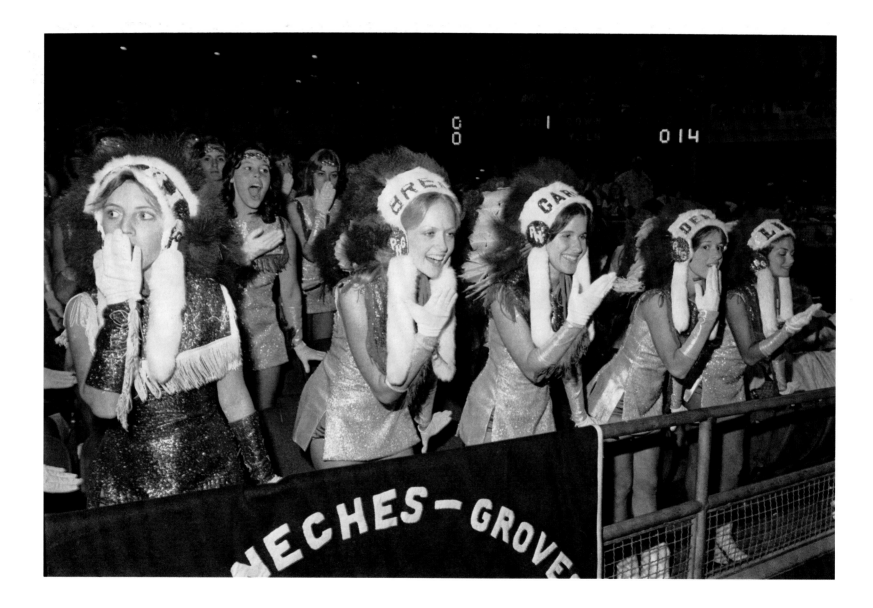

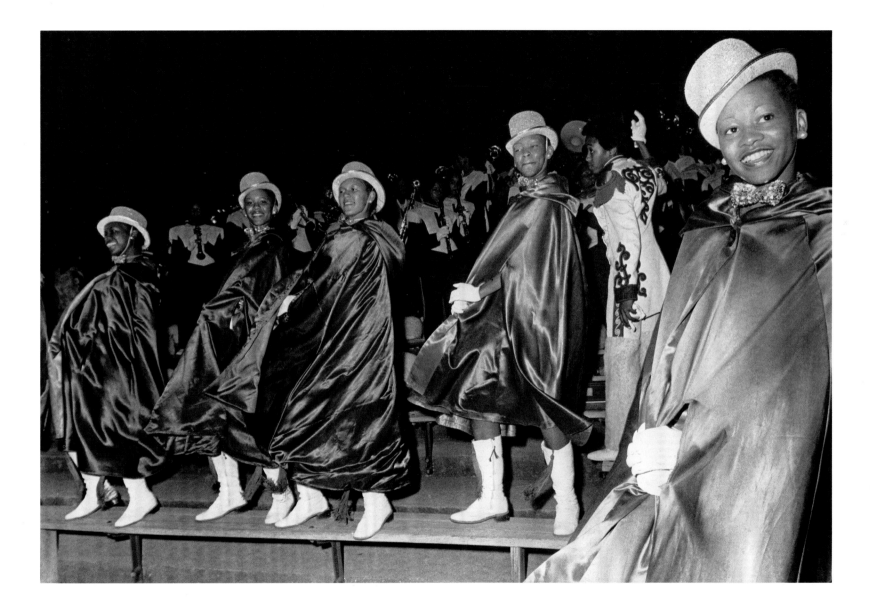

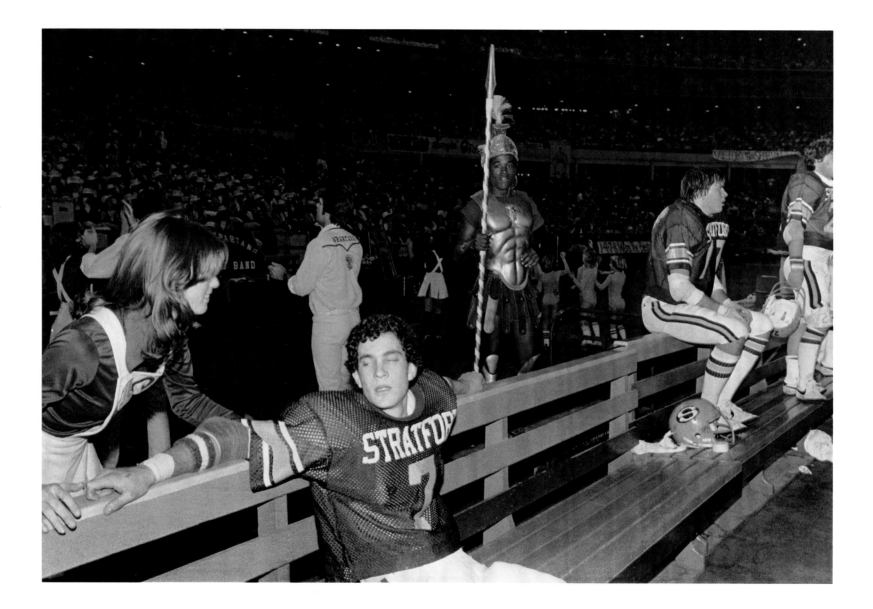

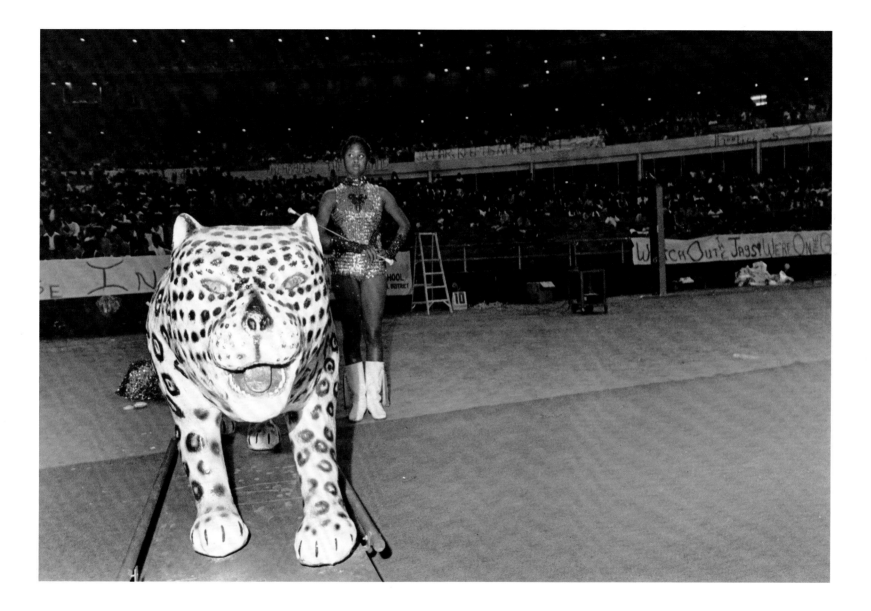

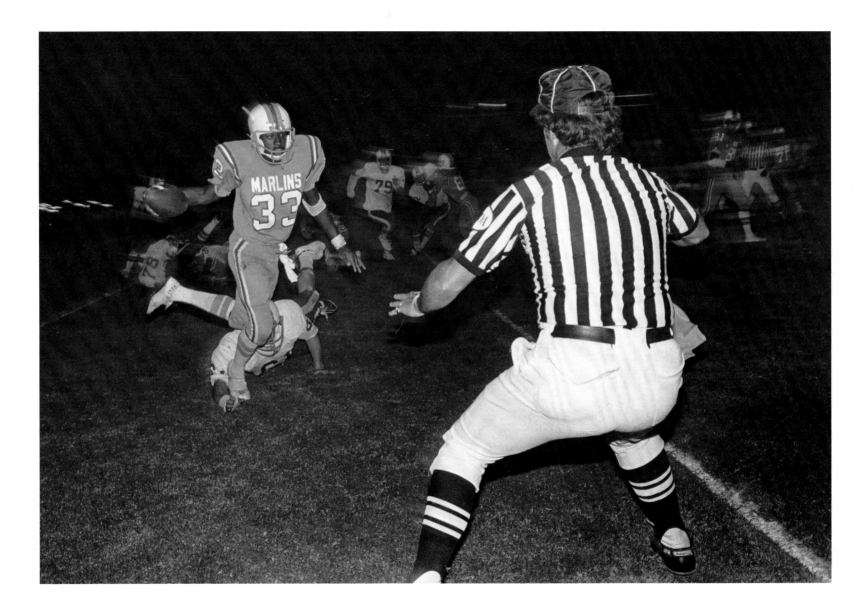

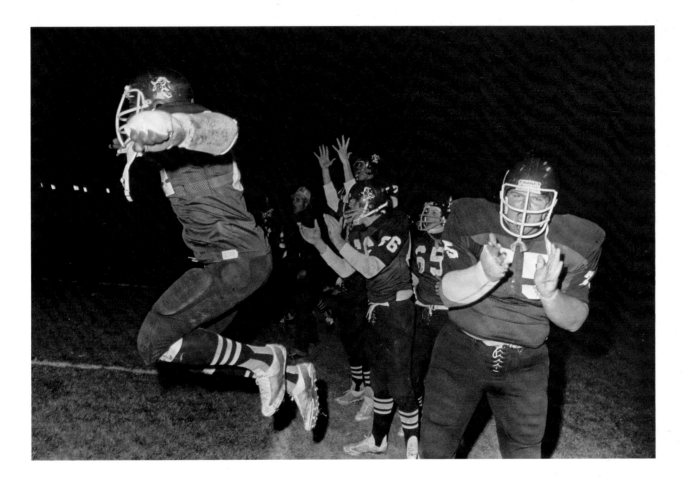

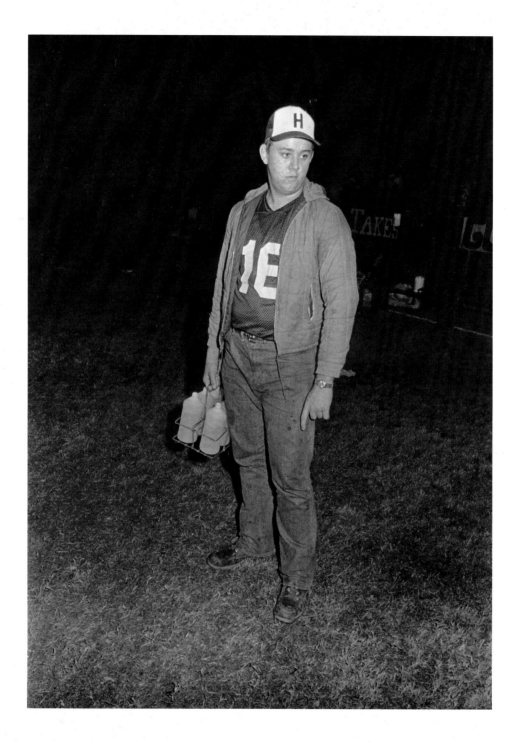

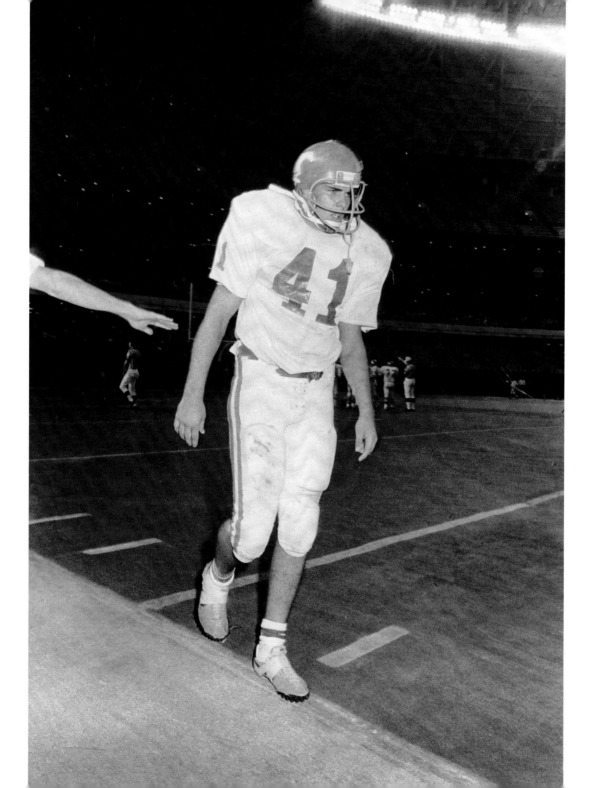

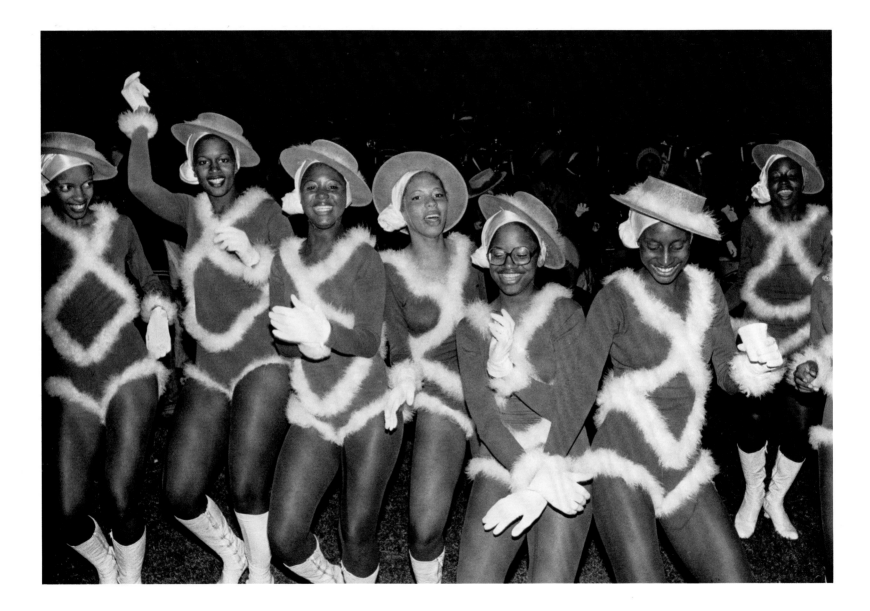

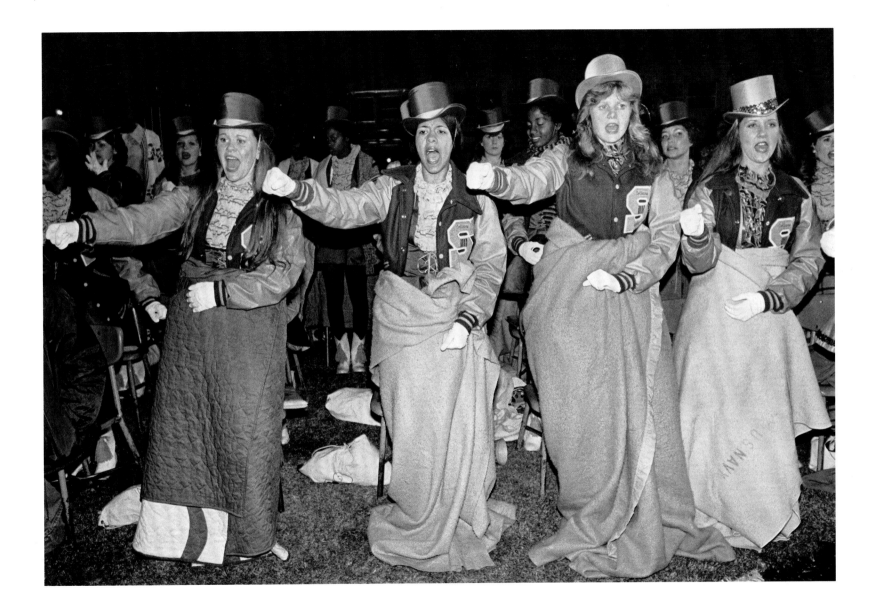

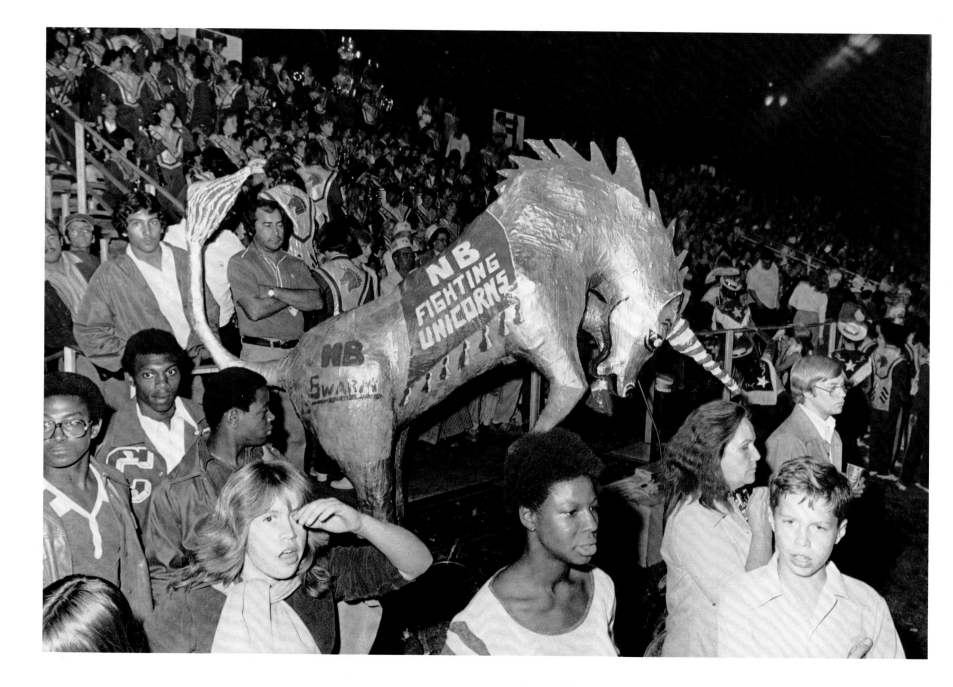

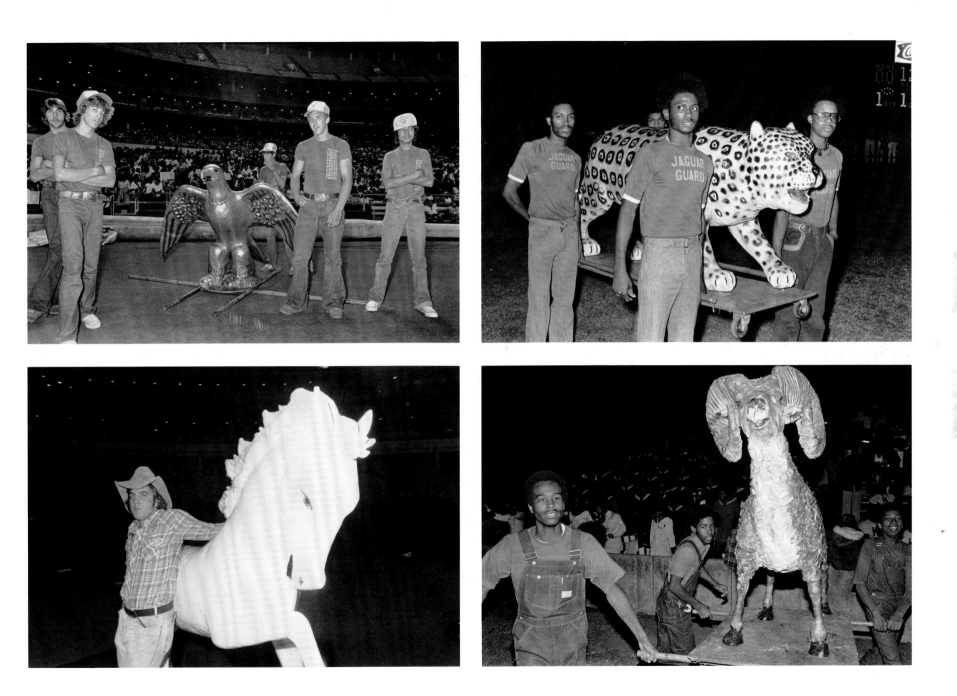

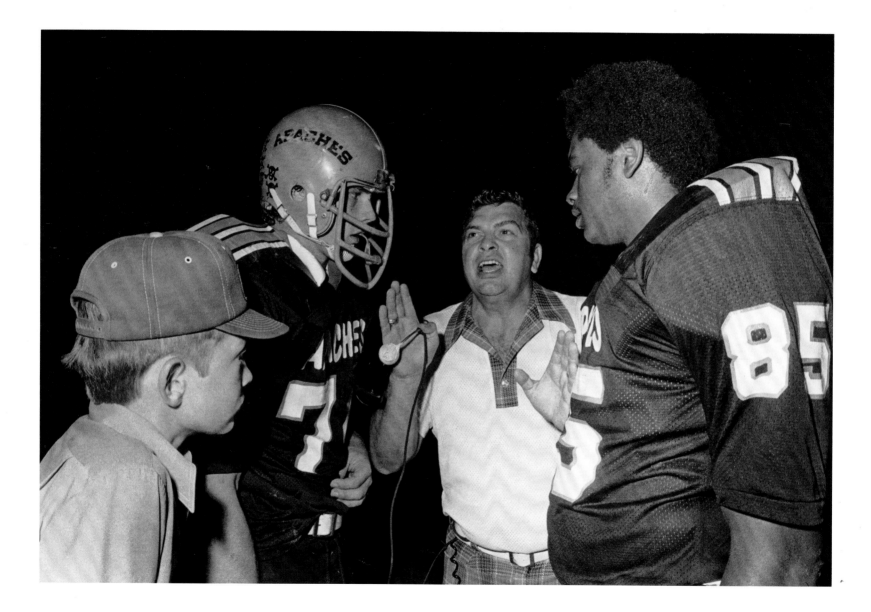

A sixteen-year-old football player is not, even in Texas, a natural-born Hero. He is merely an immature man—a volatile mixture of boyish ardor and manly dreams, still awaiting self-discovery. If in Texas more commonly than elsewhere he samples his manhood on a football field before seeking any other kind, it is only because this gives him a clear test of the sort of man he will become. It is a test that all boys seek and require, by whatever standards their people most loudly applaud. And in Texas this crucial passage is often made, for better or worse, under the guidance of a high school football coach.

The first two people to perceive and abet the man within a Texas boy are the first girl who loves him and his high school coach; at least that's how he feels at sixteen, certain that no later man or woman can ever affect him as deeply again. A coach with the vision and sensitivity to live up to this role can build winning teams in the most obscure of places, year after year, from whatever boys are on hand, by making them believe they are Football Heroes. If he has the gift he can transform a Texas town more dramatically than John Wayne: boosters clubs will rise from the doldrums, school boards will cooperate and bond elections pass, crowds begin appearing at afternoon practices. The actual winning becomes almost inevitable, at any rate predictable, as long as they all believe in their boys. The magnet for their faith is necessarily a man who has dedicated his life to football.

Back when he started playing as a schoolboy himself, it had usually been as a defensive back, a linebacker if he was big—reactive, observant positions—the traditional positions for future coaches. Often he lacked the talent or the leadership to gain much recognition as a player, but even then his commitment was more to the game per se than to its rewards or opportunities; he just plain loved football. In college he had to work especially hard to make the team and still went unnoticed, so that later when his better teammates were drafted by the pros he was overlooked, uncalled by anyone besides himself. That is when, if his love for the game was real, he turned to the only work that could satisfy it and became an assistant coach for a high school football team.

If he feels at all bitter about it, he will doubtless be the sort of coach who bosses and demeans his players and preaches a lot about toughness, since that's the only thing sustaining him. Such a man will probably never make head coach anywhere, but if somehow he should he'll never be able to inspire his boys or rally a community behind them, he'll never post a winning season, and before too long he'll give it up for the insurance business. The attrition among young high school coaches is rather severe.

A coach who stays with the game must love it enough to live it through his boys, as dependent upon them as they are upon him; only then can he truly see them as Football Heroes instead of boys. And if he can't believe in them, they surely won't be able to believe in themselves. Houston Oilers head coach Bum Phillips, who had built a remarkable record as a small-town Texas high school coach before stepping up to the pros—a step that could only take place in Texas—has often said that he treats his players no differently now than he did back then, which says less about how he treats his men than it does of the way he saw his boys.

Back in the forties and early fifties, when Bum Phillips first started coaching in the Golden Triangle, many small-town high school coaches in Texas weren't even paid a regular salary. They worked instead for a percentage of the gate, like tent revival preachers, relying for a living on the force and success of their inspiration. Moving every few seasons to a new and slightly bigger town—or at least to a larger school—they progressed if they could from the B leagues up to the 4A ranks, where the best high school football in America is played before the biggest crowds. Indeed, up until the mid fifties a Texas 4A championship game could draw bigger crowds than most pro teams saw in those days, and Texas schoolboy coaches were widely considered the best in the game.

Texas high school coaches have long been famous for their innovations and refinements, their trick plays and new formations. Old Pop Warner's revolutionary single wing was first exploited by the Waco High School Tigers under his friend Paul Tyson, inventor of the spin play and the lonely end; Tyson was the coach Knute Rockne said knew more about football than anyone else in America. The Lubbock Westerners were playing from a slot T offense in the late forties, several years before the Chicago Bears overwhelmed the NFL with it, and such major modern alignments as the wishbone and the veer, the four-five defense, were all first put to use and proven by Texas schoolboys, devised by coaches who never doubted their boys were up to it.

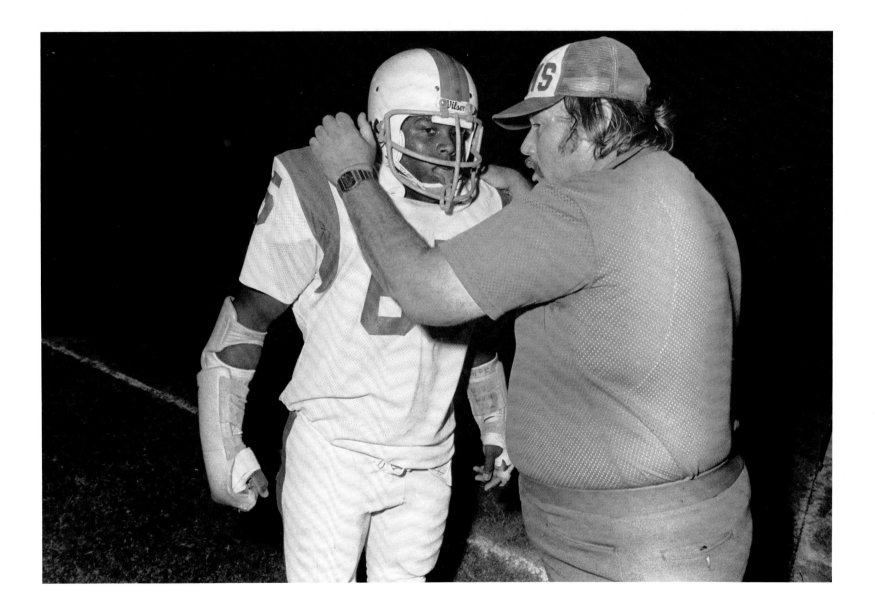

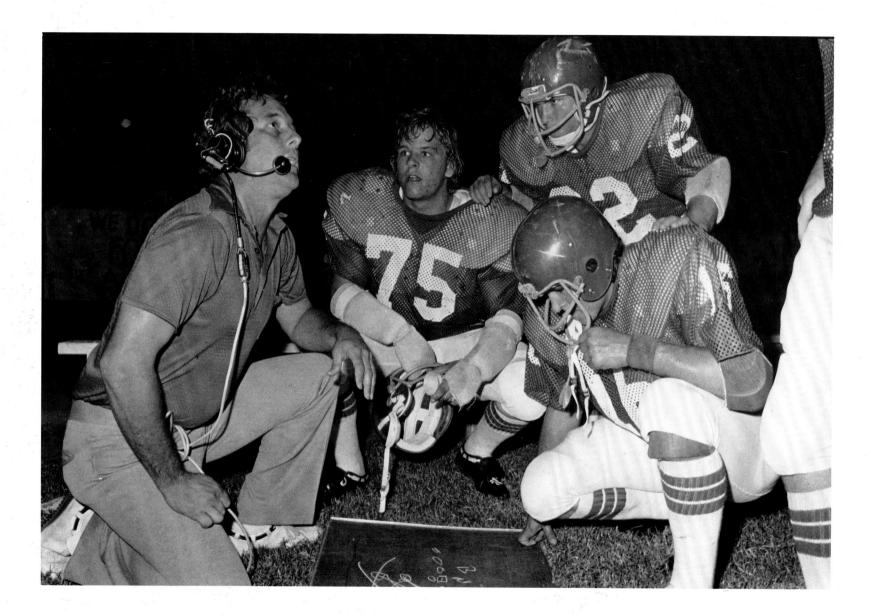

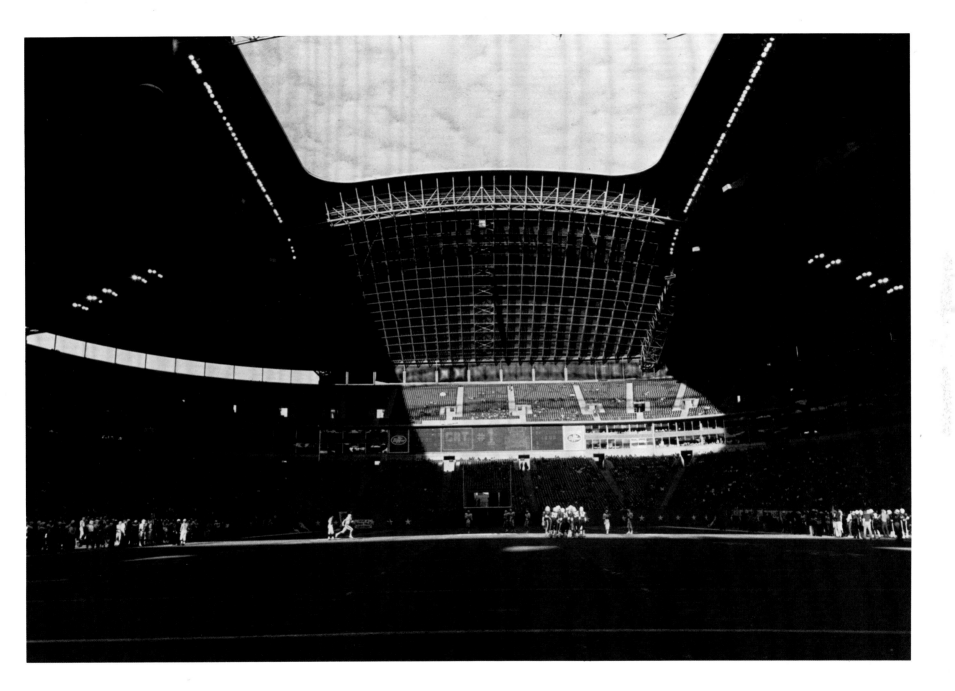

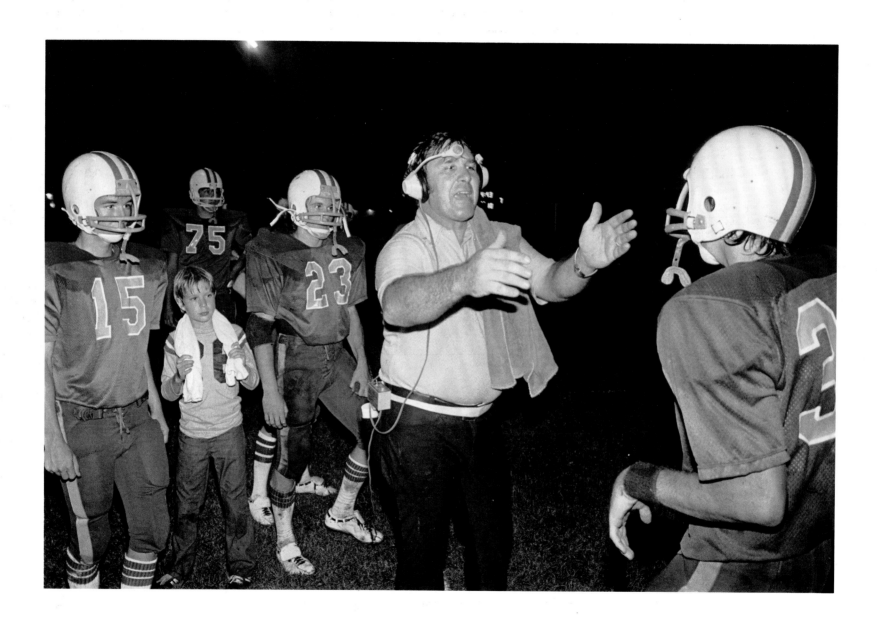

"I started playing football as a kid in Hernando, Mississippi. I remember talking to the coach standing there on the street in front of the bank one day. Told him I was interested in coming out and playing football. He said, 'We'll be glad to have you.' That was his very words, and it was very impressive to me then as a young man. 'We'll be glad to have you.'

"Now I had played baseball and I wasn't too enthused about that. I had played in the band, too. But I had some cousins who played football, and I thought it must be the greatest thing in the world to get out there and be a football player. There was something different and appealing about it that was very strong. Seeing people out there hitting and running over each other, and going after each other and yet, nobody getting mad or losing friendships over it.

"Now I'm forty-three years old and I been in the business of coaching and teaching for nineteen years. But I can't put my heart into teaching, only coaching. Right here, in football, I can say, 'Now, son, this is life. We're gonna go out there today and this is your assignment. And if you don't survive it today you're gonna get fired and lose your position. But if you do survive it, you're a starter. You're on your way.' That kid comes out here at 2:30 after classes. He's tired, drowsy. I feel like if I can teach him to reach down and give me some real go-get-um then he's got a chance. He's learned something he can use all his life. I teach him to keep challenging. If some kid knocks him on his butt, he can't accept it. He's got to learn to get up and go at him again. And again. That's football and that's life. I got kids come out and can't cut it. We all have 'em. And I can tell you from experience what'll happen to 'em. They'll be hauling pulpwood like their daddy. Or be working all their life as a laborer. They gonna be satisfied to go right back to doing that. But I have other kids I can teach to challenge, to keep coming back, and they are the kids that're gonna go somewhere.

"I remember when I was playing high school football, and I was running in the backfield, my coach called me in one day and said, I was gonna have to be doin' a little bit better if I wanted to keep my first-string position. Well, that bothered me, of course, because I was being told I needed to improve. But he did it in a way that I kept my pride and went on to improve. In the past I'd been told, 'You can't do that. Get over here. Let a man do that.' You know, my daddy dealing with me as a kid. But the coach told me the situation man to man.

"Like when he said, 'We'll be glad to have ya. We'll be glad to have ya. We start to work out August first. Come on up there and get your stuff.' And right then it was just like a fella telling me, 'Well, pardner, you can be part of our organization.' And I don't know of any coach that don't do that with a kid and I think it's the greatest thing in the world.

"My dad, when I told him I was going to Hernando to play football, he said, 'You get killed playing that damn game, and I ain't coming to your funeral.' And I'm telling you, my dad never saw me play a game in my life. My mother did. But he thought it was crazy. I could be earning money and I was risking my neck getting broke. A lotta pressure gets put on kids that way, and it's not fair. A kid should be able to make his decision to play or not to play. To belong. It makes a kid feel special. He belongs to a good program with a good purpose in life.

"Nowadays I go to a football game and you know what I think about? Gladiators. I don't see a football game at all. I picture myself out there in a toga, and everybody's shouting 'Kill the bum! Kill him!' Right here tonight, you watch what happens. These fans go crazy. And yet, it's the one time in life for that little hometown kid that he'll ever be known. He'll strut out there with that jersey and helmet on like a damn racehorse coming to run. The band's striking up and he's ready to go. God, it's the greatest thing in the world. He couldn't fight his way outta a wet popcorn bag, but I guarandamtee you right then he can whip anybody. His momma is up in the stands clapping and yelling for her boy, and soon as he gets a good lick he comes alimping off showing his battle scars.

"You ask that kid why he likes the game and he says, 'I don't know, just like it.' But it's so clear, so plain to see. We all want to be out there facing the challenge for our town, for our people. We'll never get that chance again. And if we get whipped five times in a row, we learn that you don't necessarily get whipped six. We learn to face the challenges one at a time. I mean that kid might get hit and rolled up like a nickel window shade. But he learns that if he keeps getting up he'll be admired, he'll be loved, he'll be a man, by god. It's something he may not get at home, and for sure not in the classroom."

—Jim Norman, head coach, Big Sandy School

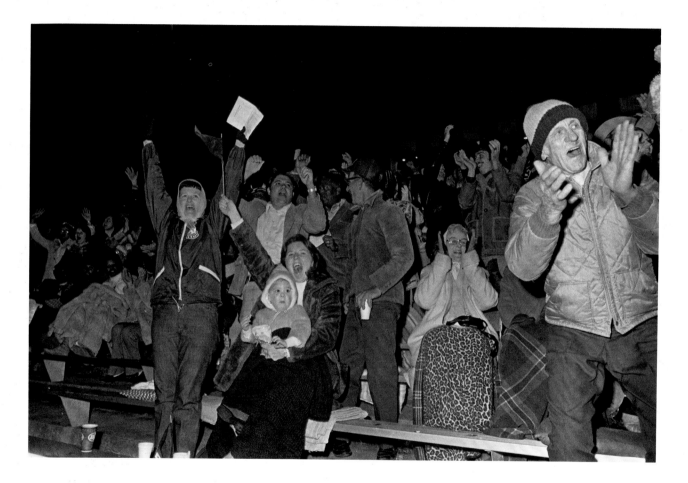

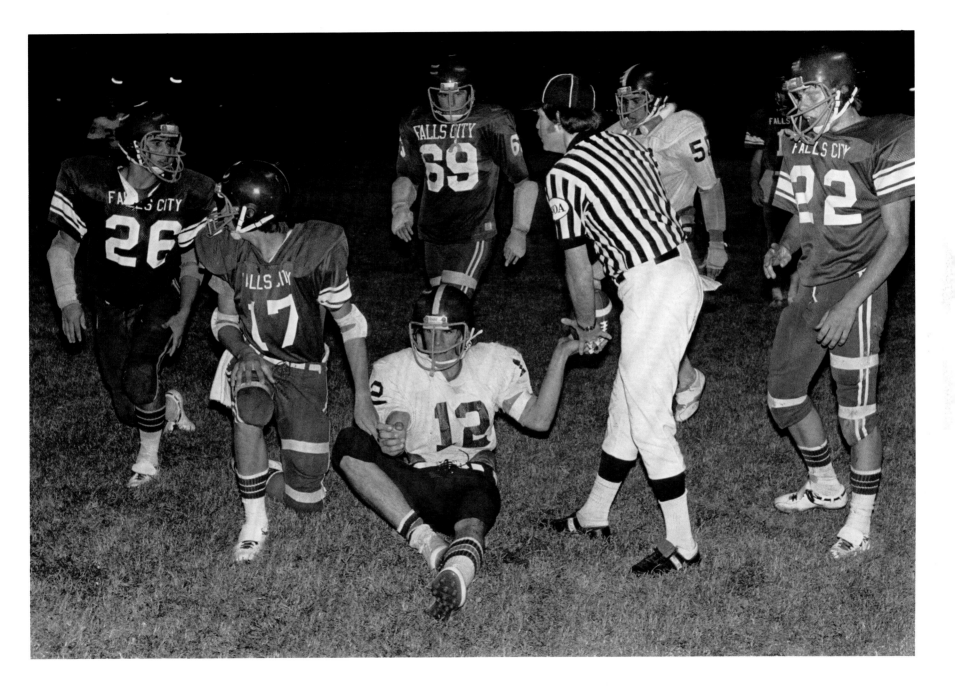

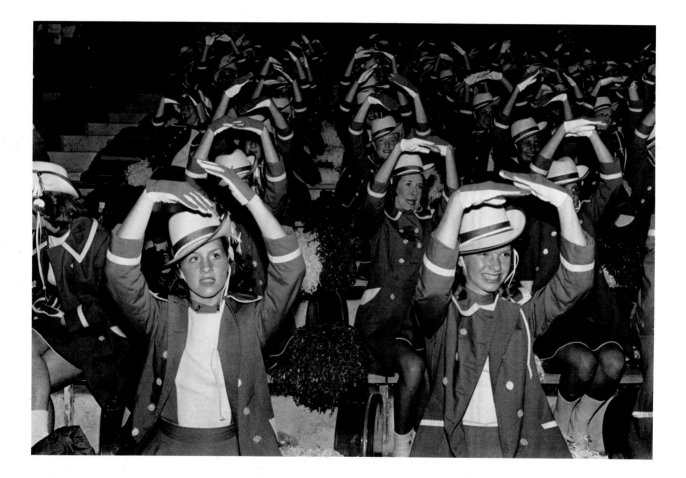

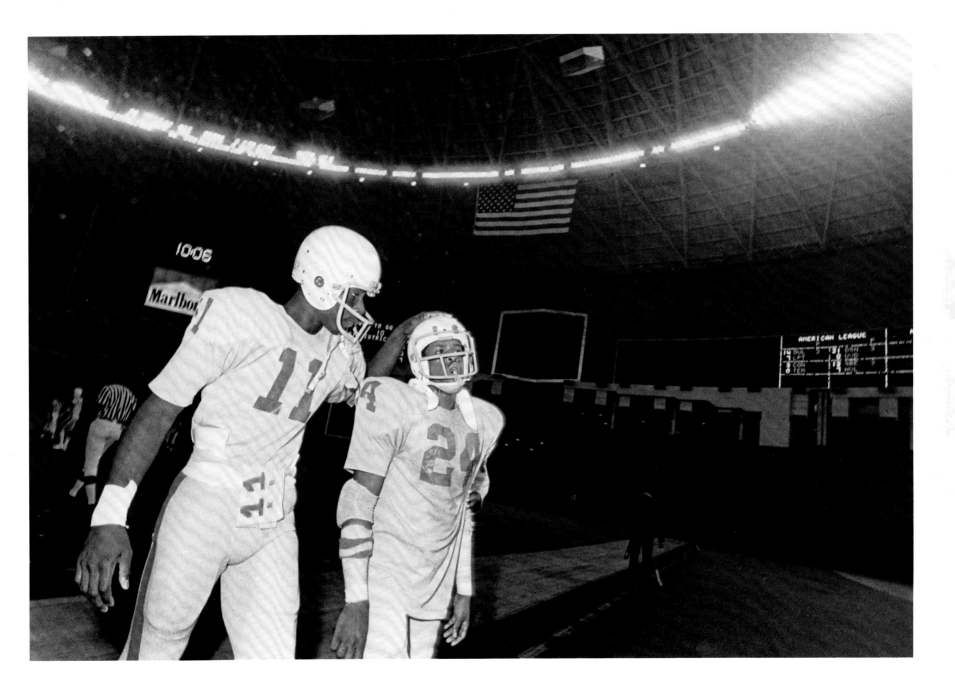

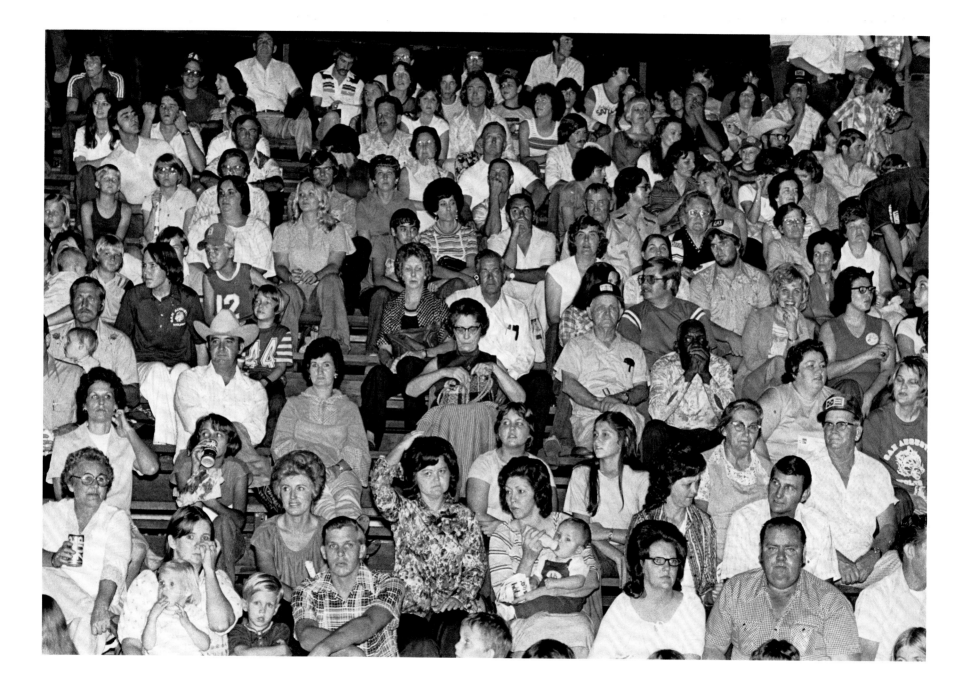

"Nowhere are there larger bands or more marching organizations, with corps of costumed girls whirling glittering batons. Sectional football games have the glory and the despair of war, and when a Texas team takes the field against a foreign state, it is an army with banners."
—John Steinbeck, *Travels with Charley*

A high school football team carries the name of its homeplace abroad in the world —across county lines, into big-city sports pages, even onto television—and Texans are too place-proud and literal-minded to treat this association lightly. The local team is their team, like it or not, and if football is important to them then so is the team; it represents them more directly and less rhetorically than their courts or politicians, more exactly than lesser arts.

Certainly the crowds attending high school football games are the most representative to gather more often than once in most Texas towns and, of course, the largest. There are more men than you see in church and more women than you'll ever see anywhere else out-of-doors, plus many of their children and occasional pets. If the team is called the Panthers, the littlest children wear "I'm a Little Panther" shirts; somewhat older boys, nine or ten, wear imitation Panther team jerseys; men wear gimme caps with the Panther logo above the bill, and a few might even dust off their old P-jackets, too. Most of the girls and women have little panther charms or pendants or badges, ribbons, appliqués, hatbands, one thing or another. When a student honor guard pulls the mascot along the sidelines—either modeled in plaster or on the hoof—it is like an icon passing before them. Everyone cheers, growls, hoots, yodels, makes hand signals, or waves bandannas, whatever the hometown liturgy calls for.

The specific details of the football ceremony are as broad and diverse as the state of Texas. A girls' drill team from the far western plains will spin rifles with stoical faces, while their counterparts in Houston's fourth ward, Kashmere High's Future Foxes of America, will do high-funk cheers copied from the dance on "Soul Train." An East Texas marching band's best song is inevitably "Dixie," in South Texas it is "Guantanamera," in north Dallas "The Ballad of the Green Berets." Across the river in south Dallas they have mastered marching to jive rhythms, while in Central Texas' German country they play thunderous Sousa marches with massed tubas. And they all can play with loud conviction, from deep in their hearts, "The Eyes of Texas (Are upon You)."

There are Texas high schools with larger marching bands than most nations and many armies can muster, some as large as two hundred pieces with entire ranks of trumpets and trombones—saxophones in the black schools—all marching differently, each to the beat of their own local drummers. A marching band is almost as essential to a football game as the teams are, and so Texans approach it with appropriate zeal and foolishness. To play in the band a young Texas musician will commit unforgivable musical sins: horn players clamp down on mouthpieces instead of kissing them, flutists hold their arms all wrong, drummers drum up embarrassing beats— all for the purpose of neater marching, louder music. Towns with impressive bands are as proud of them as they are of a winning team, giving rise to the clichéd consolation about how "the team lost the game but the band won the halftime."

Halftime is when the opposing towns show off for each other. Pep squads, drill teams, majorettes, beauty queens, award recipients, honor students: all take the field in alternate turns, one from each side, to perform or be recognized. And, Texans being the way they are, a subtle form of competition is carried on, merely disguised as entertainment. Finally the bands march onto the field, parading up and down in steady two-four time, same as a pulsebeat and as loud as possible, the music echoing through the stadium, connecting the town with their boys in the locker room.

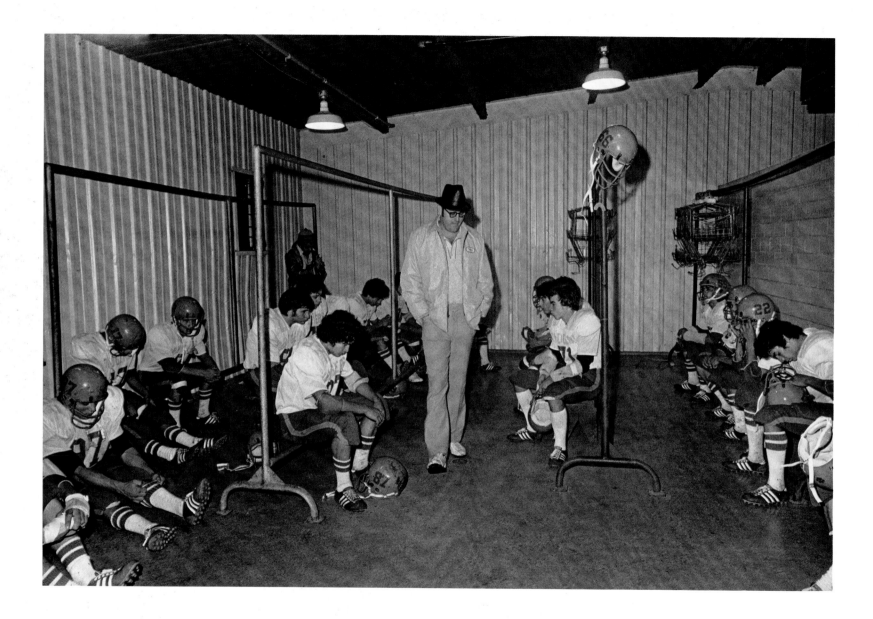

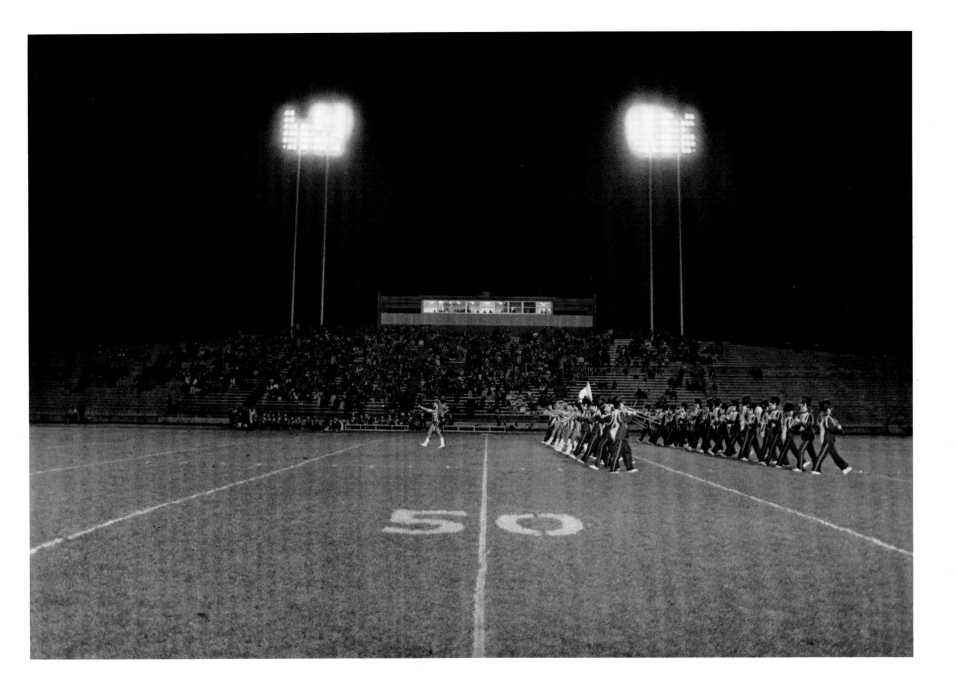

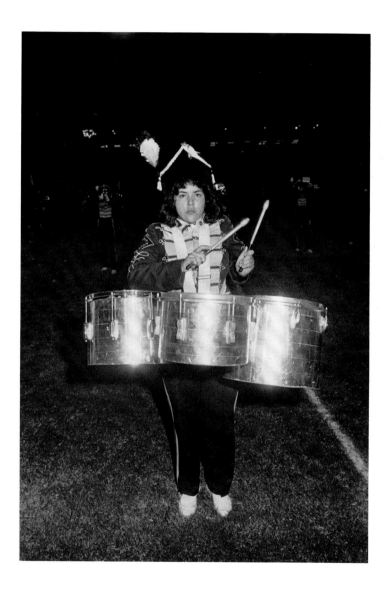

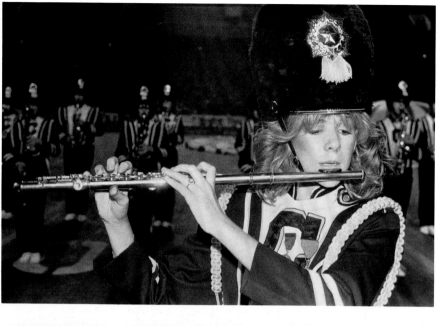

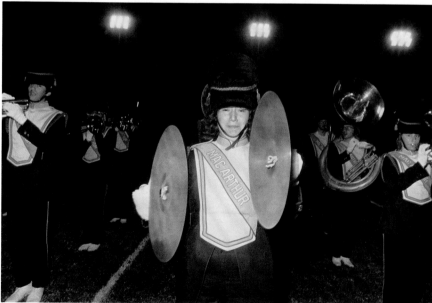

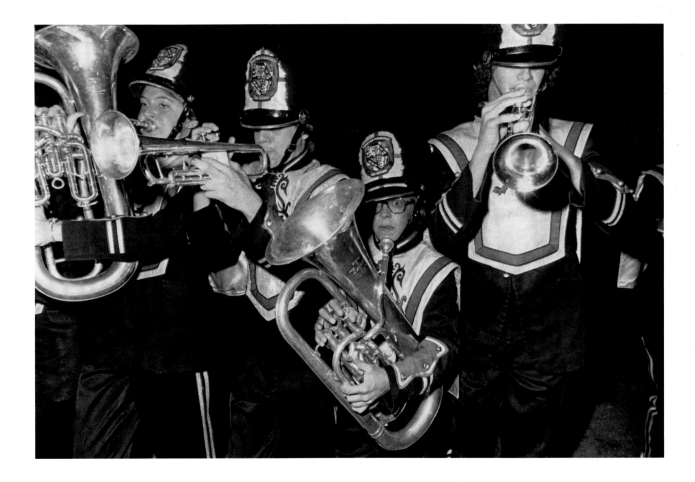

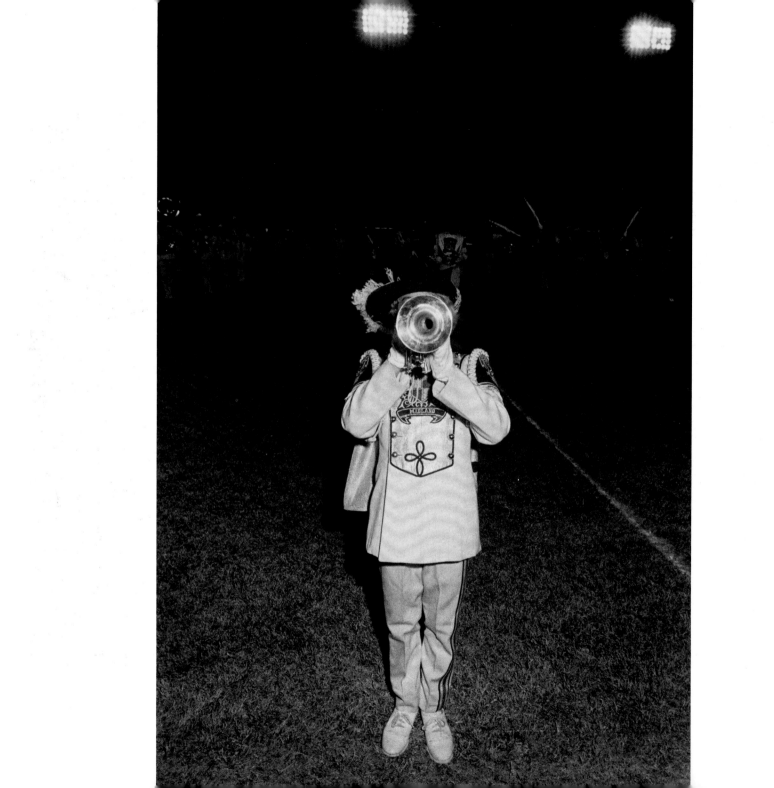

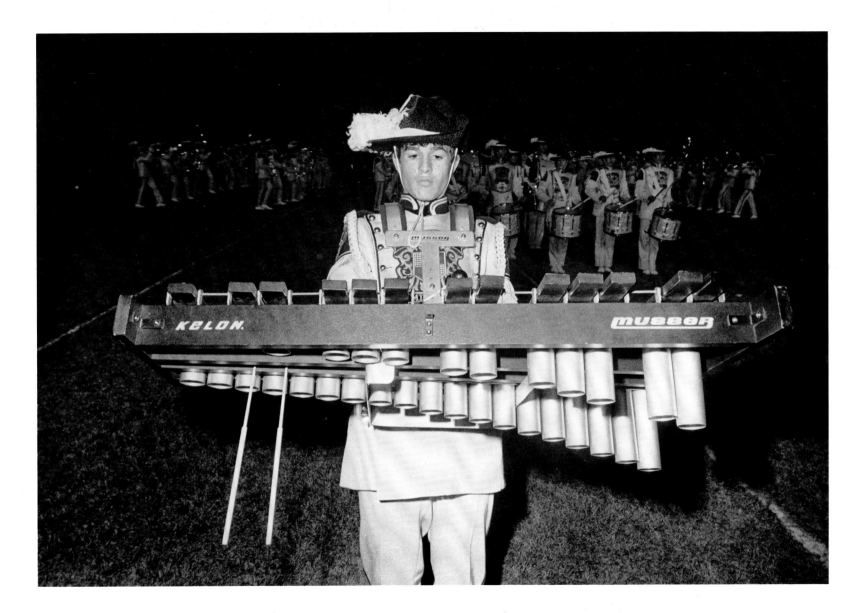

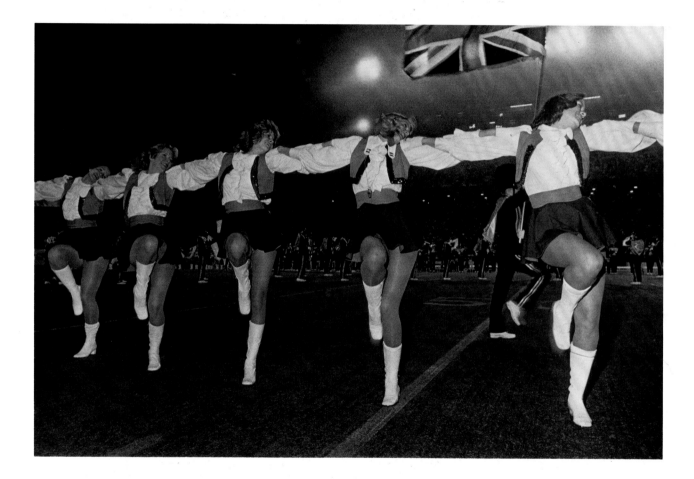

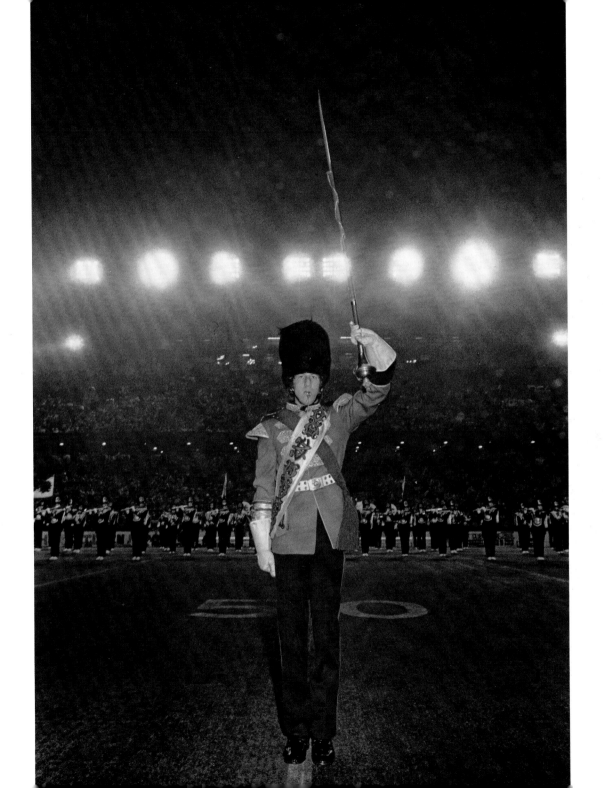

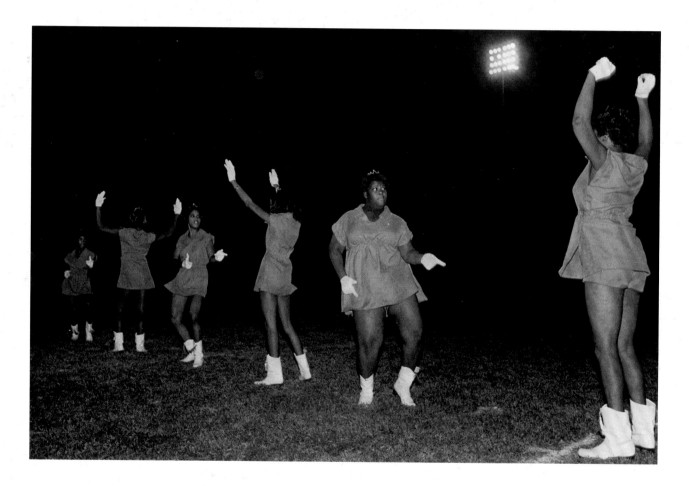

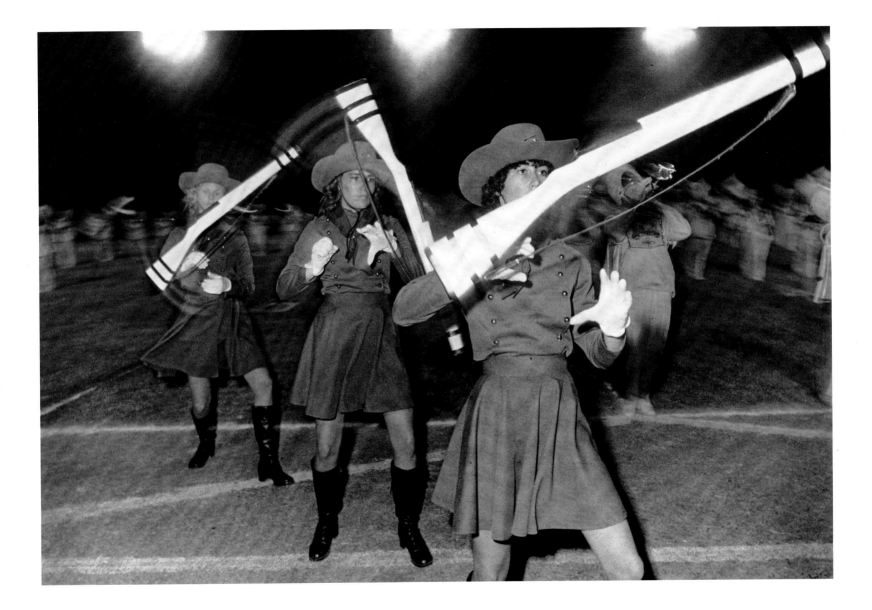

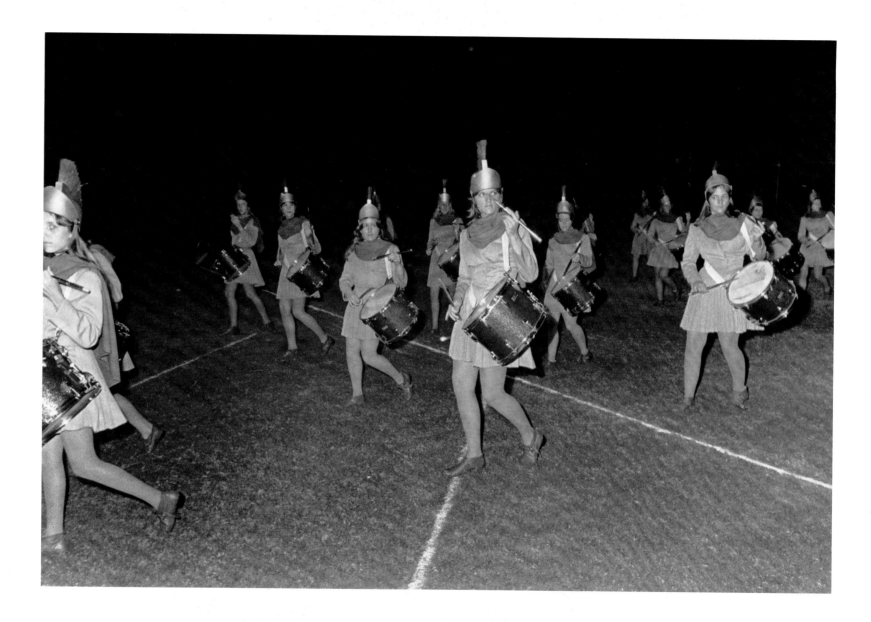

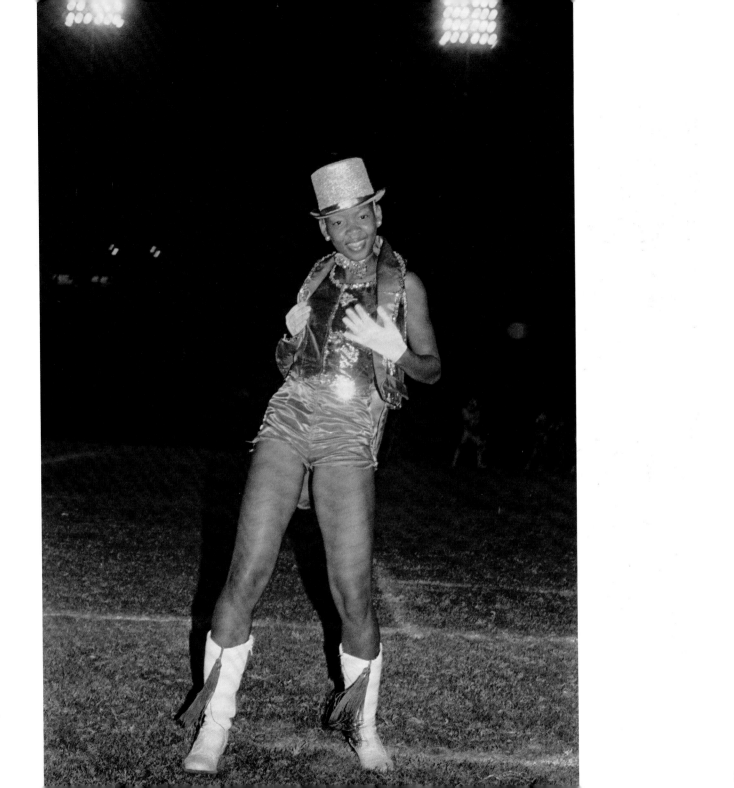

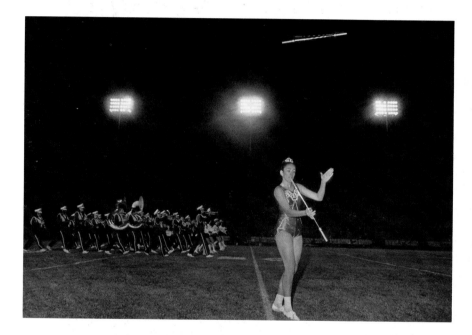
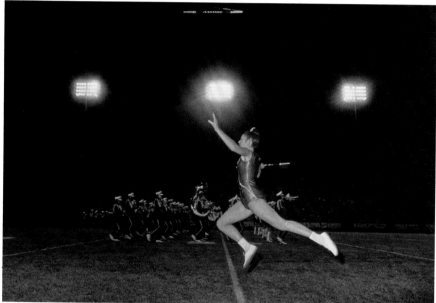

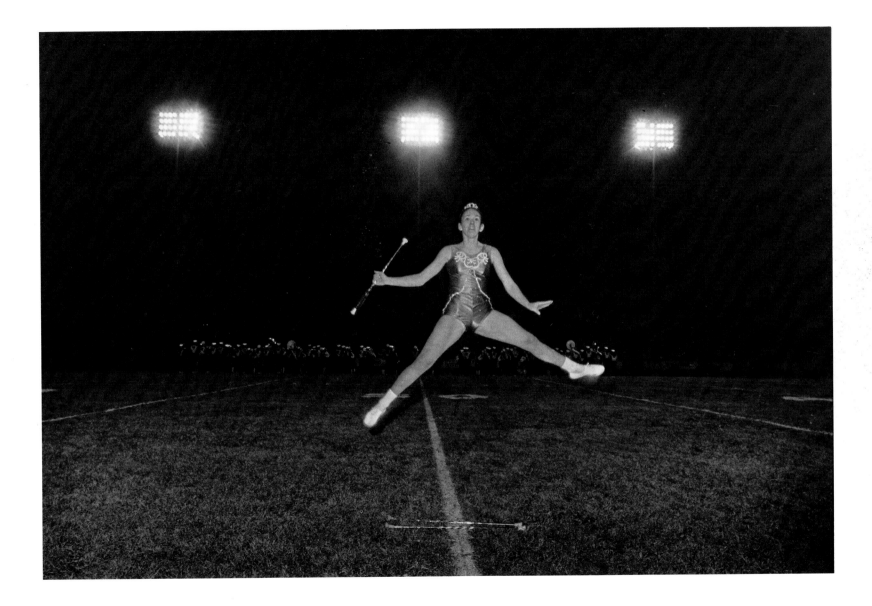

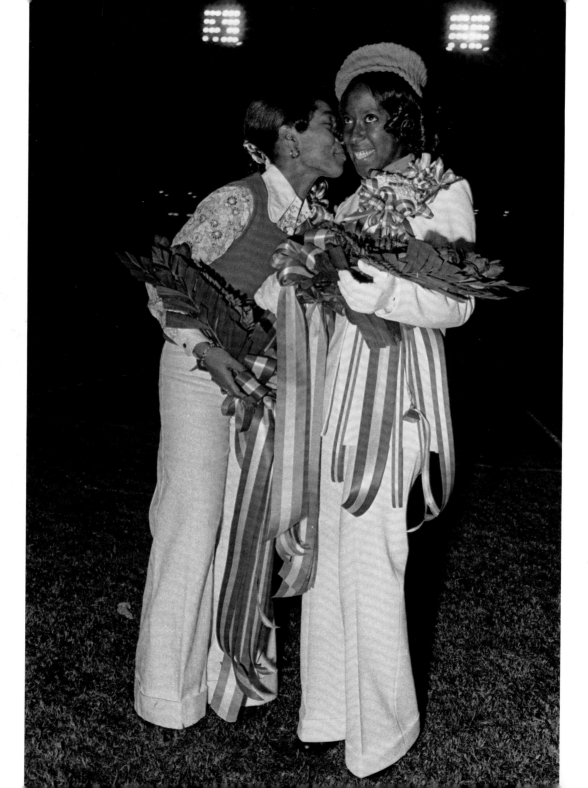

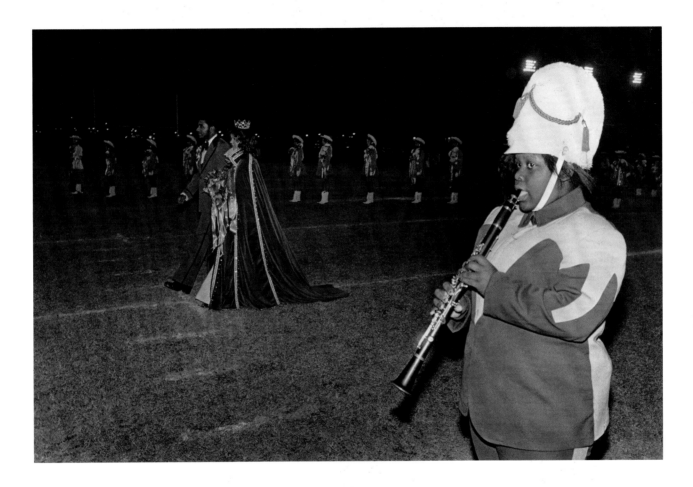

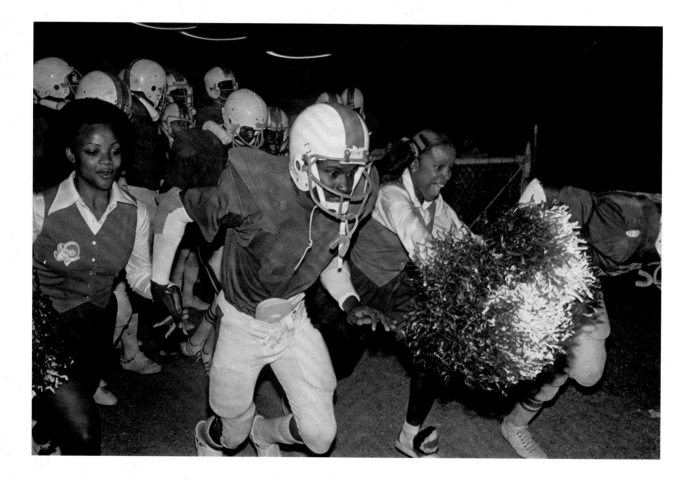

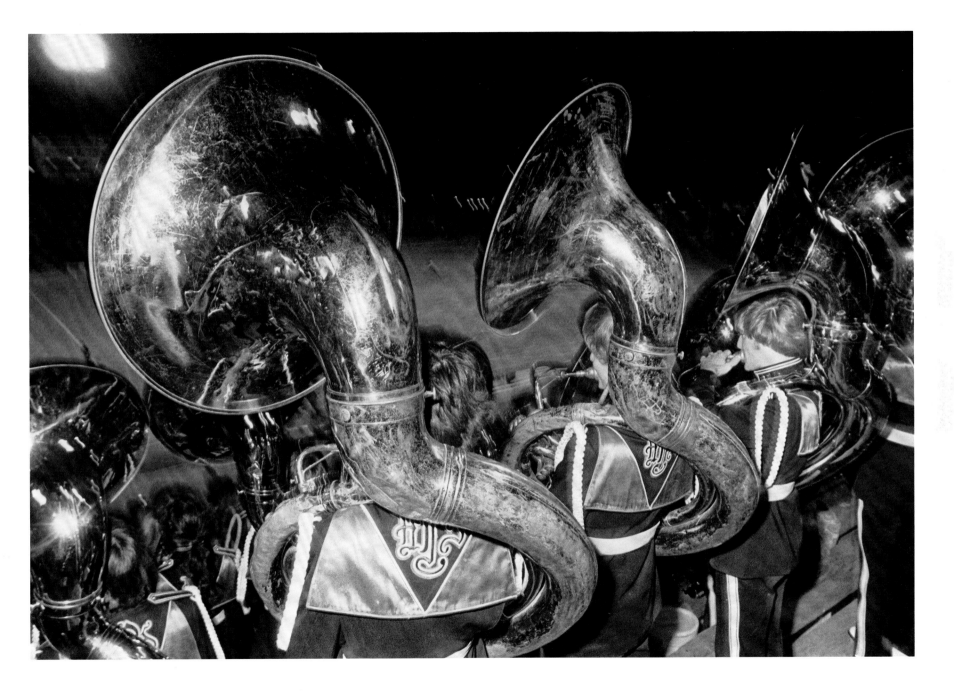

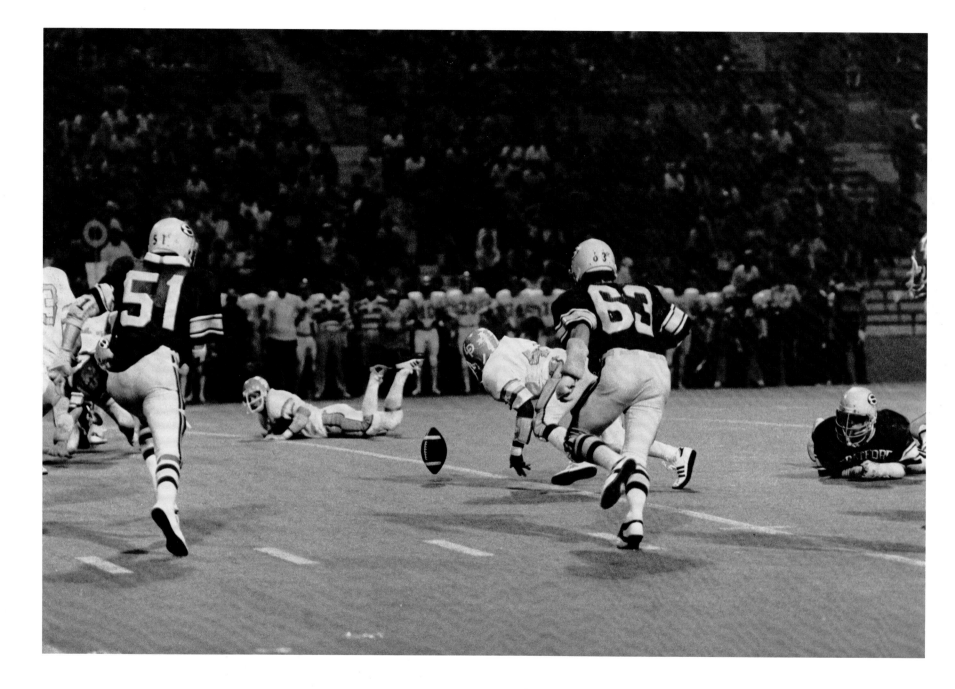

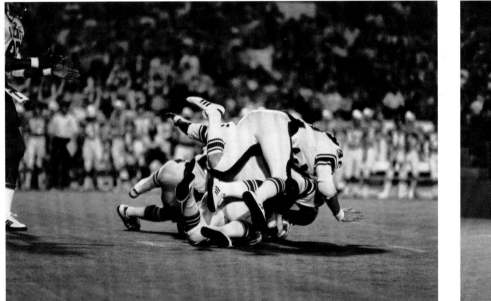
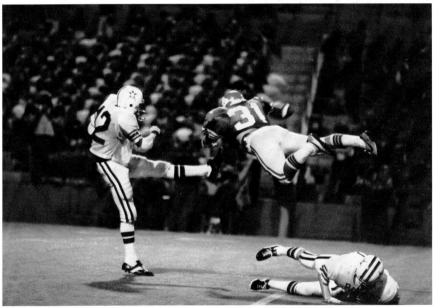

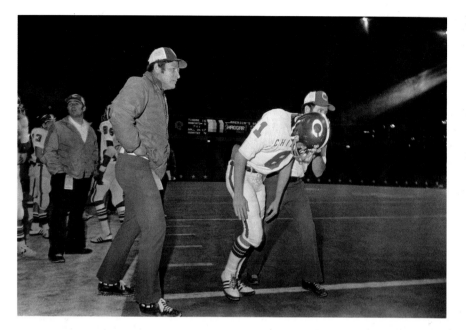

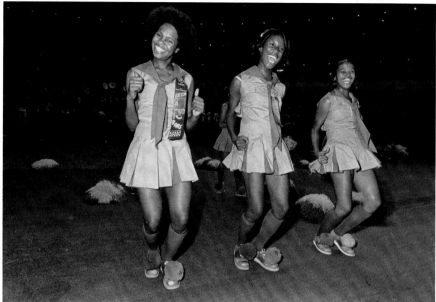

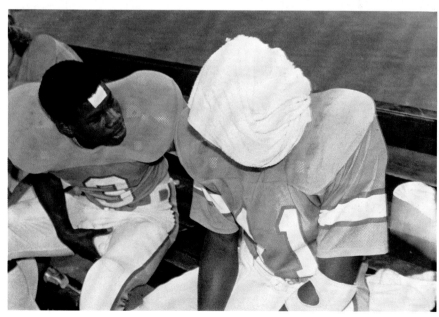

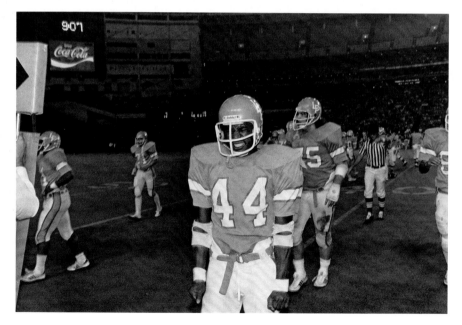

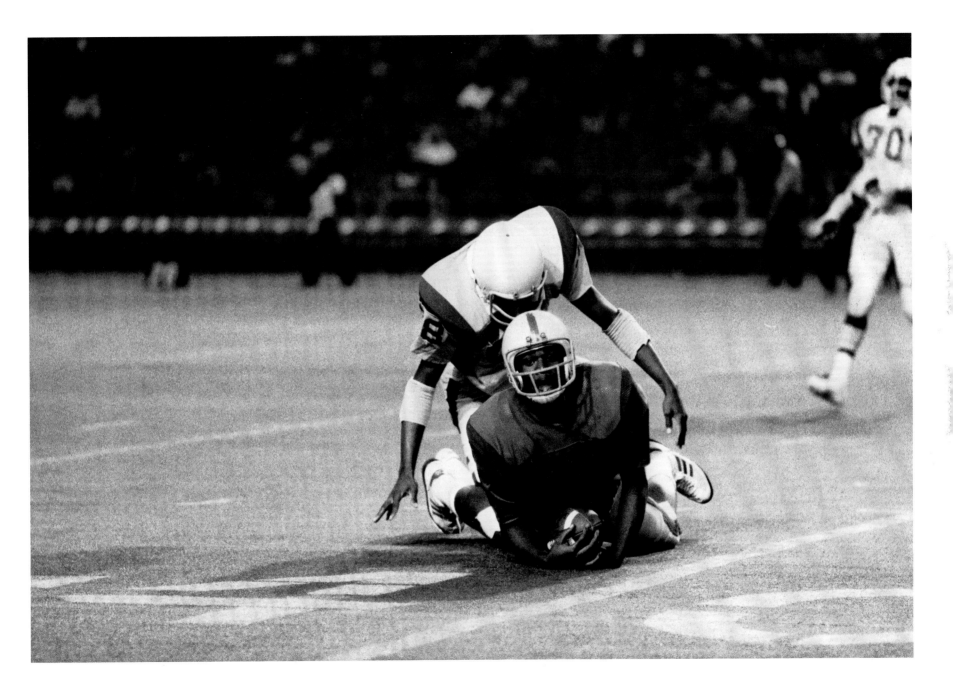

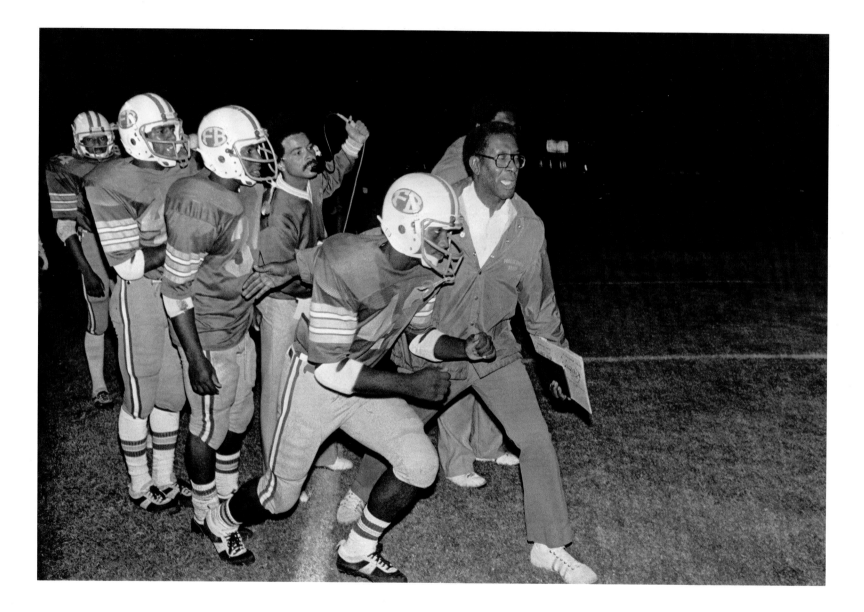

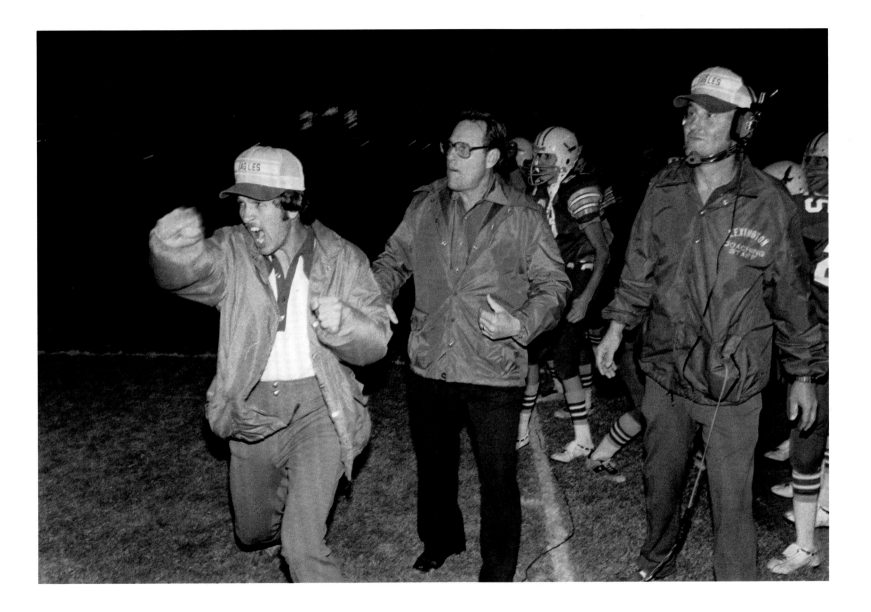

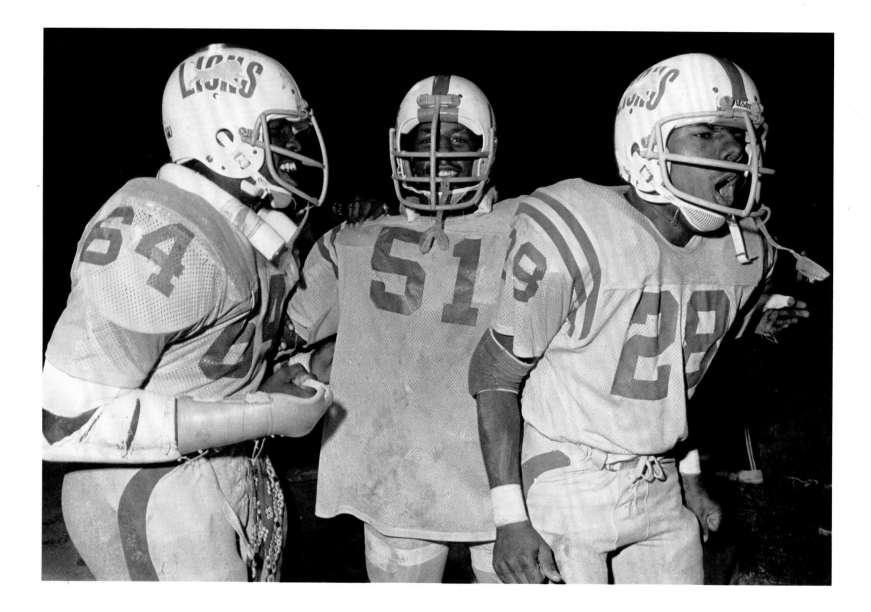

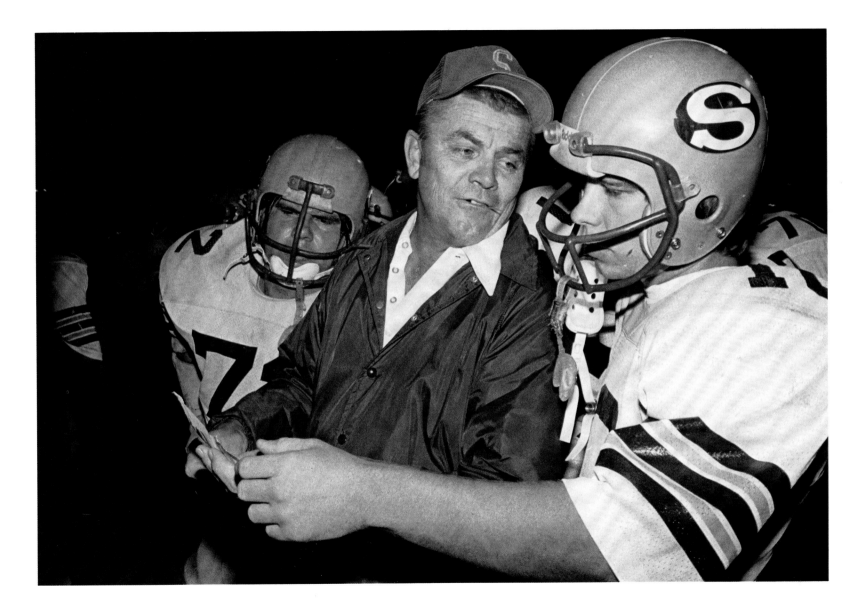

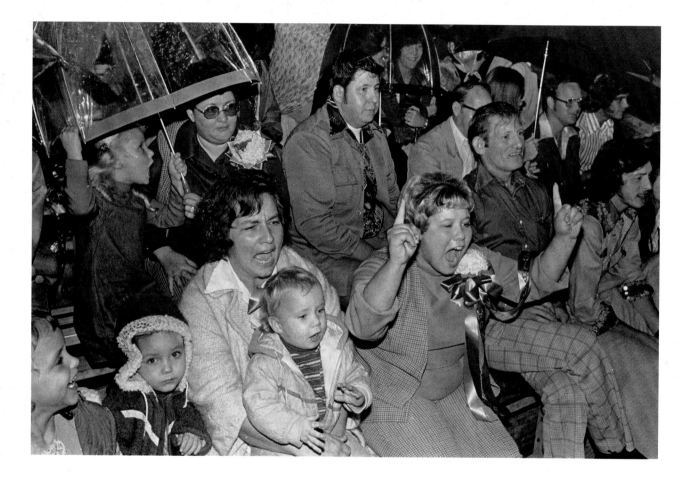

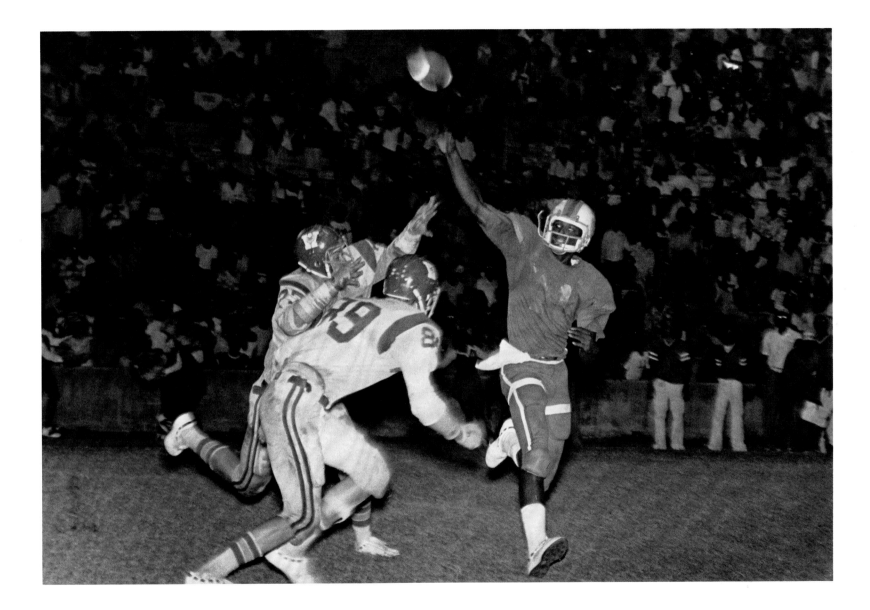

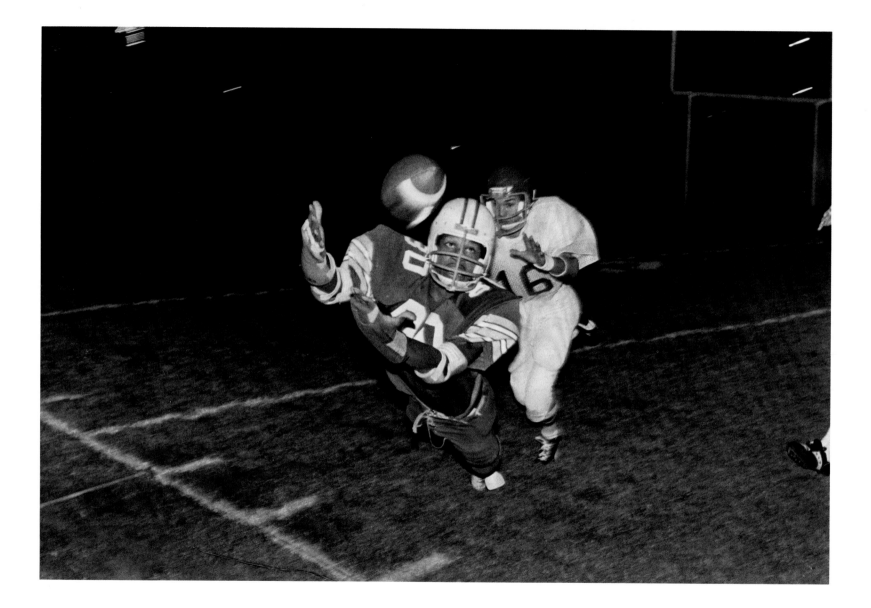

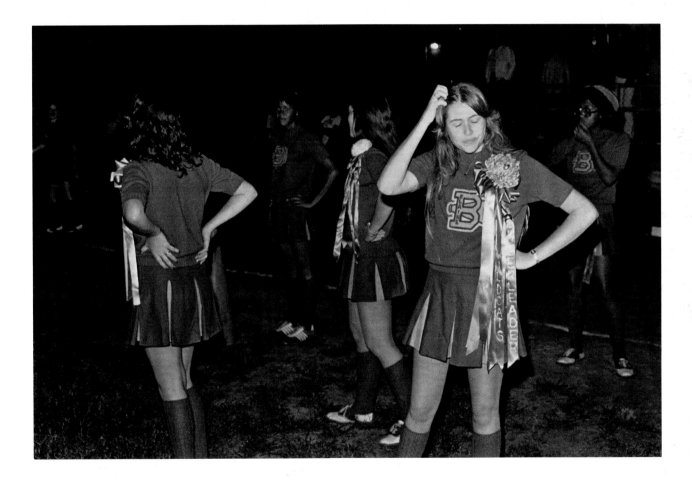

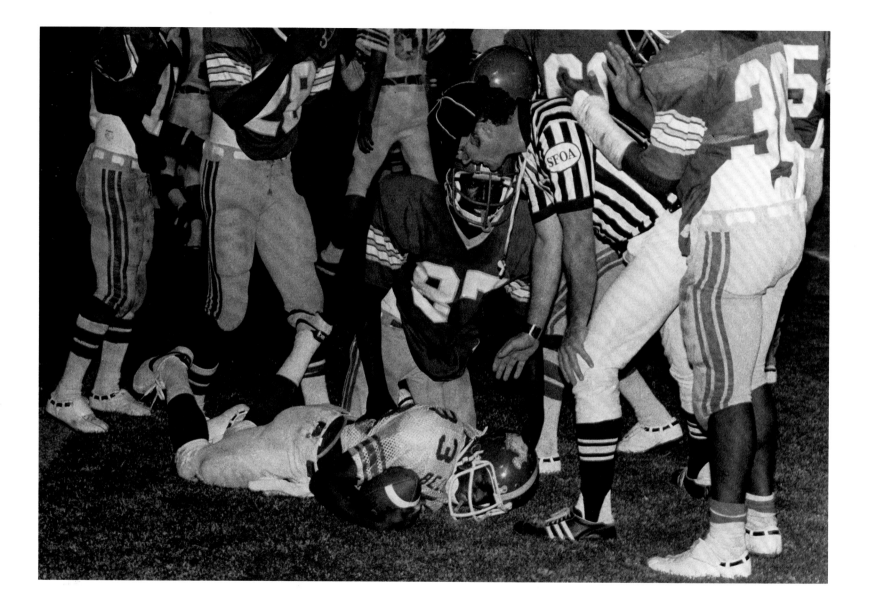

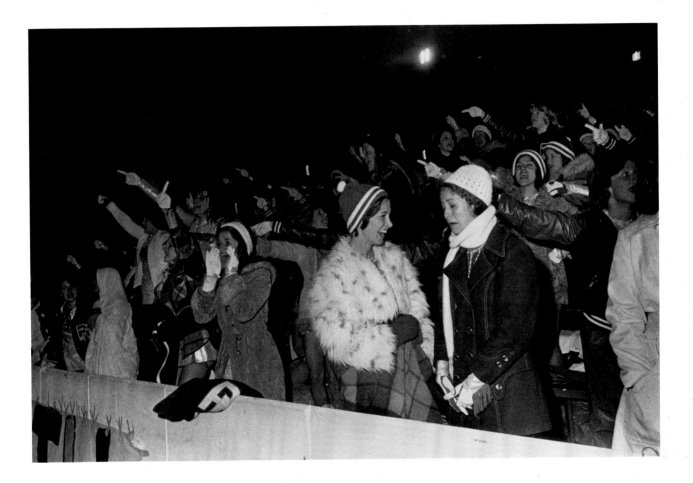

"Texas produces the best high school football players in the country. Period. Shut the book and amen."
—*Sports Illustrated*

There are places in Texas where a boy can start playing tackle football in the fourth grade with his parents' permission, which enough of them get to populate a league of 450 teams around the state, complete with their own play-off tournaments and nine-year-old cheerleaders. They usually adopt the local high school's colors and mascot and gain the support of the local boosters club, which regards them as a valuable farm team, so that before reaching puberty they have already grasped the game's basic scheme and style of play: run hard, hit low, never stand still. Weighing less than a hundred pounds apiece, looking awkward in their giant shoulderpads, they practice at aggressiveness three days a week, running and hitting, only to forget it all and act like children—hesitant and fumbling—in the actual game itself, which grade school teams play on Thursday afternoon.

On Friday afternoon the junior high games are played. Boys too young for acne will be pumping iron by then, and if their parents can afford it, attending summer football camps, specialized clinics run without league approval under the name of some famous pro and staffed by off-season collegiate stars. The famous pro will occasionally visit to pep-talk the boys, often bringing a few less famous teammates who enjoy telling football fables to all those eager, still uncorrupted young believers. They invariably find it refreshing and rewarding—the men do—and proceed to

hang around for days. On a separate tour another famous pro will come along to proselytize for the Fellowship of Christian Athletes, and most boys readily step forward to accept this message also. Feeling bold in the company of professional heroes, and instructed by only slightly less professional college heroes, the boys attack blocking sleds and tackling dummies with startling zeal, they do endless sit-ups and wind sprints, they work on impressing each other with fables of their own. They begin to think of themselves, too, as Football Heroes.

By the time they reach high school they should have reason to be confident, if they're still playing, having passed considerable winnowing already. They feel accomplished and even natural in their cleats and pads, in those claustrophobic helmets. The fraternal argot of football—the terms and nicknames, historical details and current standings—comes easily to them. For hours and hours they have drilled at fundamentals, honing their timing on trap-blocks and pass patterns, they are familiar with multiple offenses and shifting defenses, they have mastered the contents of 250-page playbooks—larger than most small colleges employ—they know how football is supposed to be played. What doubts they have are simpler, deeper.

They are still just boys, after all, fifteen or sixteen years old, seventeen at most, still too young to really shave or legally drink, to vote or enlist or give formal consent to anything at all. They have strong and healthy, Texas-bred bodies but children's eyes—clear, wide, vulnerable eyes that reveal more than they see. There is often still a little baby fat as well, pudgy ankles and cheeks that not even summer camp work-

outs could tighten up. Their youth and fecklessness are obvious. Officially classified as minors, they are the wards or dependents of virtually every adult they encounter, and they are inclined to bridle a bit. They are at that age when a boy must begin to believe in himself as he matures, and all that supervision can be awfully discouraging.

Which is the biggest reason they come to football. On Thursday night, if they play on the varsity, they are assigned no homework. On Friday morning they wear their game jerseys to school and not only their classmates but also their teachers accord them respect, as if they were important persons. The entire school assembles to acclaim them in the gym, the band clamoring martially while girls yell and leap about, the principal speaking for everyone, he says, when he tells the team they're all behind them one hundred percent. At public pep rallies, every politician for thirty miles around will flatter them, prominent businessmen rise to salute them, ministers bless them and pray for their success. Finally their coach stands up and with prosaic but ardent sincerity he proclaims his pride and faith in them, predicting victory that night; banners wave, trumpets blare, everyone cheers. Through it all the young Football Heroes sit quietly taking it in, scarcely acknowledging the hoorah, very self-conscious, trying to convince themselves that they aren't really children.

As always with would-be heroes, the strength of their conviction will help determine their success. Texas high school

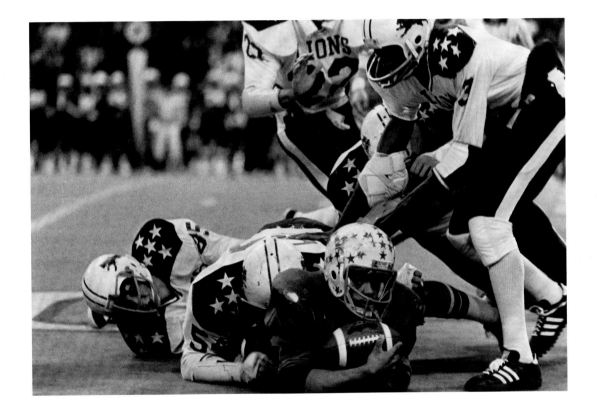

football is a face-off among boys striving earnestly to realize their image of Texas manhood—self-reliant, goal-oriented, capable of necessary violence—trying to look each other in the eye without flinching or grinning, the way boys would. They are not so ready to hit one another as they like to pretend. Most schoolboy football injuries occur during practices rather than games—the reverse of college and professional injuries—for the simple reason that they find it hard to be mean and serious at the same time. Bolder in their dreams than they know themselves to be, they are easily intimidated, so they usually hit the way children do: with their eyes closed. The most frequent admonition from a high school coach to his boys is "Open your eyes!" As if it were easy.

Runaway scores are fairly common in high school games, fifty-point drubbings of one team by another from the same county—boys of the same land and blood, the same native ability—distinguished mainly by their jauntier swagger when leaving the huddle, their sterner looks across the line of scrimmage. Phenomenal upsets and reversals can result from the silliest things: an inspiring banner or slogan, a rousing half-time plea from a devoted coach. On any particular Friday nearly anything can work or go wrong; boys will believe in themselves or they won't, play well or not. But a high school quarterback who can call signals for a whole game without letting his voice break is a winner regardless of his talent.

Friday-night football is all wish and grit, stalemate and miracle; every play requires the collaboration of adolescent minds and wills, all in a hurry and under pressure. Typically this produces vigorous confusion, misdirected plays and desperation hand-offs, horrendous pile-ups, frequent penalties. As much as half the yardage in a game might be stepped off by referees, mostly for non-contact infractions such as offsides, too much time, too many players: nervous mistakes. There are a few modern suburban schools whose teams manage to execute plays with a cool proficiency that would do the Dallas Cowboys proud, but these are exceptions, prone to collapse in crucial games. The normal mode of Friday-night play is spontaneous and passionate, emphatically boyish.

It is football played with a violent energy but an innocent violence. After high school the game becomes more truly violent as the players grow older and more deliberate, the coaches more calculating, the fans more demanding and inconsiderate. In professional football even the cheerleading is self-serving and exploitative. High school football is football at its best, its most honest and most basic: a game without great skill or elegance, perhaps, but played with a passionate spirit that rarely returns. It can make fans out of people who care little for the game itself—who might disdain or even resent more celebrated versions—people who, if they live in Texas, might drive two hundred miles to be close to that spirit.

They certainly don't come to admire the artistry. From the stands it's hard to tell brilliant improvisations from simple accidents; everything looks ad-libbed, ill-advised, stalled by hesitations. After every play there are long pauses as the boys re-

cover their illusions, tramping slowly back to their huddles with downcast eyes and clenched fists. The game appears a tedious series of team collisions and shrill whistles, yellow flags, official time-outs while bodies are unpiled, shoes retrieved, players located. Public address announcements concerning all manner of local activities—American Legion dances, firemen's benefits, choir rehearsals—fill the gaps in the very intermittent play-by-play. The crowd's attention wanes and wanders to the cheerleaders, to the band, to one another. It is a time of community ease and togetherness, a time demanding patience. Then in an instant they can all be on their feet and shouting—even the announcer shouts—unified by an act of grace.

Somehow out of the clumsy teenage struggle come astonishments of poise: a daring run, a decisive tackle, a breathtaking pass. Inspired by possibilities a boy rises to the moment, commits himself, lives his dream. This is football at its most ecstatic: there has never been a pro who could run with more abandon than a sixteen-year-old boy with a goal in sight. They are momentary glories, to be sure, at least for most boys, but they are all the more intense for being so fleeting, so unexpected. They are moments so proud and compelling that whole Texas towns will turn out to wait for them.

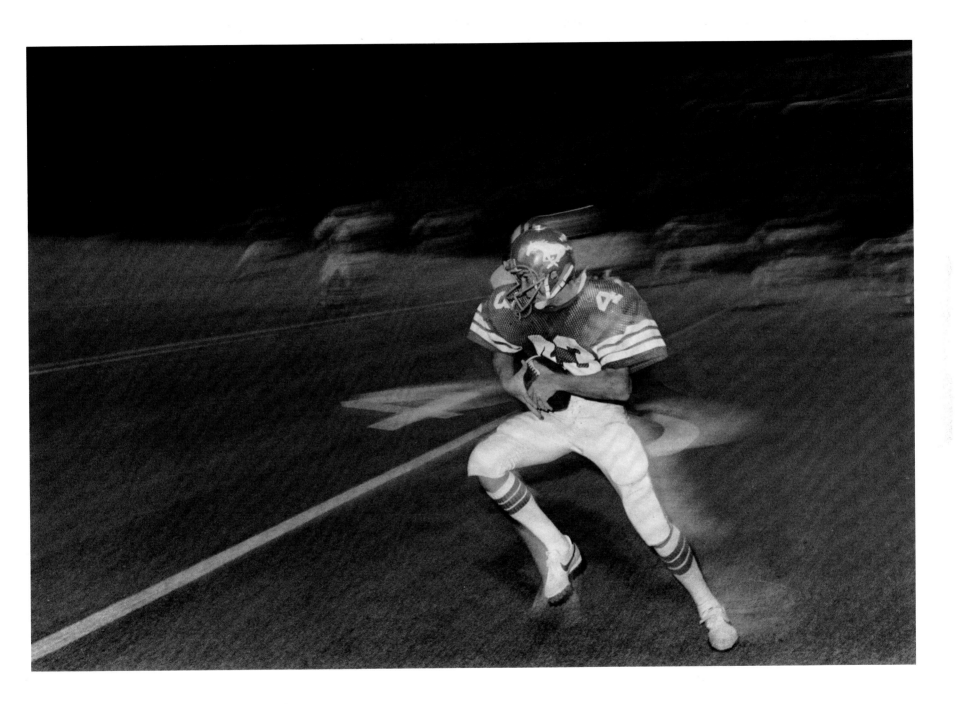

"I grew up in a small town in East Texas, a 2A town where we usually had a real good football team. From the time I can remember my dad was the football coach. He was baseball and basketball and track coach, too, but that was sort of on the side. He was the football coach mainly. I learned to play when I was only about six or seven years old, going with Dad to the team practices. Even for my age I was very small, but I was quick and fast, and I loved competing with guys much bigger than me. I loved the physical contact, too. There was something about football —the *hitting*, and being hit—that appealed to me. I also developed very good coordination when I was very young. I guess it was mostly because Dad paid me in the summers and after school to go into the gym and shoot basketball, or hit baseballs, or throw a football. He said it would be worth it in the long run—to him and to me—for him to pay me to do that, rather than me being paid by somebody else to work for them at some meaningless job.

"By the time I was ten, I could outrun a lot of the guys on the varsity football team, which they didn't like very much because if I outran them in the wind sprints, then Dad made them do laps. I was called 'The Rabbit' back then because I was so little and so fast. But by the time I was a freshman in high school I thought I was ready to be the starting varsity quarterback. But there was a senior who had played two years and he started the first two games of the season, which we won because we had a very good team that year. The third game of the year we were playing the district champions and we were behind three to nothing in the last quarter. We hadn't been able to move the ball at all. Time was running out, and the fans—and I mean the whole town was there—were getting fed up with our team. I wanted in the game so bad I was about to go nuts, but I knew Dad wouldn't put me in until *he* thought the time was right. With about two minutes left in the game, we got the ball on our own ten-yard line, just about where we'd had it all night. Dad looked around and said, 'Where's that damn Rabbit? Get in there. This is it. Run that option right. And don't look back.'

"I remember that I wasn't a bit nervous, like I thought I'd be. I took the option right and I didn't look back. All I remember is running down that sideline as fast as I could go and hearing a voice right behind me. It was yelling, seemed like right in my ear, 'Run, you little son of a bitch, RUN!' I tried to outrun him, but he stayed with me, seemed like one step behind me, yelling 'RUN, you little son of a bitch, RUN!' When I crossed the goal line for a touchdown the crowd was going crazy. Then I saw Dad, red in the face, huffing and puffing. He had chased me the last sixty yards down the sideline, right behind me, yelling in my ear.

"That was the greatest moment in my life, I guess. At least I remember it best. The whole town standing on its feet, cheering for me, and our team carried me off the field. We missed the extra point, but we won the game, and I was the starting quarterback from then on.

"I've always had a lot of confidence in myself, especially since that first varsity play. That's the biggest difference maybe between me and some other guys. When the chips are down, when it's third and long, *I* want the ball. I'll give it to someone else, of course, if it seems like the best thing to do. But I'm hoping it's me that gets it, because I always believe I can make the first down. Always. And I usually do."

—Les Koenig, Jr., former quarterback, Hamshire-Fannett High School and Memorial High School, Houston

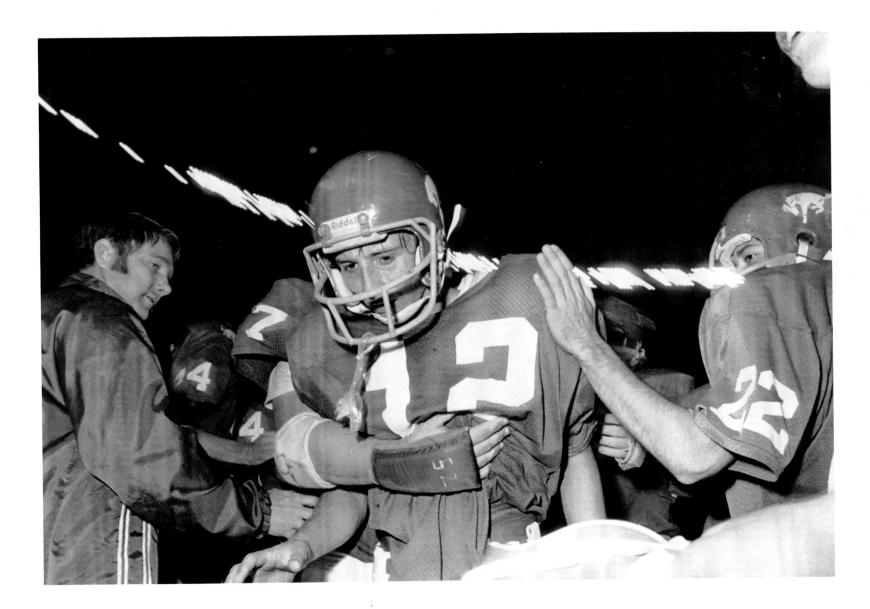

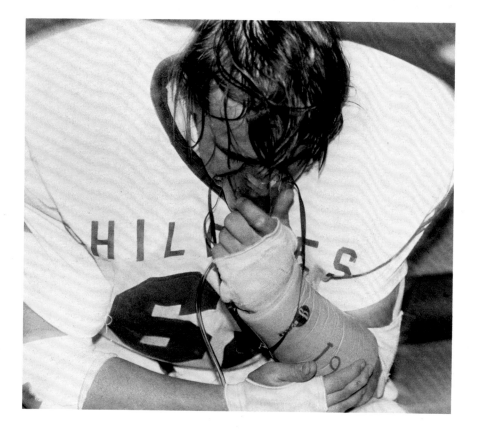

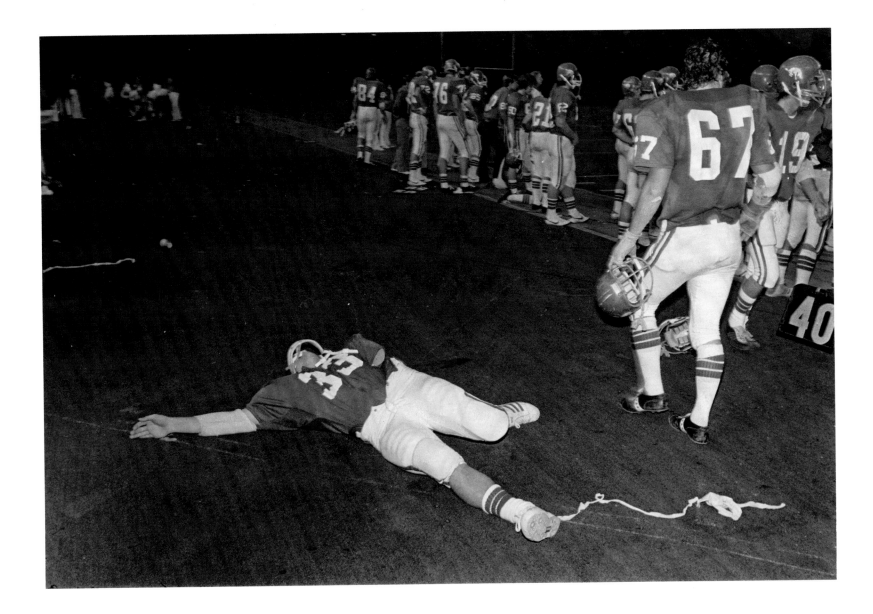

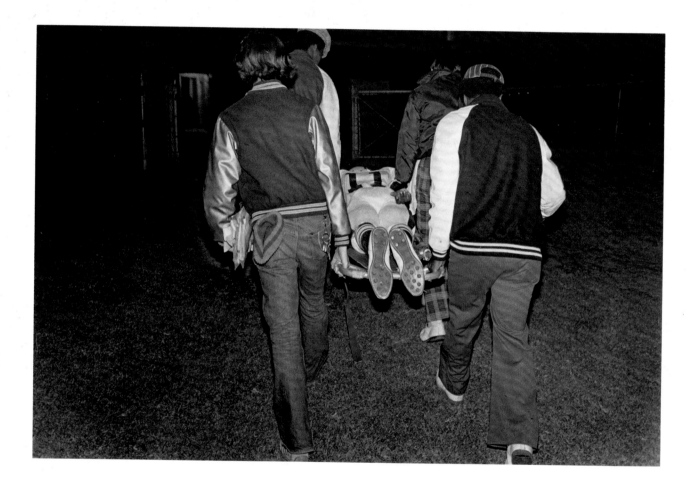

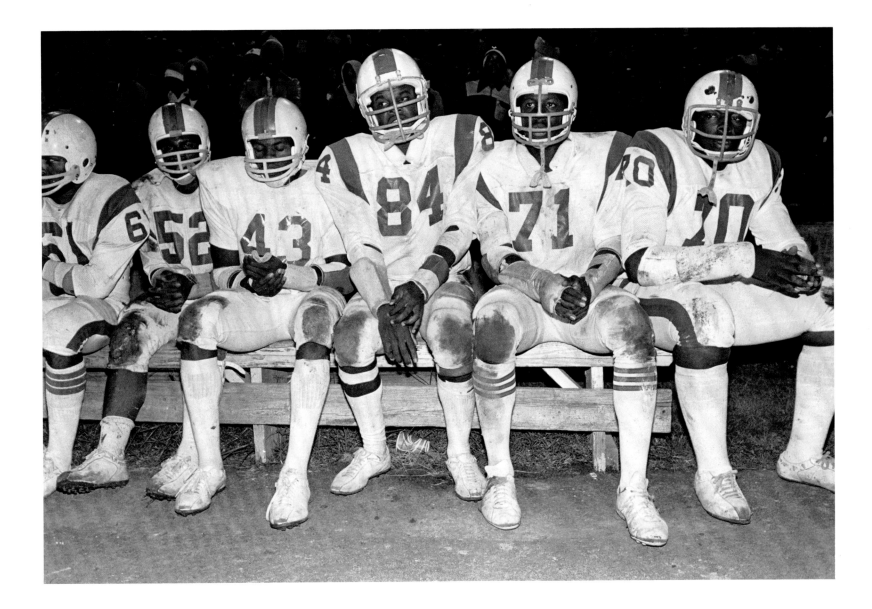

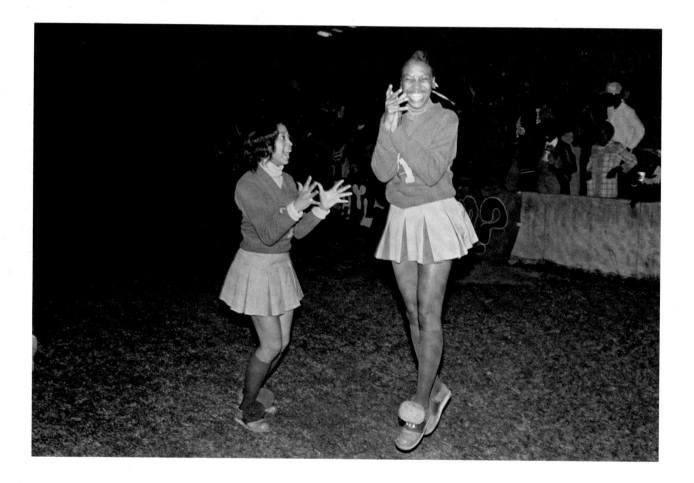

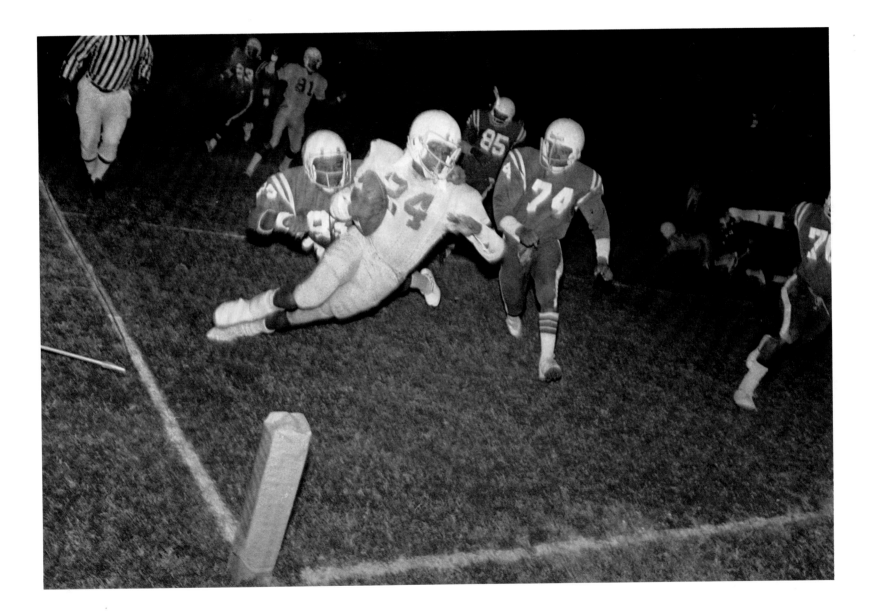

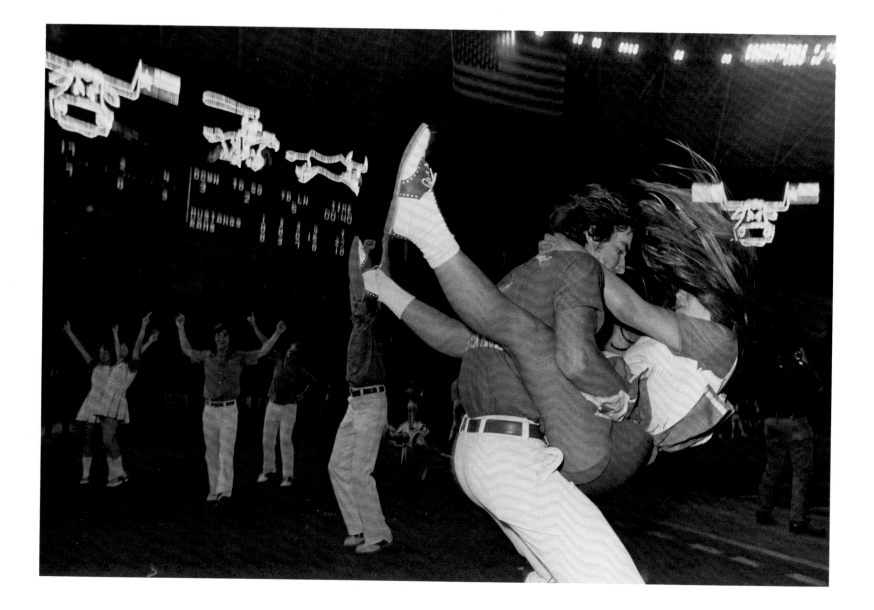

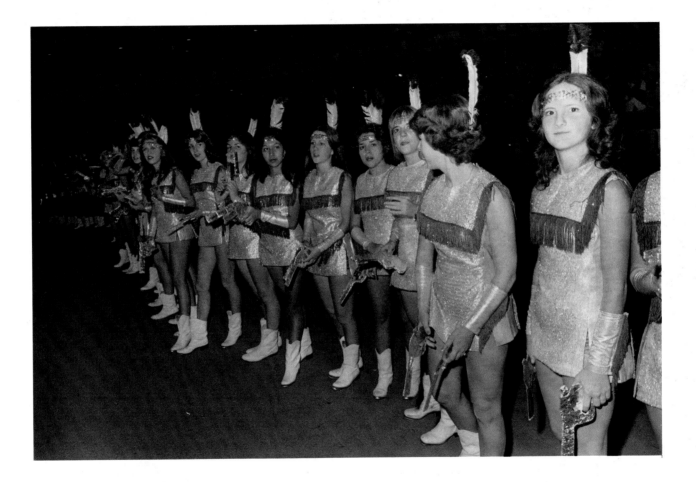

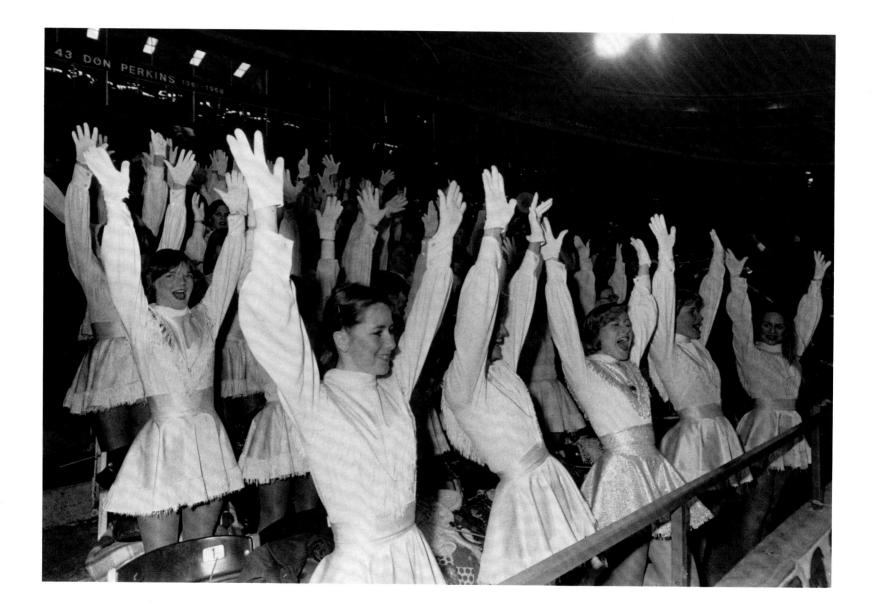

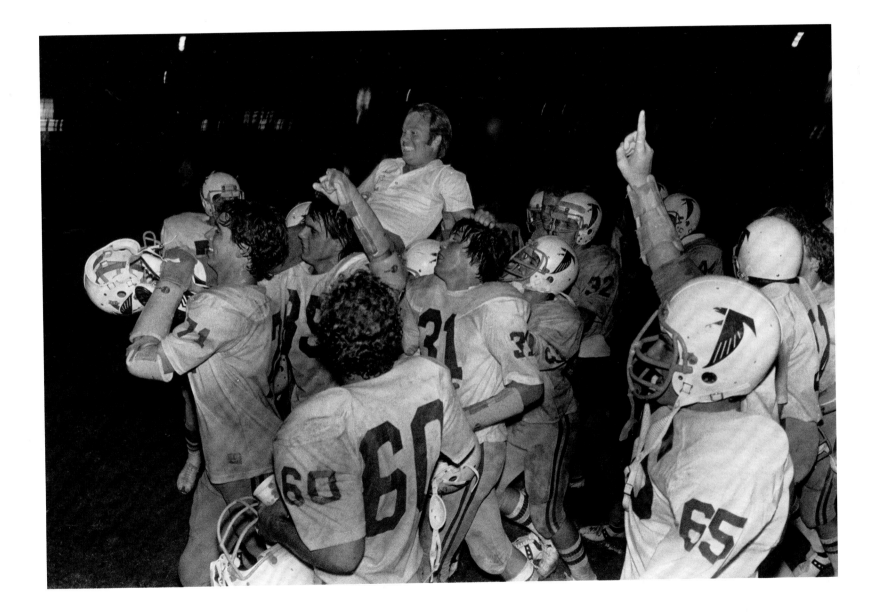

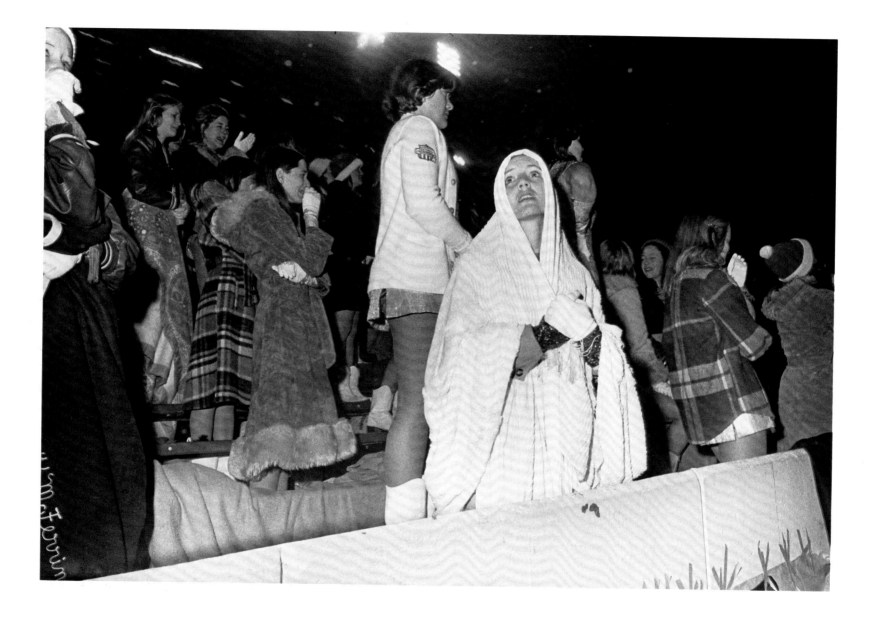

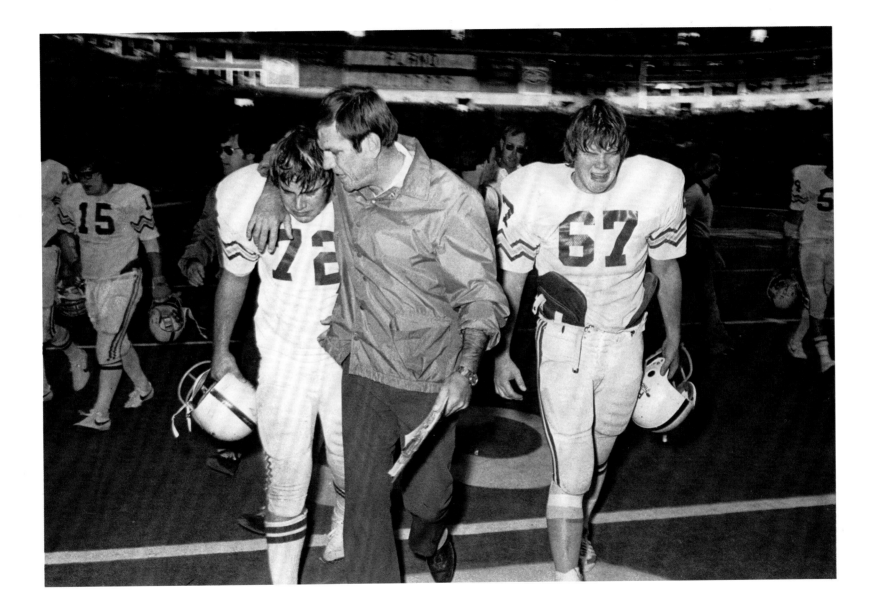

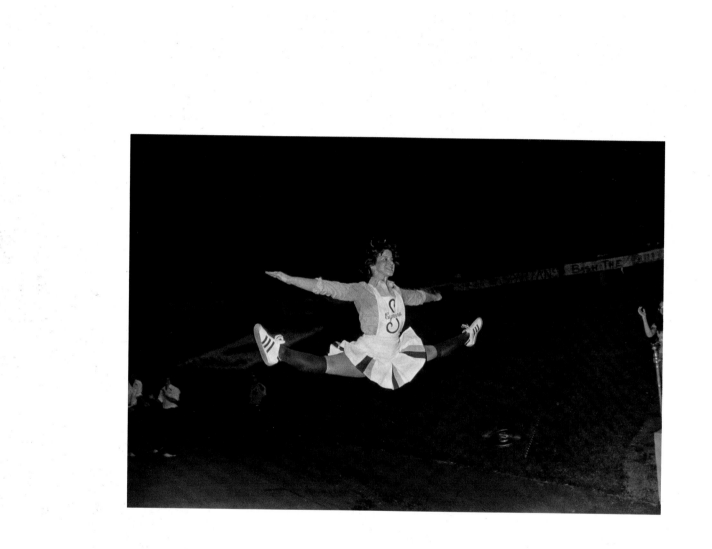

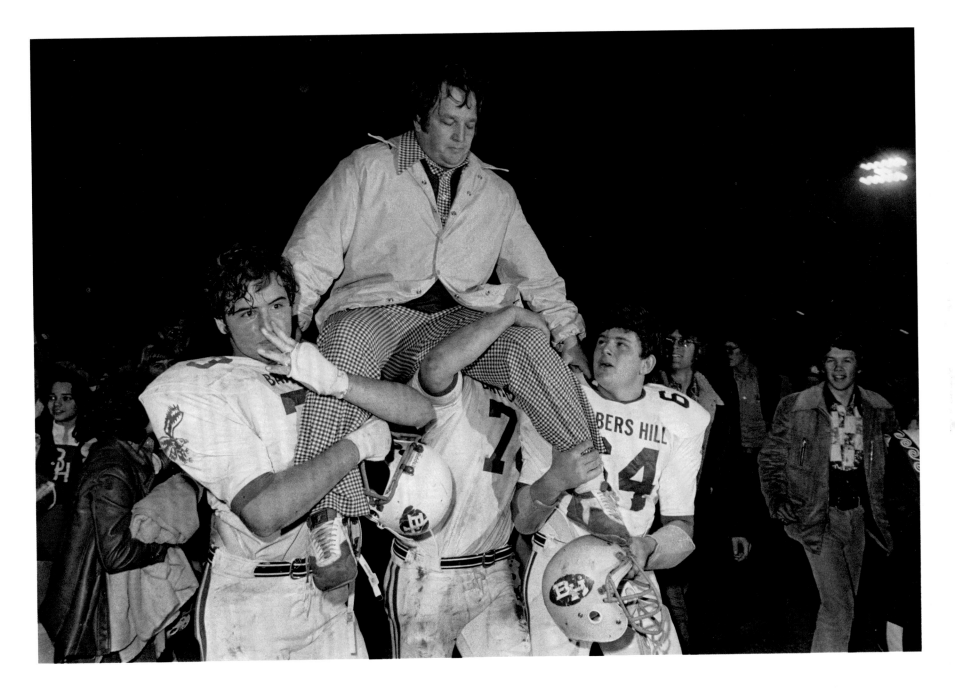

"Like every other instrument that man has invented, sport can be used either for good or evil purposes. Used well, it can teach endurance and courage, a sense of fair play and a respect for rules, coordinated effort and a subordination of personal interests to those of the group. Used badly, it can encourage personal vanity and group vanity, greedy desire for victory and hatred for rivals, an intolerant *esprit de corps* and contempt for people."
— Aldous Huxley

If you fly over Texas on an autumn Friday night you can see them below, in the distance, glowing yellow ovals visible for miles in the darkly empty countryside. Brighter always than the towns adjacent to them, they scatter across the state like enormous modern campfires, not so far apart in the east as in the west, differing in size, vibrant with activity. Even in the cities they stand out dramatically, giant suburban stadiums abreast of one highway or another, lit more grandly than office towers, busier than shopping centers. On a typical autumn Friday night over 4 million Texans gather in these places, around small lumpy fields of native grass, to join in observing the rites of fall.

High school football is an obvious rite of passage for the boys who play it. Flexing their muscles for the first time in public, instead of merely around each other, they bear down manfully, trying to open their eyes and look convincingly cool and determined, sure of themselves: like Football Heroes. The role has the same bold features and dimensions as Texas' traditional image of manhood, and tradition-minded Texans are quick to respond to it. More than the actual game itself, they come to applaud the values that football expresses—Texas values of land and will, mutual effort—encouraging their boys to embrace and adhere to them. Most of the young Football Heroes will never play organized football again after high school, and by the time they are seniors they usually realize it. Some never manage to accept it, of course, thus crippling themselves, but most find other pursuits that suit them better or seem more rewarding, more likely of fulfillment.

Fulfillment is often confused with winning by many Texans, who tend like Darwin to regard living as a competition, and this, too, is neatly exemplified by football. This is especially so at the high school level, where the boyish Football Hero sees himself, first and foremost, as a team member. He wins for his school, his girlfriend, his mother and father, brothers and sisters, for his town or neighborhood, for his coach and his teammates. These are truly unselfish victories, celebrated accordingly. On the winning side of a Friday-night football field there is more boyish hugging, touching, and unrestrained affection than most Texas males will permit themselves for the rest of their lives.

On the losing side the desolation can seem overwhelming: the boys are all grief-stricken tears and averted eyes, children again. Even the most sensitive coaches admit there is no consoling a team that drops the big game—unless maybe their girlfriends can do it, and the coaches are divided on whether that's even possible. Nonetheless, though, all coaches firmly believe that their boys will be back at practice come Monday afternoon; resilience is one of the major virtues of the Football Hero, after all, perhaps the most important one. As they cross the field to shake each other's hand, formally sealing the end of the game, the two opposing coaches represent their teams and towns in accepting its conclusions—final conclusions until the next week, or the next season, or the next, when new heroes, just like the old, play to another final conclusion that isn't final after all.

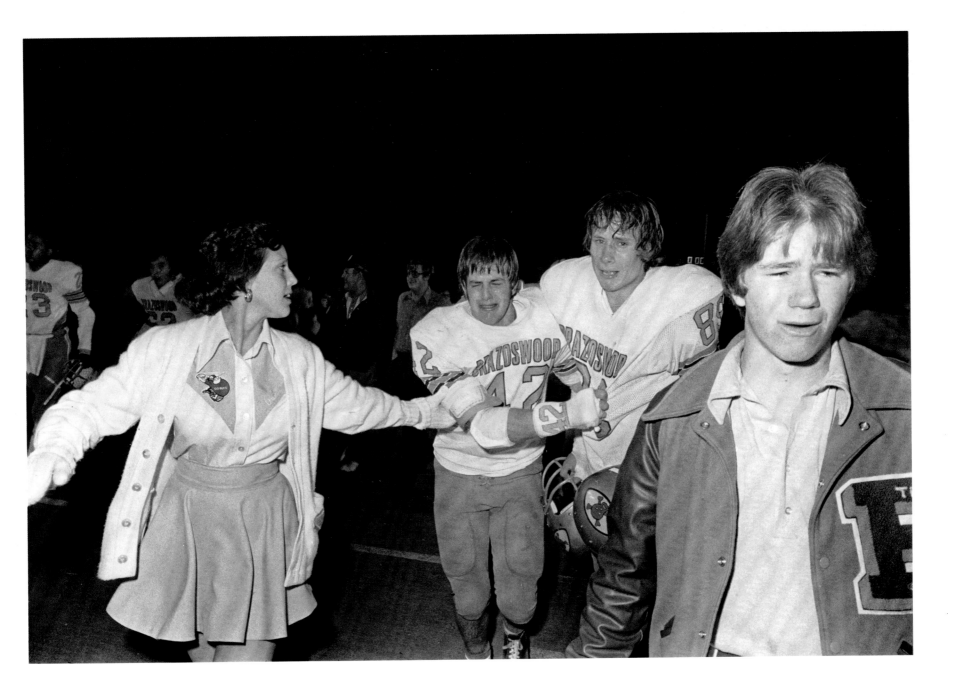

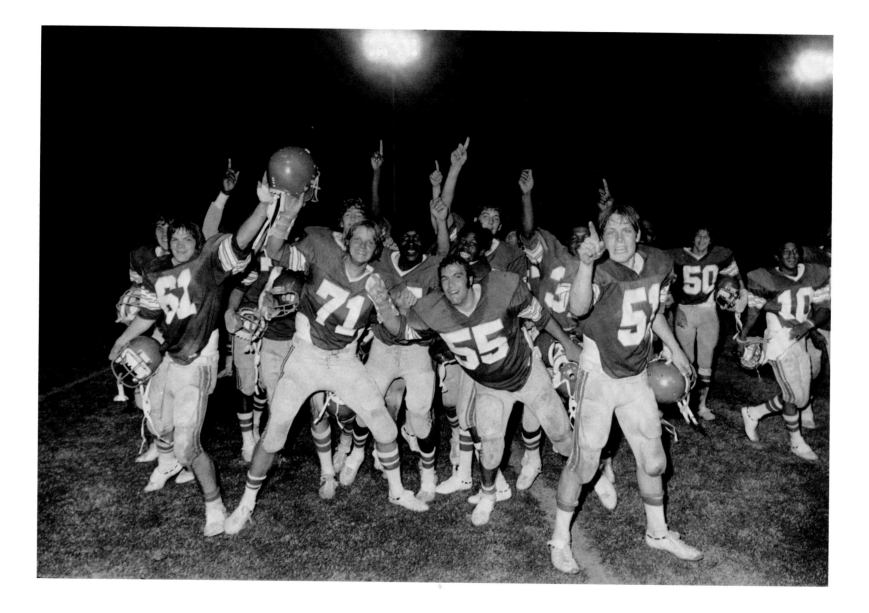

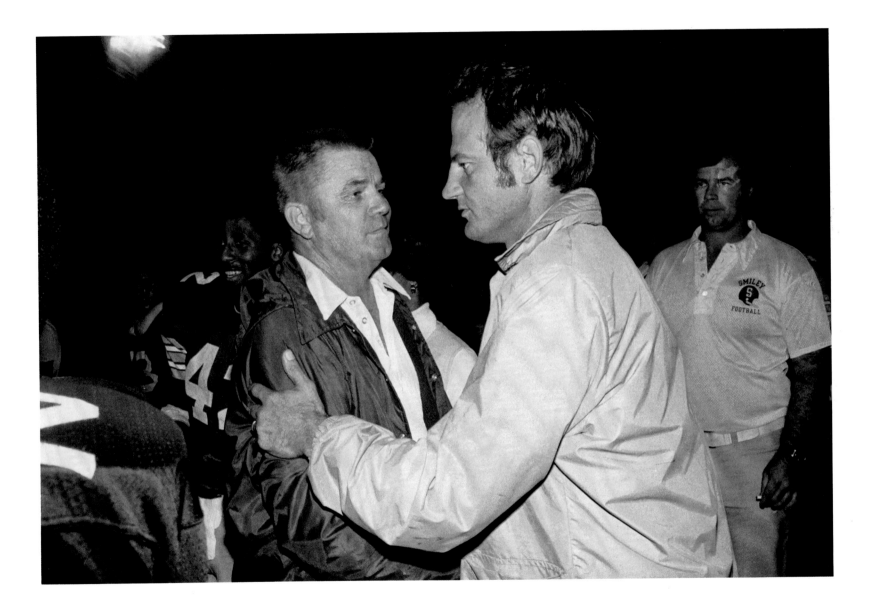

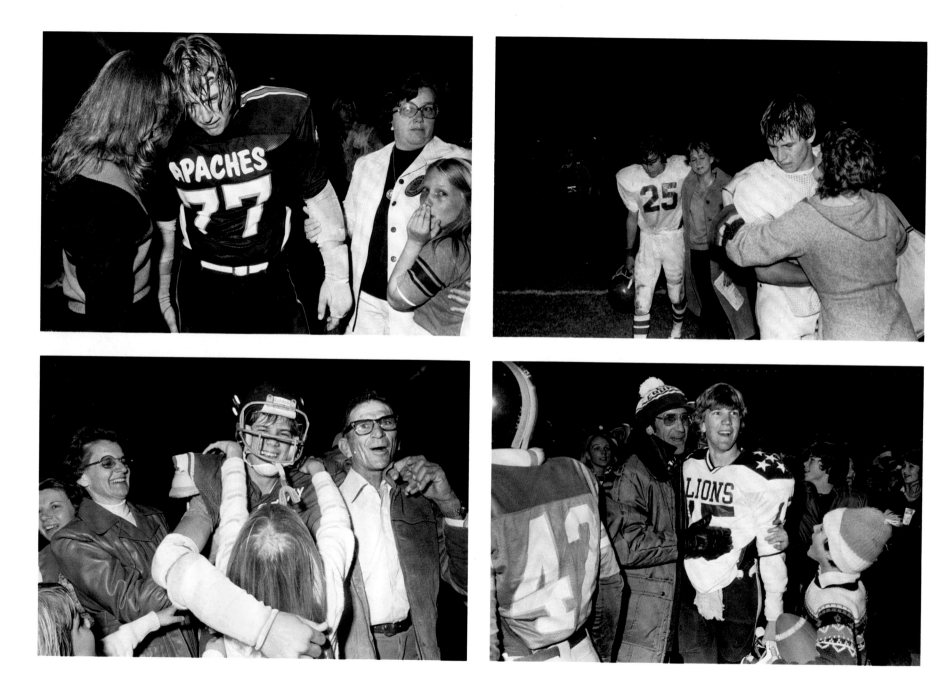

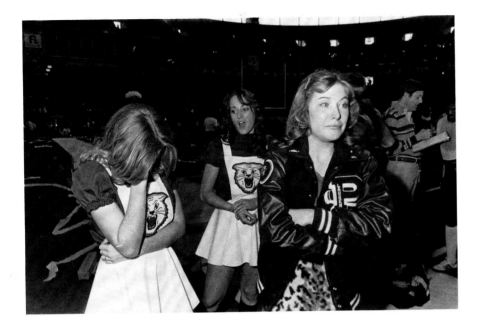

"Heavenly Father, we thank you for the privilege of playing together as a team. We thank you for Coach's guidance. We pray that we will live all our lives, as we played today, as true Christian sportsmen, as champions. And thank you, dear God, for enabling us to bring honor to our town, to our parents, and to ourselves. In Jesus' name we pray. Amen."
—postgame prayer by Gary Chalk, team captain, Big Sandy Wildcats, 1976

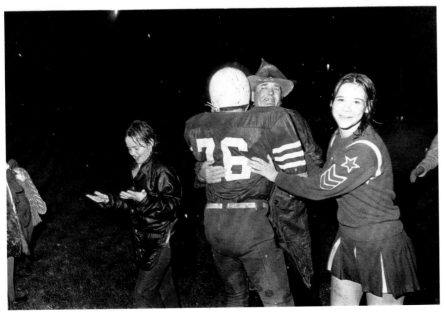

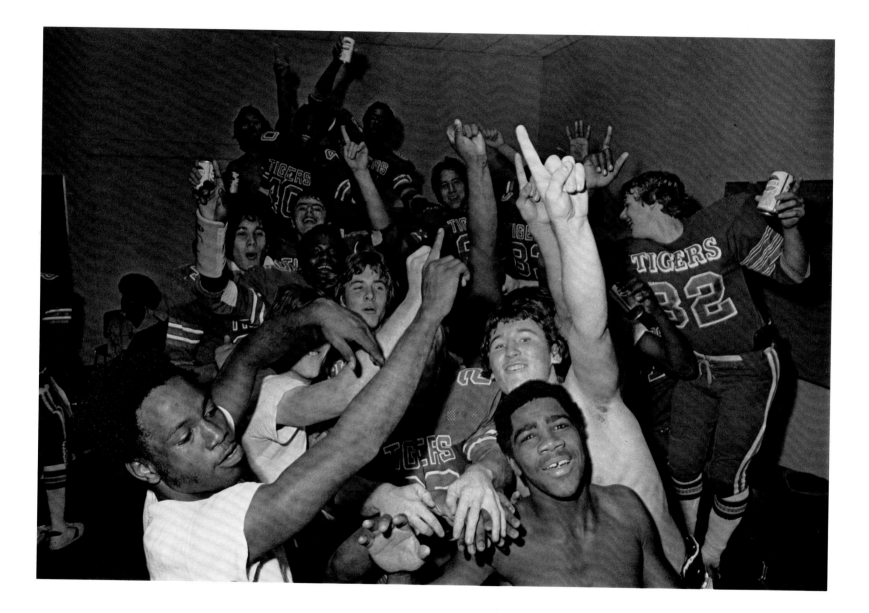

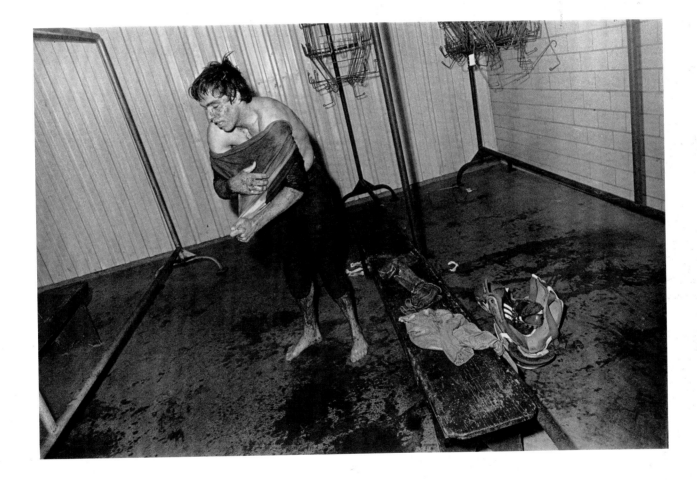

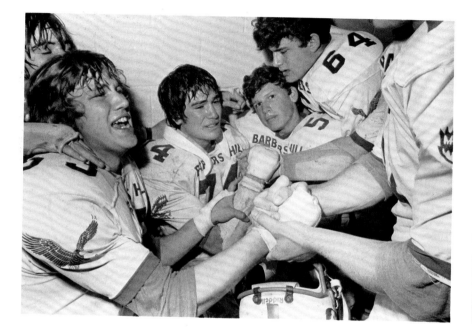

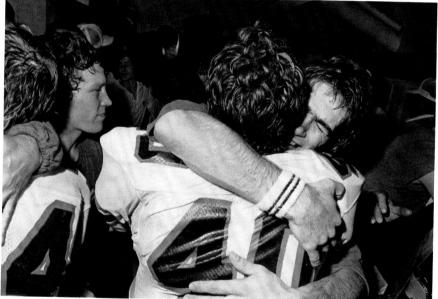

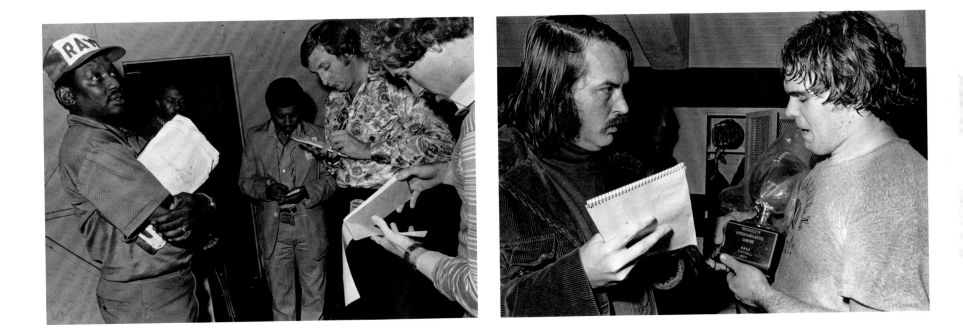

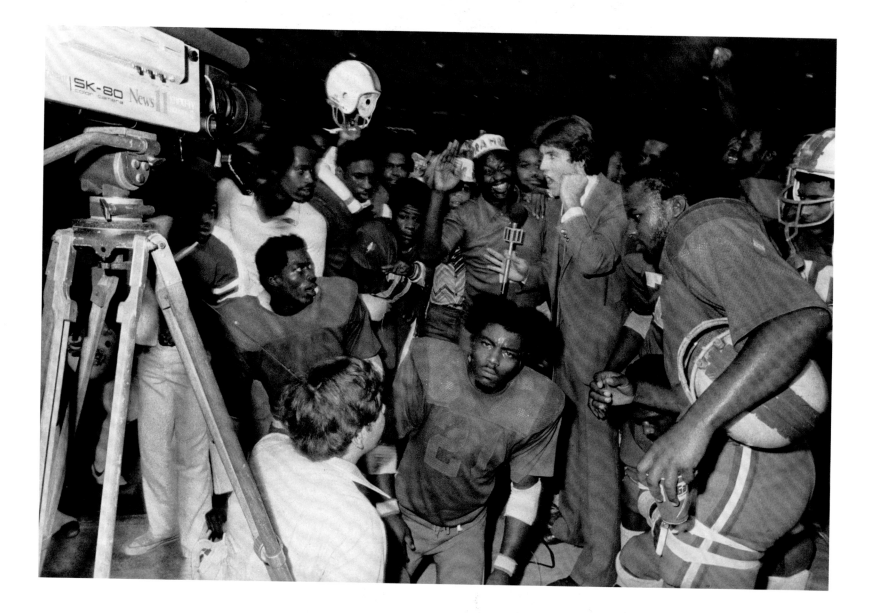

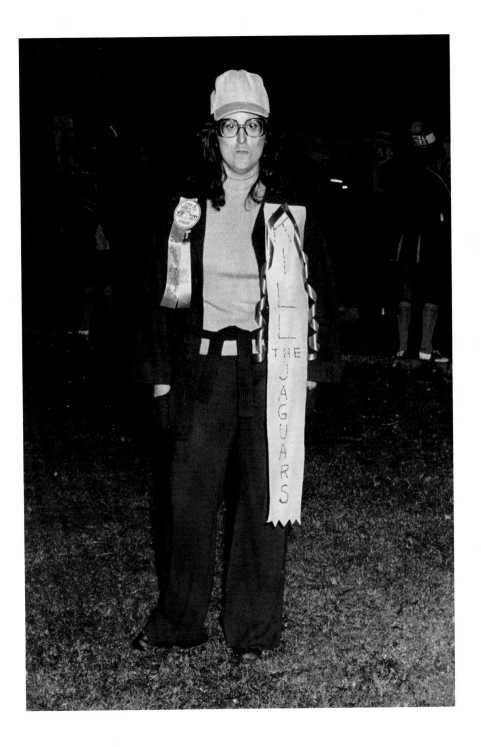

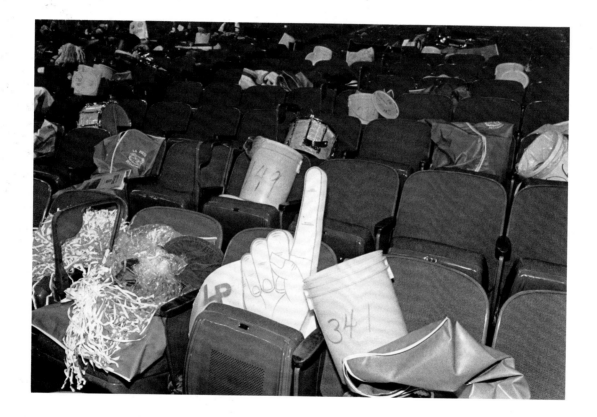

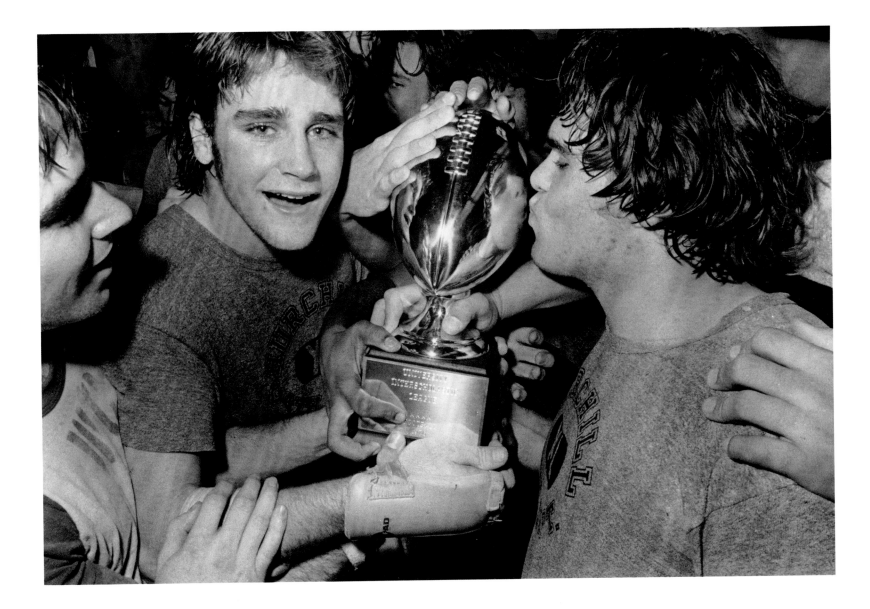

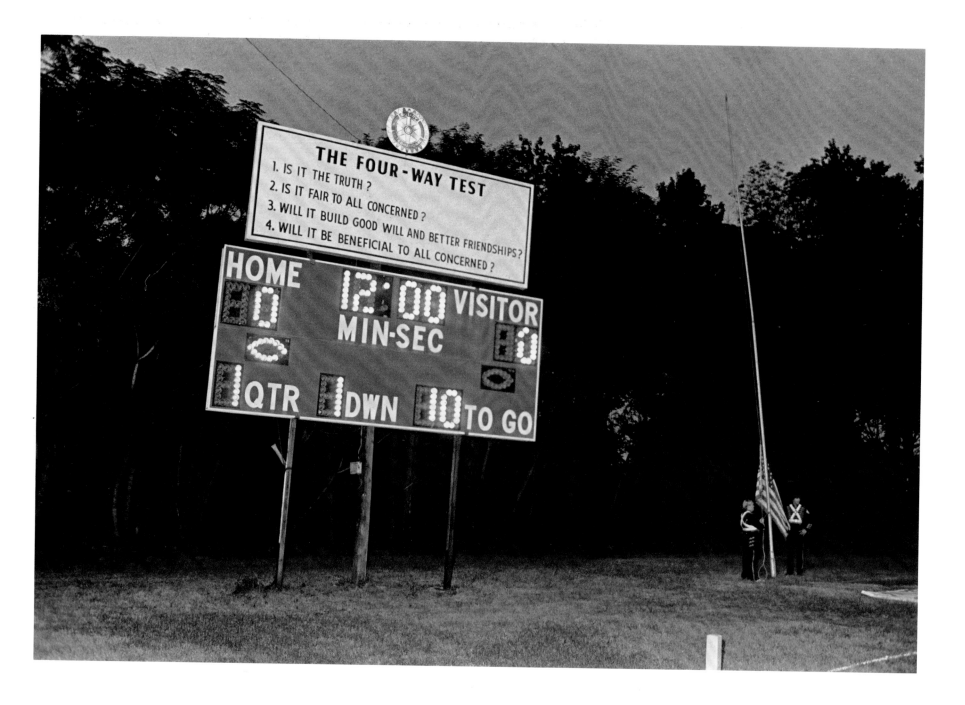

Commentary by Don Meredith

There is something special about high school football in Texas, something that makes it different from high school football in other states, and I think it's because Texas itself is so different. This was something I sort of felt even when I was playing in high school, but I didn't understand it then. I'm not sure I understand it now. After I went to college and then into professional football, though, and traveled around the country and visited with people from other states, I began to realize what a significant part high school football plays in Texas: it does symbolize something the state represents.

I guess it's probably several things, but number one is that it's a physical concept, a physical confrontation of one against another. I think football has that attraction for everyone to some extent, but particularly for Texans. Whether it's true or not the image of Texas and the setting of Texas is that it was done by rugged individuals who would *physically* stand their ground, who would *physically* settle an area. Football, one town against another, became a great outlet for Texans, a way of saying this is what makes us best. But of course you don't realize any of this when you're growing up in Texas, I know I certainly didn't. Football was just part of the school structure you grew up with: you just sort of accepted it. You just went out and played.

Mt. Vernon was just a little northeast Texas town, basically a farming community of about fifteen hundred people. There were maybe two hundred kids in the high school, and some of them came a pretty good ways to get there. We lived a block from the school, a block from church. My dad owned a dry goods store that sold a combination of work clothes, Wolverine work shoes, Big Smith overalls, yellow dent corn, with a part in the back where he sold seeds. He always had those posters up back there that gave the football team schedule, and he'd write in the scores after every game. Dad was on the school board. And I have a brother, Billy Jack, who's five-and-a-half years older than me, and he had always played ball.

We played against towns like Sulphur Springs, Mt. Pleasant, Pittsburg, Gilmer, Atlanta, and all these towns are bigger than Mt. Vernon. It was the smallest town in the 2A district but we had always had a reputation for having good athletic teams. Back in 1948 they won state in football *and* basketball, went undefeated in both sports, and it was mostly the same kids playing on both teams. So that kind of tradition was there when I was growing up; you were just expected to play ball. It wasn't really a pressure thing—it had already gone past pressure.

I started playing football when I was in the second grade. I was on the eighth-grade team and the only kid below the fifth grade, I believe, who played that year. I was seven years old. That didn't seem unusual to me or anybody else; it was just a natural flow of consequences from the games and things I had always done. I played basketball, too, twelve months a year; to me it was just as much fun as football. The sense of play was what I really loved. I believe that the guys who play football well for a long time, who go on to be successful in professional football, have somehow maintained that sense of play in their minds or they wouldn't have been able to do it. If your first experiences in football are really fun for you, then hopefully you can carry that over for the rest of your football career—however long it turns out to be—and hopefully into the rest of your life as well.

I can honestly say that football was always fun for me; I really did enjoy it. Partly it was that physical thing, of course, learning to do something well with your body, learning *about* your body. This is especially true for young kids. There's a kind of sensuous pleasure in being able to do something that is physically coordinated, that is totally in synch, when the flow of your body becomes a movement. That part is really so special, I think it's something that kids can feel instinctively.

Then as I got older and started playing high school ball I bumped into new emotional things, too, feelings I'd never run into before and don't know if I'd have found some other way or not. Like when you're fourteen or fifteen years old and you start to eat on Friday—you're going to play that night—and by this time you realize it's a game and it's very competitive and your stomach starts turning around, maybe even a little diarrhea slips in. And you get up to go to the bathroom and you pee so many times you can't believe it. All these things are building up and because they're new sensations they're kind of exciting, they're kind of a high. Those were early thrills for me.

Then you realize that it's become much more than that, it's bigger than that, it becomes a com-

munal thing. In a small town everybody sort of gets involved some way or another, and you see all these supporters—the townsfolk—and whether you know them well or not you still know who they are. I think it's the first time that a young kid feels all the different responsibilities of belonging to a group, being a real member of his community. That's when it becomes a rather heavy trip. You say to yourself, 'uh-oh,' and you get that identification everybody kind of strives for by pleasing other people. Unfortunately this can carry over for a long time and you spend your whole life trying to please somebody else.

The most important thing about playing in high school is that you learn to deal with all these new emotions and sensations. Like getting out in front of all those people, for instance. I saw a survey a while ago that listed the various things that most people are afraid of. Snakes were number two. The number one thing that most people feared was getting up in front of a group of other people. Through athletics you're more or less pushed out there and it helps to eliminate some of that fear, you realize it doesn't hurt. It's a way of learning something about yourself, learning to be proud of yourself.

I remember we had a graduating class of thirty-five kids my senior year (class of '56), and about seventeen of us were boys. Out of that seventeen I'd guess maybe twelve played football, and the other five were exempt for obvious reasons: just a little bit too small, glasses too thick, or lived too far out of town. If you were able to play football, you did, it was as simple as that. I was the tallest kid in the school, six-three my senior year, so I played center on the basketball team. In foot-ball I was quarterback on offense and middle linebacker on defense.

The name of our team was the Mt. Vernon Purple & White Tigers. I don't know why we were called that, I've never heard of a purple-and-white tiger. The one moment I remember best was during my junior year. We were playing against Sulphur Springs and they were the big powerhouse that year. It was our homecoming game, I think, and I wanted to play really well because it was the first game that my brother had come back to see me play in. He was the quarterback for Texas Christian University, and I sure did want to look good for him.

And I sure had the chance. Sulphur Springs ran a single wing and was real strong on the ground, so we put in a new defense that was basically a ten-man line with me playing linebacker and the whole secondary, since they didn't throw very much. It was a pretty weird defense. Then on offense we ran kind of a spread with me at quarterback. So it was a deal where I had the chance to either really do something wonderful or else get ripped apart. I guess I ran with the ball almost every play on offense and made almost every tackle on defense.

I think it was probably the best game, physically, I ever played. I was so tired—by the last quarter I was just exhausted. Then on one play I got tackled and was hit in the groin somehow, and it made me sick to my stomach. I knew I was going to throw up. We used an inverted huddle where ten guys line up while the quarterback stands in front calling the plays, and I remember wondering why the other ten guys wouldn't come into the huddle. I was throwing up and yet at the same time I couldn't figure out why the rest of my team didn't gather around me. So I was just standing there in the middle of the field all by myself, throwing up.

It was a kind of a combination of an embarrassing moment and yet at the same time it was—I don't know how to explain it. It was almost like I knew at that moment that I'd given everything I had to give, total commitment. Not holding back anything. Like being truly clean and truly free as far as maximum effort. It's an emotional feeling, an emotional high that is basically unparalleled. Once you've had that experience I believe it's something you keep looking for the rest of your life in whatever you do.

You can have it in other things besides athletics, of course, that feeling of, you know, that's *it*, you've got my best shot. This is my best lick. It's that feeling that gives you self-respect—in the long run it's much more important than whether you win or lose or whatever. Our game with Sulphur Springs was maybe the game I'm proudest of in my whole career. If you can walk away from something like that and still hold your head up, it's a nice feeling. Maybe the best feeling there is. Well, the second best feeling there is.

Index of Photographs